THE
MAKING OF AMERICA
SERIES

PUYALLUP
A PIONEER PARADISE

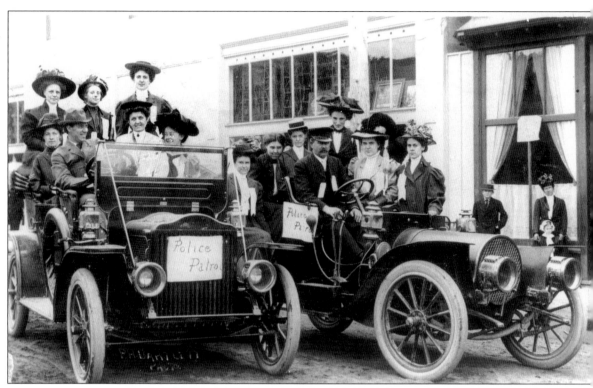

LIBRARY TAG DAY. *The women of Puyallup took over the "town government" in 1912 for the purpose of levying fines on miscreants to raise money for a new public library building. The library was later partially financed by Andrew Carnegie, steel magnate and financier, who helped to build public libraries throughout the United States. Drivers J.P. Leavitt (left) and Jim Stevenson provide the mock police patrol with transportation. A respectable $425 was collected in this effort. (Courtesy Beta Club Collection.)*

ON THE COVER: PUYALLUP'S PROSPEROUS TWENTIES. *This view was taken from Stewart Avenue, looking south on Meridian. (Courtesy Washington State Historical Society, Tacoma.)*

THE
MAKING OF AMERICA
SERIES

PUYALLUP
A PIONEER PARADISE

LORI PRICE AND RUTH ANDERSON
EZRA MEEKER HISTORICAL SOCIETY

ARCADIA

Published by Arcadia Publishing,
an imprint of Tempus Publishing, Inc.
2 Cumberland Street
Charleston, SC 29401

Printed in Great Britain.

Library of Congress Catalog Card Number: 2001099035

For all general information contact Arcadia Publishing at:
Telephone 843-853-2070
Fax 843-853-0044
E-Mail sales@arcadiapublishing.com

For customer service and orders:
Toll-Free 1-888-313-2665

Visit us on the Internet at http://www.arcadiapublishing.com

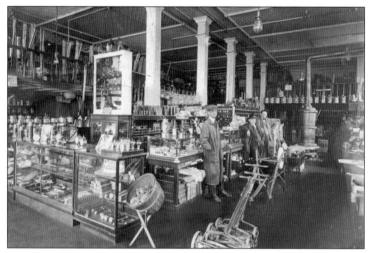

STEWART STORE. Seen here c. 1890s, the Stewart Hardware Store was located in the large building constructed on the southwest corner of Stewart Avenue and Meridian Street by pioneer James P. Stewart. The building was replaced by the Uniland Office complex in the 1960s. (Courtesy Ezra Meeker Historical Society.)

CONTENTS

ACKNOWLEDGMENTS

We were honored to accept the Ezra Meeker Historical Society commission to write the first history of this vibrant community. A generous gift from the late Henry Welzel and contributions from the Board of the Western Washington Fair, Korum Motors, and several other organizations and individuals made it possible for us to conduct our research. Many sources of information and photos came our way. Historical society members Hazel Hood, Bob Ujick, and Georgia Stickney, among others, lent documents, photos, and their considerable knowledge of the town. Bob Minnich and Ray Eagan provided valuable critiques of our drafts, but we hasten to say we alone are accountable for the contents. Lyn Iverson, editor of the *Puyallup Herald*, granted access to old editions of Puyallup newspapers and a room for research. Gay Uhl, Puyallup Public Library, accorded use of the women's Beta Club Photo Collection; and Elaine Miller, Washington State Historical Society, Tacoma, and Robert Schuler, Tacoma Public Library, helped us select photos from the collections they oversee. Wes and Sue Perkinson, Gary McCutcheon, and several others let us borrow from their personal collections. Carrington, Ink! scanned and edited each photo to produce the best quality possible from aging images. We are indebted to Arcadia editors Mark Berry, who selected our manuscript for this series, and Christine Riley for skillfully leading us through the production process. Our deepest appreciation to all of you and countless others for helping us tell the story of this pioneer paradise.

Finally, we acknowledge the support and patience of our husbands, Earl H Price and J.M. "Andy" Anderson.

Lori Price
Ruth Anderson

INTRODUCTION

Puyallup, a city approaching a population of 35,000, sprawls along the Puyallup River between two hills in Pierce County, Washington. Tacoma, 10 miles northwest, is the county seat; Seattle lies 30 miles north. The town's unusual name derives from the small tribe of indigenous Americans who resided here when the white man arrived. The tribe enjoyed the reputation of being magnanimous with Indians who traversed the Cascade Mountains to trade. The Yakima Indians and other tribes began calling these people who lived by the river, "Pough-Allup," meaning "Generous People," and the name stuck.

Pioneers who came over the Oregon Trail and headed north found promise in the fertile valley soil, as did those who made the harrowing trip over the Naches Pass in the Cascade Mountains. First, the farmers had to clear the land of towering stands of old-growth timber. Lumbering became a thriving business, and several mills were established to plane the high-quality wood.

In 1865, pioneer Ezra Meeker and his father planted hops, and Ezra amassed considerable wealth. Civic-minded, he platted the town in 1877, donating land for community use, as did others. A year after Washington became a state in 1889, Puyallup was incorporated as a city.

When pests and disease suddenly wiped out the hop crops, farmers turned to berries. Fruitgrowers banded together to create cooperatives and canneries, marketing their products as far away as England. A handful of farmers also started raising daffodils, finding lucrative markets here and abroad.

Today, the Valley is filled with bedrooms where once grew towering trees, hops, berries, and daffodils. But the looming presence of Mount Rainier, an active volcano to the southeast, leaves little doubt that nature still controls this wondrous setting.

1. PARADISE REVEALED

Once there was only the water, moving in unending great gray waves from horizon to horizon, an unbroken liquid movement. Under the mists and storms of the Miocene Age sky, nothing impeded the water's relentless power and foam-rimmed progression. Slowly, slowly the ocean bottom arched and cracked and began an incredibly protracted ascent. Great masses of rock tilted and twisted as if they were on the hinges of a gigantic door, emerging from the gray waters, becoming land.

Scientists of today call it the Cascade Revolution, and tell us that it lasted into the next geological period, the Pleistocene Age. In fact, they tell us that the revolution was only a minor part of the larger uplift that affected the entire western half of what we call the North American continent, and was accompanied by both igneous and volcanic action which lasted for millions of years, and indeed continues today.

Along with these geological changes, the forces of erosion made the Cascade Mountains and the Puget Sound the beautiful regions they are. Unremitting rains, collecting in streams with yearly run-offs swollen by melting snows, etched the great rock wall of the Cascades in thousands of downward cuts. The artistry continues as the channels deepen with each passing year.

Another and greater source of change upon the land were the glaciers, formed originally by the abnormally heavy snowfall of the great Pleistocene storms that raged almost unceasingly for thousands of years. During this time, these interminable snows compacted into ice that formed glaciers and flowed into the already eroding valleys like primordial giant bulldozers.

At least twice during this Pleistocene Age—and perhaps many more times that we cannot document—thick lobes of ice crept slowly down from the ice fields that covered the area now known as British Columbia, entering an already existing structural depression that became, with this glacial impetus, the then nameless Puget Sound.

This massive ice sheet capped the entire top of our planet, with its western edge completely filling the depression between the Olympic and Cascade Mountain ranges, extending as far south as the present towns of Tenino and Centralia, Washington.

Millions of tons of ice, which weighs 57.2 pounds per cubic foot, scooped a deeper basin in the soft igneous rock, allowing an arm of the Pacific Ocean to enter as the ice receded northward. These incoming waters drowned an extensive drainage system

ON PUGET SOUND.
Puyallup lies southeast of
Tacoma on the Puyallup
River just off the sound
that defines Western
Washington. (Courtesy
Kroll Maps, Seattle.)

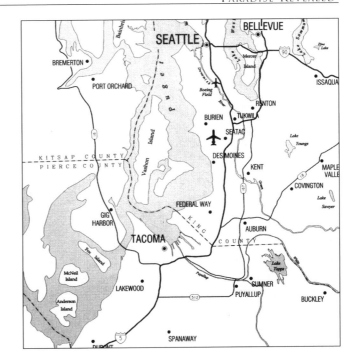

formed earlier by the rivers and streams flowing from higher lands, cutting channels that forked or branched and then reunited in the cradle of the basin.

Most of these channels still remain, although some of them have become filled with silt. Our beautiful Puyallup Valley is one of them, almost completely filled in. With its deep alluvial soil, it is a mellow and fertile land. Its mild marine climate, once the glaciers receded, produced forests and dense undergrowth that were almost tropical. A natural wonderland developed in the Valley and throughout the area between the mountain ranges.

The most dominating land feature of this wonderland is the mountain that crowns the Cascade crest, a sparkling presence on our southeastern horizon, trailing scarves of opalescent mist. Visible on clear days from almost everywhere in the Puget Sound area, Mount Rainier is a constant fact of life for us.

Geologists tell us that the history of Mount Rainier is much like that of volcanoes the world around. It once blazed—and may again—in a line-up of fiery beacons, which extended the entire length of the Cascade Mountain crest. The geologists believe Mount Rainier was once over 16,000 feet high, before the explosion that removed about 2,000 feet from its top, an event they believe happened about 6,000 years ago. In addition to some geologic evidence supporting this theory, there are Indian legends telling of a great eruption of the mountain.

Geologists have reconstructed the eruption, which collapsed the summit of Mount Rainier, and the resultant disastrous mudflow, the Osceola mudflow, one of the largest ever known. It extended 65 miles and covered more than 125 square miles of the Puget Sound lowlands. One lobe of the flow reached an arm of the sound, burying the sites of

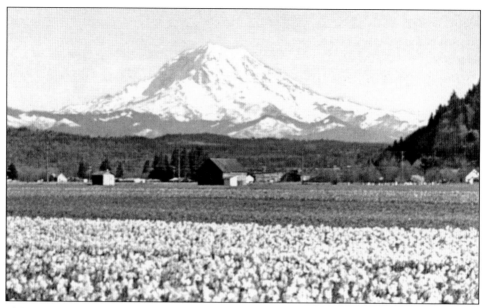

"THE MOUNTAIN WHO IS GOD." That is how the Indians who lived in the Pacific Northwest referred to the snowy mountain on the southeast horizon. Home of 29 glaciers and the source of most of the region's rivers, the mountain overshadows the Puyallup Valley, seen here in its glory days blanketed in radiant daffodils. (Courtesy Beta Club Collection.)

Kent, Auburn, Sumner, and Puyallup. Another mudflow subsequently covered the site of Orting.

The Indians who inhabited the Puget Sound region for thousands of years before the white man came are believed to have wandered across a land bridge from Siberia, probably in search of food, and spread throughout the continents now called North and South America. They were given the name "Indian" many thousands of years later by Christopher Columbus when he believed he had reached India in 1492, and they retain that generic name today. Just when they settled along the river now known as the Puyallup is unknown, but it is believed they have been here for more than 10,000 years.

The Indians of the Puyallup Valley called the mountain "Tecopt" or "Tuchoma," which, loosely translated, meant the "mountain who is God." Its looming presence must have been awesome to them. Some historians, however, have declared that the words referred to any snowy mountain peak, not just Mount Rainier.

The name "Puyallup" is likewise disputable but the generally accepted meaning is "generous people." The name was given to a relatively small tribe of Indians who lived along a river, also unnamed, by other Indians who traded with them and visited them.

All of the Indians of the Northwest were accustomed to fish and hunt around the sound, which they called "Whulge," and up the various rivers that emptied into it. Even the Indians from east of the Cascades came over the mountains to trade.

Those who visited these local Indians found a real welcome and heaped-up trade goods when they started home. The visitors were even loaned large canoes to transport the trade

goods, plus abundant food for long journeys and generous gifts. It was this spirit of hospitality and generosity that led to the naming of the Indians. The Yakima Indians began referring to them as Pough-Allup, or "generous people." Other tribes, having experienced the same hospitable spirit, took up the name, and it soon became the accepted designation of the people.

The houses of the Puyallup Indians were substantial and permanent. They resembled long sheds, 80 to 100 feet, covered with slabs of cedar, which shed the rain with great efficiency. An entire family group occupied each shed. The family head, usually the grandfather or grandmother, occupied the center of the building with the families of the children spread out on either side. Each family had its own fire in the center of the family room, with a smoke hole in the roof and an opening or doorway to the outside.

The women wove cattail reeds with the fibrous inner bark of cedar trees to make curtains or door coverings. This same cedar bark and reeds were used to make clothing, with the skins of animals employed in some rare cases.

For food, they had both salt- and fresh-water fish, clams, and abundant game, which the women were adept at drying, and berries, hazelnuts, and the roots of the camas and the wapato, a potato-like root. These roots grew in inland swamps and around the numerous small lakes in the area, but the Indians soon learned to cultivate their own fields of both camas and wapato.

The roots of these plants were dried for storage. The women dug them with sticks until after the white man came, and then they were able to use iron rods that were flattened and pointed at one end, with a stag horn handle placed crosswise on the other end of the rod. They were very efficient digging tools.

When fresh, the roots were full of a watery substance somewhat like the core of a quince. Once the women had great piles of them, the men dug a huge hole, lined it with flat stones, and built a fire in it. The fire was kept burning for 24 hours, then the coals and ashes were cleaned out and fresh ferns were laid in for a lining over the hot stones. Then came the camas roots and another layer of stones. Over that, they heaped earth. Three days later, this "fireless cooker" was opened and the roots came out, sweet and mealy and delicious. More than one pioneer mentioned how delectable camas roots were, cooked in this fashion.

These roots could also be dried and stored to serve as food during the winter months. Indian women were also adept at drying fish and meat. In addition, there was almost an overabundance of fish, available year round, in the many streams west of the Cascade Mountain range. This ready availability of food made the Puyallup Indians prosperous. With few other hardships, they lived happily and contentedly in their beautiful valley, and participated in a highly organized society of their own.

Into this natural paradise came the white man from beyond the oceans, borne on the white wings of sail. The first white man to come to the Puget Sound region was probably the old Greek seaman Apostolos Valerianos, known in the history books as Juan de Fuca. In 1596, he told the story in Venice to a reputable English merchant named Michael Lok that he had been in the employ of Spain for 40 years and had piloted several ships into the fabled "Strait of Anian," and that it lay between the 47th and 48th degrees of latitude on the northwestern shore of the North American continent.

Juan de Fuca reportedly gave a plausible description of the country and the natives he had seen in this strait—but he also sailed out of the strait and never returned. Within 10 years after this interview with Lok, Juan de Fuca was dead. It was the Englishman, Charles Barclay, who combined exploration with trade in 1787 and discovered—or re-discovered—the strait, naming it for the old Greek seaman.

Captain George Vancouver, also sailing under the flag of Great Britain, entered the strait in 1792, applied the names Admiralty Inlet and Puget Sound to its waters, and named the highest snowy mountain of the Cascade crest Rainier, to honor his friend, the myopic Admiral Peter Rainier. He also named Mount St. Helens and Mount Baker for other friends in the Admiralty. Vancouver stayed in Puget Sound only a short while before returning to England.

Three decades after Captain George Vancouver's short visit, the men of the Hudson's Bay Company came. The company was formed in England in 1667 for the express purpose of exploring Hudson's Bay "in the northwest parts of America, for a discovery of a new passage into the South Seas, and for finding some trade for furs, minerals and other considerable commodities."

By the time the agents of Hudson's Bay Company, or HBC, as it was more commonly called, reached the Puget Sound region, it was the trading aspect that was the prime reason for its existence. HBC established a network of trading posts throughout the northwestern parts of the North American continent. In 1833, Fort Nisqually, at the mouth of the Sequalitchew Creek in present-day Pierce County, Washington, was the last of these posts to be established.

It was from Fort Nisqually, in that same year, that the first white man of record came to the Puyallup Valley. Dr. William Fraser Tolmie had been sent to the fort in May 1833 to care for the health of the HBC employees. He was also interested in botany and spent a lot of time following his naturalist bent. In August, he persuaded an Indian chief named Lachalet and a Puyallup Indian named Quilliliaish to accompany him on a research trip to Mount Rainier.

His route to the mountain lay through the Puyallup River Valley, which he called "Poyallipa." He wrote the following in his diary: "The Poyallipa flows rapidly and is about 10 or 12 yards broad. Its banks are high and covered with lofty cedars and pines. The water is a dirty white colour, being impregnated with white clay." Later on, a diary entry described the river as having several steep banks, bordered by dense and tangled thickets. Tolmie mentioned "a tedious walk through the wood bordering the Poyallipa."

It was not until 1838 that the first Americans arrived in what is today Pierce County. Jason Lee, the Methodist missionary who had come to Oregon in 1834 and established a mission in the Willamette Valley, visited Fort Nisqually with the idea of locating a mission school there. Shortly thereafter, two other men, W.H. Wilson and the Reverend David Leslie, began construction of the school.

The Reverend John P. Richmond and his wife, America, were given charge of the mission school when it was completed. It was located about a mile east of the fort buildings. A young, unmarried woman named Chloe A. Clark was hired as schoolteacher, and it was not long before she and Wilson, who had been given charge of the secular department, were married.

DR. WILLIAM FRASER TOLMIE.
Dr. Tolmie was assigned to Fort
Nisqually when it was established in
1833. He also was the first white man
of record to visit the Puyallup Valley,
which he did that year. He later
became the factor at Fort Nisqually
and although British, was a friend
to the American settlers who came
to the Puget Sound area.
(Courtesy Washington State Historical
Society, Tacoma.)

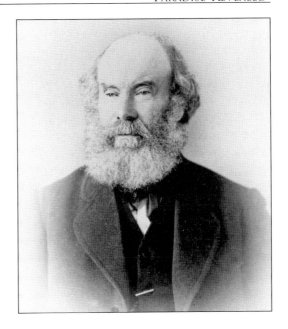

In spite of the presence of these Americans, the British acted as if the area north of the Columbia River was English territory. Their first attempt to colonize the area occurred in 1839 when the stockholders of the Hudson's Bay Company established the Puget Sound Agricultural Company to produce food for its trading posts, as a place where HBC employees might settle to farm and ranch. They also planned to develop a market with the Russians in Alaska who had a need for food and other supplies.

Two farms were established, one at Cowlitz Prairie and the other at Fort Nisqually. An additional farming operation was begun at Fort Vancouver on the north bank of the Columbia. The first employees on the Nisqually farm were Canadians, Frenchmen, and Scots hired as indentured labor, and there were also men from the Sandwich Islands brought over to work.

Some of the men took Indian wives, and these Indian women, as well as native men, were also hired by the Puget Sound Agricultural Company to work on the farms. HBC advocated these marriages of their male employees to the native women. It made for more peaceful relations with the Indians.

The Company settlements were also intended to attract settlers from Canada and Britain to solidify a British presence north of the Columbia and bolster British claims to the area. Their first attempt at colonization in 1841 failed when settlers from the Red River Colony in Manitoba came, after a horrendous journey from Canada, but were not impressed with their prospects and gradually drifted away. There was also an unspoken policy of HBC to divert American settlers south of the Columbia River to the Willamette Valley.

The young United States government was making efforts at extending the new nation to the Pacific Ocean, having reached it by the astounding experiment in exploration of Meriwether Lewis and William Clark and their small band of hardy explorers in

1805–1806. But it was not until 1838 that Congress authorized and funded a voyage of discovery to the area. The idea of such a voyage had been suggested to President James Madison even before the War of 1812, but it was slow in developing, with the appropriation of $300,000 coming only in 1836.

Lieutenant Charles Wilkes was appointed captain of a voyage of discovery and given a fleet of four ships: *Vincennes*, a 780-ton sloop-of-war; *Peacock*, a 650-ton sloop; *Porpoise*, a 230-ton brigantine; and *Relief*, a store ship. Three years later, after touching on the continent of Antarctica and visiting most of the islands of the South Seas, Wilkes and his crews finally reached Puget Sound on May 11, 1841.

The purpose of the Wilkes Expedition was primarily exploration and discovery, and in that capacity, it left an impressive total of 261 names on the local map, including Commencement Bay, where the American exploration of the Puget Sound area actually commenced. Many of the Wilkes names disappeared as time passed, but one which remained was that of the "Stuck River." It was an Indian word for "breaking away," just what the Stuck did from the White River.

In addition to being one of the biggest "name droppers" in the Puget Sound area, Wilkes brought the first authentic American holiday to the region. He and his crew were still anchored off Fort Nisqually on Independence Day in 1841. July 4 that year fell on a Sunday, so the holiday was celebrated on July 5.

Wilkes bought an ox from Fort Nisqually's factor and the crew barbecued it on the American mission grounds near the fort. They borrowed horses from the nearby Indians and held horse races, as well as other games of their devising. After feasting and firing off their guns to salute the Independence holiday (which the Englishmen only joined in halfheartedly), they returned at sunset to their ship. The next day, the surveying party was again dispatched to complete the survey of the Puget Sound.

The Wilkes Expedition gave the young United States a further claim to the Northwest area of the continent, but it was not until 1846 when a treaty was signed with Great Britain that the boundary was settled at the 49th parallel west of the Rocky Mountains. The United States–Canadian boundary has become the longest peaceful border between any two nations in the world.

This treaty recognized the rights of the Hudson's Bay Company and the Puget Sound Agricultural Company, but their presence in the area and the $6 million HBC claimed for their holdings remained a thorn in the sides of the American settlers. Later negotiations resulted in the payment by the U.S. government of $650,000 to the two companies, which was less than 10 percent of what the British-held companies were seeking.

The Territory of Oregon was created by the U.S. Congress and ratified on August 14, 1848, and President Millard Fillmore signed the "Oregon Land Law" on September 27, 1850. This law, officially known as the Donation Land Act, was one of the most compelling factors in drawing American settlers to the Oregon (and later Washington) Territory. On March 2, 1853, Congress divided Oregon Territory, making the northern part into Washington, not Columbia Territory, as the local citizens had petitioned.

The Donation Land Act provided that every male citizen above the age of 21 years who would go to Oregon/Washington Territory could select a half section of land and, upon proper proof of having lived thereon for the full period of five years, would receive a

patent for the land. A married man taking his family could locate on 640 acres. The law was to be in effect until December 1, 1853, but it was extended for another two years in February 1853, with the provision that the amount of land that could be claimed was reduced by half.

The Pre-emption Land Act had become a law in 1841, allowing the outright purchase of public lands, and this law was extended to Washington Territory when it was created. Another land act, the Homestead Act, became effective in 1862. Farms under this act could also be commuted under the pre-emption law, thus avoiding the necessity of the five-year residence requirement.

Pierce County was established while it was still a part of Oregon Territory. It actually began as a number—County No. 4—at the Cowlitz Convention in August 1851, when citizens north of the Columbia River laid out the boundaries of 12 counties in all. Those of County No. 4 were listed as follows:

> From the north side of the Puyallup [river] beginning on the Sound, running due east with County No. 3 to the Cascade Mountain, thence south with said Cascade Mountain until the line reaches the dividing ridge between the waters of the Cowlitz and Nesqually rivers; thence westwardly with said dividing ridge sufficiently far until a line due north will strike the mouth of the Nesqually river, thence west in the channel of the Sound sufficiently far to include the islands lying north of Nesqually and west of the Puyallup river, thence to the place of beginning at the mouth of the Puyallup.

Before Congress could act on this petition, however, the Oregon Territorial Legislature formed Thurston County on January 22, 1852. One of its five precincts was Steilacoom, which roughly corresponded to the present boundaries of Pierce County, and incorporated the whole of the Puyallup Valley.

In December of that year, the Oregon Territorial Legislature created Pierce County out of Thurston County, naming it for the president-elect of the United States, Franklin Pierce. Another act appointed officers for the county and a third act located the county seat at Steilacoom, which was the only real settlement within the county boundaries at that time.

There were a number of men, most of them current or former employees of HBC, living with their Indian wives in rude cabins along the Puyallup River in 1852. They included Adam Benston and his brother William as well as a man named George Haywood, who lived on the Stuck River.

With the exception of these early "squatters," some of whom later filed land claims, the earliest settlers in the Puyallup Valley were members of the first immigrant train to cross the Cascade range north of the Columbia River in the autumn of 1853. These hardy pioneers were known as the Naches Pass Immigrants.

2. The Quest for a Home

By the summer of 1853, much of the good farming land south of the Columbia River had been claimed by the American settlers coming west over the Oregon Trail, and they had started moving north to the Puget Sound region. They began looking for a direct route over the Cascade Mountains, which would cut off a lot of miles for new settlers coming from "the States."

Shortly after Congress created the new territory, it also appropriated $20,000 for a military road between Fort Steilacoom in the west and Fort Walla Walla in the eastern part of the territory. Isaac I. Stevens, a graduate of West Point and hero of the Mexican War, was in charge of the U.S. Survey Office in Washington, D.C. when he accepted his appointment as territorial governor. He also asked for the office of Indian Affairs and command of a party to survey a practical route for a railroad from the Mississippi River to the Pacific Ocean. Both requests were granted, and Stevens organized a surveying party of 300, including 11 Army officers and several artists and scientists.

Among them was George Brinton McClellan, who was sent ahead to survey a route for a wagon road across the Cascades by way of the Naches Pass. He was also instructed to build a road from Fort Walla Walla to Fort Steilacoom, but failed to complete either assignment. The reason he gave was inclement wintry weather. McClellan's foot dragging became a characteristic that showed up nearly a decade later when both he and Isaac Stevens served as Army generals for the Union during the Civil War. Stevens became a genuine hero and was killed leading his men in a charge in the Battle of Chantilly, Virginia.

McClellan was chosen by President Abraham Lincoln as his general in chief of the Union Army. He was brilliant in training the army, but reluctant to use his men to fight the Confederate forces, always insisting that he needed more personnel. It soon became apparent to Lincoln that McClellan would always find excuses for things he did not want to do, and eventually Lincoln replaced him with a series of other generals until he found one—Ulysses S. Grant—who would fight.

Since McClellan was a long time arriving to build the cross-territory road, a number of settlers decided to build the road themselves, as many of them were expecting relations or friends already on their way. Edward J. Allen was appointed to head a party of four to "view out" Naches Pass and report on the practicality of a wagon road through it. He followed the old Klickitat trail, used by the Indians for years—perhaps for centuries—for both trade and war. The surveying party rode on horseback up the densely forested ridges

NACHES PASS. The twisting, root-rutted road over Naches Pass by which the first wagon train direct to Puget Sound traversed the Cascade Mountain range. The road can still be seen today, nearly 150 years later. (Courtesy Lori Price Collection.)

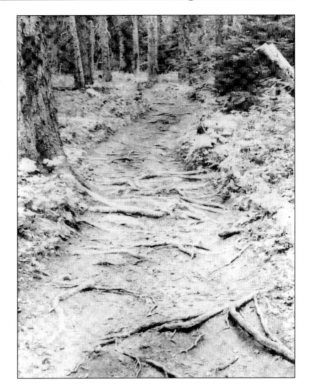

and down into deep defiles, crossing the turbulent White River seven times. There was still snow on the summit when they reached it in early June, but descending the other side, they found the trail was clear of snow from the Yakima Valley to Walla Walla.

Allen and a companion hurried back to Olympia to tell the Americans the road was, indeed, feasible. Enthusiastically, the settlers pledged $1,200 in cash, provisions, tools, and labor. Leschi, of the Nisqually tribe, lent them 14 horses. Farmers left their farms to work on the road so that it would be ready for the 1853 immigration.

The road building was a monumental task and largely thankless for men with nothing but hand tools such as axes, saws, picks, and shovels. One crew, under the supervision of Whitfield Kirtley, went to the Yakima Valley to work westward. Allen was in charge of the 18 men who would build toward the east.

The western crew crossed and recrossed the roaring White River, felling the enormous trees at ground level. Where trees were already down due to storms, the road had to be built around the stumps, or the fallen trees had to be cut so that the wagons could be driven over them.

Andrew Burge was hired as a packer to bring food supplies and new tools to the builders. He was often late, and the laborers were sometimes without food. Once, when a bear pillaged their cached supplies, Burge had to make an emergency trip back to Steilacoom for more provisions. In the meantime, the road builders ate berries and three squirrels they shot.

When Burge finally arrived four days later, he brought food, but also some disturbing news. Captain McClellan had finally arrived in the territory, but he was busy exploring Snoqualmie Pass, not Naches, and was expected to recommend the northern route for the military road. If he did, there would be no pay for the road builders.

Burge also told them runners from Portland to Fort Boise were telling the immigrants that the Cascade route was impassable. It was enough to dishearten the men, especially when the eastern crew showed up saying they had finished their part of the job, and they were going home. It was months later that the western crew found out that the eastern crew had actually not finished the project but abandoned it after fights broke out among the laborers. Only a few miles of road had been cut.

Allen and his crew persisted, however, and in late September they reached the west end of the road Kirtley and his crew had worked on, about 8 miles down the Naches River. Believing the road completed all the way from the Yakima Valley, they started for home, happy that the shorter road to Puget Sound was now ready for the first immigrant train.

They had reached the Greenwater River when a lone horseman appeared at their camp, saying he was John Aiken, from the Longmire-Biles wagon train that was struggling up the eastern side of the Cascades and they were near starvation. Allen immediately dispatched most of the provisions of the road-building crew to the wagon train by packhorses, and, after feeding Aiken, rode with him to Steilacoom.

NOTICE TO EMIGRANTS TO WASHINGTON.

Emigrants desirous of settling in Washington Territory, are notified that the road across the Cascade Mountains through the *Na Chess* Pass, opened by the citizens of Washington Territory for the benefit of the Emigration of 1853, and through which some two hundred emigrants with waggons, stock, &c., passed last season, has, by order of the Secretary of *War*, been adopted as the line for the Millitary Road from Fort Steilacoom to Fort Walla Walla.

FIFTEEN THOUSAND DOLLARS

Will be expended on the road this summer, and a contractor is now upon the work with a large body of men, with instructions to push the road to as early a completion as possible, in order to benefit those now on the road.

This route leaves the old Emigrant Road in the valley of Umatilla river, and crosses the Columbia at Fort Walla-Walla, where a ferry has been established. Here, by order of Government an Indian guide will be stationed to go through with the first trains.

Water will be found in abundance the entire route, and the eastern slope of the Cascade mountains is covered with luxurient grass. The valley of *W*hite River on the western side contains also excellent pasturage. This entrance to the Territory will materially reduce the distance and cost to emigration—the distance from Fort Walla-walla to Fort Steilacoom being 225 miles, to the first settlement 190 miles. All information will be furnished the emigrant at Fort Walla-walla.

Emigrants are particularly cautioned not to allow their fires to spread in the mountains, as the road thereby may be filled up by fallen timber.

Olympia, W. T. 1854.

C. H. MASON,
Acting Governor of Washington Territory.

NACHES PASS FLYER, 1854. The road through Naches Pass was touted in this flyer circulated among emigrants coming to Washington Territory. Even though the route was not yet a viable wagon road, it was designated a military road by the U.S. government. It would take some time before the pass became a well-traveled way. (Courtesy Lori Price Collection.)

Excitement exploded in Steilacoom and Olympia. The coming of the immigrants was the culmination of the dreams of the western settlers, and they quickly gathered a thousand pounds of food and sent it up the mountain.

In the meantime, the wagon train members, who had been in dire straits ever since crossing the Columbia near Fort Walla Walla, were almost at the end of their endurance. They had followed Indian guides whom they feared were leading them into a trap on the sagebrush plains of what is today eastern Washington. At Wells Springs, the Indians left them, much to their relief. Later, they found out the Indians had been trying to lead them to Fort Colville, believing the snow in the Cascades would prevent them from making it through Naches Pass this late in the year.

Eventually, they reached the Naches River, and crossed and recrossed this stream 68 times in four days as they struggled up the mountain. After leaving the Naches, they spent three more days before reaching the pass. They even managed to miss the short road that the eastern crew had cut.

It was bitterly cold in early October when they achieved the summit. Many of the immigrants were without shoes and adequate clothing—and all were without food. Soon after they started down the western side of the mountains, they came to a precipitous drop in their way. "We have come to the jumping-off place at last," groaned one woman.

George Himes was a ten-year-old boy at the time. Years later, he wrote the story of their journey over the pass, and said the wagons had to be lowered by ropes and by hand. He said all the ropes in the wagon train were not sufficient, and the men decided to kill three steers, cutting the hides into strips and tying them into rawhide ropes. His story entered the popular folklore of the event.

James Longmire, one of the adult immigrants, disputed this story about killing the steers, but did admit that the wagons had to be lowered by ropes, one by one down a 300-yard slope. Then, the ropes were loosened and the wagons were drawn a quarter of a mile farther with locked wheels. All of the wagons were successfully lowered, with one exception. Daniel Lane's wagon was on the rope line when it broke, and his wagon crashed down the steep hill, breaking into pieces. He and his family made the rest of the trip on horseback. Many years later, in 1937, a U.S. Forest Service ranger found a huge old wagon wheel and it was determined to be one from Lane's wagon. Today, it is at the Washington State Historical Society Museum in Tacoma.

The trip down the western side of the mountain was almost as arduous as the trip up the east side. They crossed the Greenwater River 16 times, following it until they came to the White River, which they crossed 6 times. The trail, after leaving the river, was not much better. They began the dreary pull over Wind Mountain (now Mud Mountain), covered with fir and cedar trees. It was destitute of grass, however, and the oxen and horses had to eat the foliage of the sparse vine maples for seven days before they again crossed the White River and came to Connell's Prairie.

Soon, the weary travelers were straggling down the western slope of Elhi Hill into a heavily timbered valley through which the Puyallup River took its rushing way to Commencement Bay. Leaves from tall cottonwood trees carpeted the floor of the valley with gold, punctuated by the red flames of maple and alder. The orange-red berries of mountain ash hung in clusters and there was heavy underbrush of salal and salmonberry.

They crossed the Puyallup at what later was known as Van Ogle's Ford, east of Alderton. The water was low and filled with humpback salmon on their way upstream to spawn. The hungry immigrants armed themselves with clubs, axes, and shovels—and went fishing. What a feast they had! Some of the party stayed up all night, cooking and eating fish.

The next day, the wagon train climbed one last hill, where Sunrise Terrace is now located, and wended its way to its last campground on the banks of Clover Creek. Settlers of Steilacoom and Olympia sent out welcoming committees, who brought gifts of fresh vegetables, and Dr. William Fraser Tolmie, head of the Puget Sound Agricultural Company, sent fresh beef as a gift.

Relations and friends already in the Puget Sound region helped the members of the Longmire-Biles wagon train, thereafter known as the Naches Pass Immigrants, through the winter. Twenty-two of them eventually returned to the valley of the Puyallup they had crossed in October to make their permanent homes.

The soil of the Puyallup Valley is of alluvial origin and mainly composed of a sandy loam with some argillaceous silt and volcanic ash. It was derived mainly from the decomposition of the granite, mica schist, and slate rocks of Mount Rainier, deposited during the Osceola mudflow. It has also some lime, nitrogen, and potash. To enhance this rich soil, the climate of the Valley is temperate, with cool summers and mild winters. There are few storms and the average rainfall is about 48 inches, which accounts for the year-round green landscape.

The farmers who came to the Puget Sound area did not know the soil analysis, but they knew it looked like good land. They were also aware it would take backbreaking labor to clear the land, but they were a hardy race and hard work did not scare them.

Among the early settlers in the Puyallup Valley—many of them these Naches Pass Immigrants—were William M. Kincaid, Isaac Woolery, Abram Woolery, James H. Bell, B.F. Wright, Henry Whitesell, Jonathan McCarty, Rominous Nix, Adam Benston, William Benston, Daniel Lane, Abele Morrison, Willis Boatman, Robert S. More, Paul Emery, Daniel Varner, Thomas Headley, Jacob B. Leach, and John Carson. Most of them took donation land claims but not all of them proved up on them.

When the first territorial governor of Washington Territory arrived in Olympia, the capital, he also bore the added title of superintendent of Indian Affairs. He began negotiations with the tribes as soon as he arrived in December 1854.

By that time, the first welcoming attitude of the Indians for the white settlers had turned to suspicion, and a growing unrest had developed on the part of both Indians and settlers. Governor Stevens turned his first efforts at treaty-making to the Puyallup and Nisqually tribes, which numbered about 800 members. Several other tribes, with only a dozen or so members and no tribal structure, were lumped together with the larger tribes in the negotiations.

Negotiation might be too strong a term. According to Ezra Meeker, who wrote and published a book in 1905, *Pioneer Reminiscences: The Tragedy of Leschi*, the new governor/superintendent enlisted the aid of Michael T. Simmons, an early pioneer in the Olympia area, to help draft a treaty. Meeker wrote that Simmons told Stevens the Indians would sign any paper he, Simmons, told them to sign.

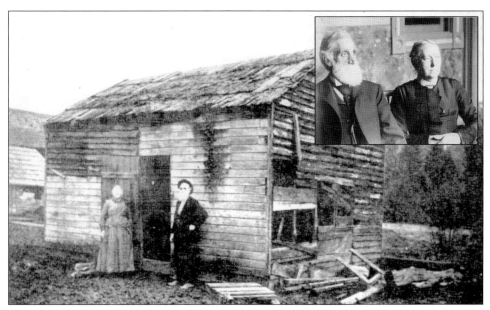

PIONEER HOME OF WILLIS AND MARY ANN BOATMAN, C. 1904. Built in 1854, the Boatman house was the only structure not destroyed by the Indians in the Puyallup Valley during the Indian War of 1855–1856. (Courtesy Lori Price Collection)

On December 24, 1854, more than 600 Indian men, women, and children came to the treaty grounds, which was a small knoll on the right bank of Sch-na-nam Creek, known to the white men as McAllister Creek. It was about a mile downstream from the smaller Medicine Creek, where it flowed into the Nisqually River.

The Indians had heard that the U.S. government planned to send them all to the "land of perpetual darkness" (Alaska) and were there largely to protest. They did not like what the governor really had in store for them, either. The treaty called for both tribes to be confined to small reservations. The Nisqually land was about 1,200 acres in size, on the tideflats of the Nisqually. It would not allow the Indians so much as a potato patch or a place to build their houses out of the reach of tides unless it was in dense forest. The Puyallup reservation also was unsatisfactory.

Stevens insisted that the treaty be explained to the Indians in the trade language, Chinook, even though there were people present who could have interpreted in the language of the Indians. Many of the complex terms of the treaty were beyond the trade dialect, which included only about 300 terms. Few of the Indians, therefore, understood the treaty.

One Indian who did was Leschi, a sub-chief of the Nisquallies. When the governor ignored his protests, Leschi refused to sign the treaty, tore up his commission as chief, which Stevens had issued, and left the treaty grounds. How his name and mark appeared in third place on the treaty has never been satisfactorily explained. Leschi maintained, as long as he lived, that he never signed, and many of his friends, both Indian and white, agreed that he had not signed.

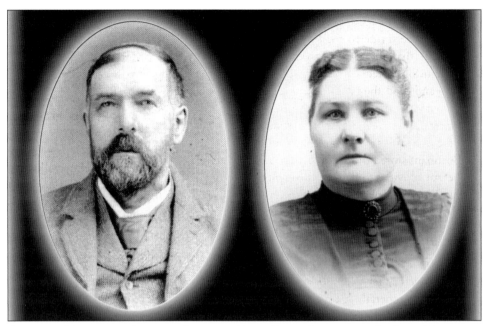

MR. AND MRS. JAMES PORTER STEWART. James Porter Stewart was the first white man to return to the Puyallup Valley after the Indian War. He later married Margaret McMillen, one of his students when he taught school in the area. Stewart became an affluent hop and fruit farmer, banker, and merchant. (Courtesy Beta Club Collection.)

Despite the controversy, the treaty was concluded, and Stevens went east of the Cascades to make treaties with the other Indian tribes of the Northwest—treaties, which were no more popular with the Indians than the Medicine Creek treaty.

In September 1855, the Yakima Indians killed several white men traveling through Indian country east of the mountains on their way to the gold fields of Colville. When Indian agent A.J. Bolan demanded those responsible for the deed be surrendered to white justice, he also was slain. The U.S. Army, headquartered at Fort Steilacoom, was sent to enforce Bolan's demand.

In the meantime, the Indians west of the Cascades were believed to be preparing for war. Some of the settlers thought that Leschi, whose mother was a Yakima, was stirring up the Indians. Among them was 25-year-old Territorial secretary Charles H. Mason, who was acting as governor in the absence of Stevens.

He issued a call for volunteers to back up the army in its confrontation with the Yakimas. He sent one of these volunteer companies, the Eaton Rangers, to apprehend Leschi, who was at his home on the banks of the Mashel River.

Leschi and his brother Quiemuth were plowing in the brother's wheat field when word came to them that the Eaton Rangers were coming to arrest them. Leaving the plow in the furrow, they fled to the mountains.

Mason called up more militia units and began preparing for war. It was not long in coming.

A few days later, the news of the massacre of several members of two white families on the White River came to the Puyallup Valley settlers. Salitat, a friendly Indian, came to warn them that the Indians were on the warpath. Immediately, they fled to Fort Steilacoom for protection, taking with them only the clothes they wore and what other clothing and food they could carry on their backs. Most of them stayed at the fort for years; some never returned to the Valley.

During the next few months, the Indians looted and burned all the homes in the Valley, with the exception of the Boatman cabin. It was learned that the Indians had found out the Boatmans stored their potato crop under the floor.

The war activities took place throughout Washington and Oregon Territories, but most of the action took place west of the Cascades. There were never any large-scale battles. The largest probably took place in Seattle when shells from the ship *Decatur* routed the Indians, more out of fear of the noise the shells made rather than the damage they caused. Other small skirmishes in guerrilla-type actions killed a few settlers who had enlisted in the various militia formed when hostilities began. The number of Indian casualties, although much larger than those of the whites, was never determined.

The settlers generally believed that Leschi was the organizing force behind the Indians. Others believed that many Indians acted without Leschi's knowledge or approval. Many Indians fought each other, and some of them even sided with the white men and worked for them.

The U.S. Army was in charge of both the military forces and the special volunteers, but there was controversy between them as to how the war should be fought and later, how it should be paid for. Later on, politicians even differed on whether or not the war had been necessary at all.

As in most wars, supplies played a great part in determining the outcome. When the Indians ran out of food and ammunition in the spring of 1856, Leschi came to his good friend, Dr. Tolmie, and offered to cut off his right hand to show he wanted peace with the white man. Tolmie advised him, instead, to return to the forests until tempers cooled.

By the fall of 1856, hostilities had ceased, although Governor Stevens, who had returned from his treaty-making ventures, was still seeking the capture of Leschi. He had developed an almost paranoid hatred of the Indian leader. One of Leschi's own family, a nephew named Sluggia, betrayed his uncle to the governor for, it was said, a few blankets. On November 18, Leschi was seized and brought to Stevens in Olympia.

Three days later, he was on trial for his life, charged with murder in the wartime death of A.B. Moses. Among the men on the jury were William M. Kincaid and Ezra Meeker, and these two refused to vote for his conviction. A second trial was ordered and took place in Olympia. This time, the jury convicted him of murder, and he was sentenced to hang.

Throughout the summer and fall, appeals were made on his behalf, and laws were manipulated both for and against the fulfillment of the sentence. All efforts to save him failed, however, and on February 19, 1858, Leschi was hanged on a gallows built in what is today a shopping center parking lot on Steilacoom Boulevard.

His body was first buried in the Hudson's Bay Company cemetery, then moved to the Nisqually Reservation; when Camp Lewis was established in 1917, it was moved for the third and final time to the old Indian cemetery overlooking the Puyallup River on the

eastern edge of Tacoma. His tombstone epitaph includes the following inscription: "This is a memorial to Chief Leschi, 1808-1859 / An Arbitrator of his People."

Even though the Indian War ended in 1856, the pioneers were slow to return to their donation land claims in the Puyallup Valley. One reason was that their homes, crude cabins though they were, had been destroyed and had to be rebuilt. Another issue was safety. Occasionally some of the men would band together and come into the Valley to plant a few crops, but most of the women and children remained near Steilacoom until about 1860.

There were 420 white persons in Pierce County at that time, with men outnumbering women nearly three to one. There were, however, many more Indians, most of them not yet confined to the reservations set out for them by Governor Stevens. A few brave— or foolish—young men were in the Valley at this time. John Walker was sharing his cabin with Marcus Ball, about a half mile beyond the John Carson claim. Upriver, Jacob Leach was tending some government-owned horses on land between the Puyallup and Stuck Rivers.

In 1859, a young man named James Porter Stewart came to Steilacoom from Oregon where he had been farming, logging, teaching school, and serving as a deputy sheriff. His cousin Linus Brownson operated a gristmill 3 miles from Steilacoom, and he told Stewart there was first-class land in the river bottoms around Puget Sound, particularly in the Puyallup Valley, about 15 miles from Steilacoom.

Stewart stayed with his cousin a brief time, and then rode his horse into the Valley where he was warmly welcomed at the Walker cabin. He also went upriver and talked with Leach, but returned to locate a homestead claim south of the Carson claim, where the Puyallup River, which meandered all over the Puyallup Valley, swung southward in a giant loop. He found the land covered with cottonwood, alder, vine maple, crabapple, and a heavy growth of salmonberry and salal bushes. The undergrowth was so dense that he had to hack a trail for his horse. Such rank growth indicated to him, however, that the soil was remarkably fertile.

Stewart built himself a small cabin of logs as a claim-holder, assisted by a Hudson's Bay Company employee named George Headley, who was living with his Indian wife farther upstream. Headley remained overnight with Stewart to become his witness that the claim was "occupied." This was the first claim registered in the Puyallup Valley following the Indian War.

Shortly after this time, the settlers began returning to the Valley, and more people came for the first time, looking for homes and farmland. John Valentine Meeker, the brother of Ezra Meeker, and his family came by sailing ship in 1859. He stayed with Stewart in his cabin for a year before filing a claim on property adjoining Stewart's land.

A little way south of the Stewart land was a small clearing in the dense forest on the valley floor. A former employee of HBC, Jeremiah Stilley had built himself a cabin on a "squatter" claim there. The cabin was a sound one as Stilley was known as an expert builder of log houses, although a shiftless and indolent farmer. He also had a reputation as an educated man, fond of quoting Shakespeare and Gibbon. Sometime in 1862, Stilley sold his "improvements" to Ezra Meeker, who had rejected the Valley as a place to live nearly 10 years before. Now, with his brother John on adjoining land, and his father, Jacob R. Meeker, taking a claim near the Stuck River, Ezra thought he would try it again.

Ezra and Oliver Meeker had joined with their father, Jacob, in a mercantile venture in Steilacoom during the Indian War. It was moderately successful, and they decided to stay with it, borrowing money from their friends and neighbors and sending Oliver to San Francisco to purchase supplies for their store. He was returning home on the steamer *Northerner* when it sank during a storm off Cape Mendocino on January 5, 1861. Oliver lost his life and his grieving family was deeply in debt.

In addition to this tragedy, Ezra was not happy with the choice he had made of a donation land claim in the Fern Hill area southeast of present-day Tacoma. The claim was covered with hardhack and was almost impossible to clear. He called it "The Swamp Place." Mosquitoes abounded, and the 10 acres of potatoes he had planted had been lost in an early frost.

At the same time, Ezra had become rather well acquainted with the fertility of the soil in the Puyallup Valley. Some of the Valley settlers had brought vegetables into the Meeker store in Steilacoom to trade for supplies, and the size of the produce astounded everyone.

By now, there was a road of sorts into the Valley, and the first telegraph line had been strung along the route of the military road that crossed the Puyallup at Fort Maloney, now

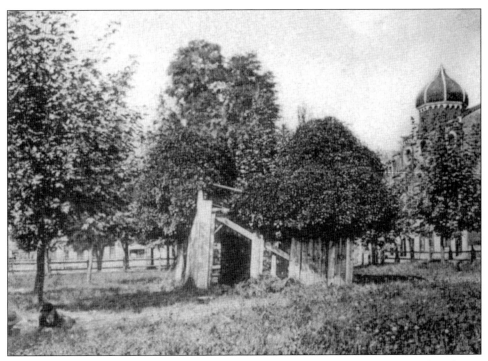

OLD PIONEER HOME. *Ezra Meeker's first cabin home in Puyallup was part of the legacy of Pioneer Park, when he and Eliza Jane, his wife, donated the park to the City of Puyallup. The cabin, and his first hop house nearby, were to be left until they mouldered away, examples of the early pioneer life in the Valley. The house was demolished in 1905, but the ivy planted by Eliza Jane some 40 years before was preserved, and grows today at the same spot. (Courtesy Perkinson Collection.)*

known more familiarly as Fort Carson, as the Carson family was using the abandoned blockhouse as their home. The telegraph line was part of the system that was to connect America to Europe through Alaska to Russia. When cable was successfully laid across the Atlantic Ocean, work ceased in Alaska and the line was not completed.

A post office was established in 1862 through the efforts of J.P. Stewart. It was located at Fort Carson, with Carson as the first postmaster. Carson also ran a ferry across the river at that point and was in the process of building a bridge. The mail came from Fort Steilacoom once a week. Jesse Dunlap had the contract to carry it in his saddlebags on horseback, making the round trip in two days. He was paid $20 a month.

With the coming of a post office, there had to be a name for the settlement. Stewart called it Franklin, after his hometown in upstate New York.

Whether Meeker sold his donation land claim or just his improvements to Dr. Charles H. Spinning, the newly appointed physician on the expanded Puyallup Indian

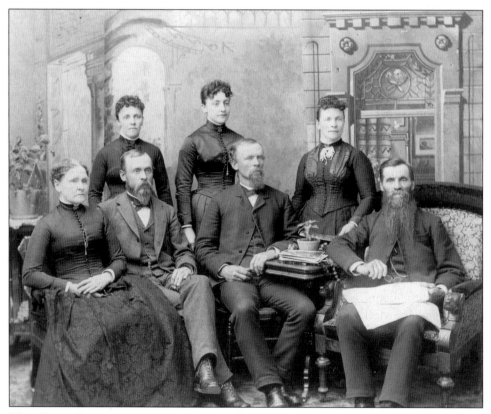

THE ROSS FAMILY. Prominent in pioneer days in Puyallup was the family of Darius M. and Eliza Ross, who settled on a homestead claim on the banks of Clark's Creek in 1862. About 1890, Darius Ross and one of his sons, Charles H., donated land for the establishment of the Washington State University's western experimental station, called Ross Station. In this family portrait, they are identified, from left to right, as follows: (seated) Eliza, Charles, Albert, and Darius; (standing) Mildred, Nellie, and Alice. (Courtesy Beta Club Collection.)

Reservation, is not clear. He was happy to give up "the swamp place," however, to bring his little family, along with Oliver's widow and son, to the Puyallup Valley.

Desperately poor, Ezra did not even have an overcoat, but wore an old blanket with a hole cut for his head. Thirty-two years old and the father of four living children (one son, Thomas, had died while they lived at Steilacoom), he owned only one ox, seven cows, a few pigs, and some chickens.

The Stilley cabin was a one-room structure, 16 feet square, with walls 8 feet high. Shortly after they moved in, Meeker built another cabin of like size, leaving a 5-foot space between them for a double fireplace. Both sections of the house were covered with shakes. Ezra and Eliza covered the interior walls of the house with newspapers in lieu of wallpaper.

The little clearing that surrounded the cabin was about 5 acres in size, but the rest of the quarter section, which Ezra claimed under the Homestead Land Act, was heavily timbered. He later wrote that he "never let up until the last tree, log, stump and root disappeared." Meeker delayed filing his homestead claim for some time because he said he could not, "for the life of me," raise the $16 it required to file in Pierce County. Finally, becoming uneasy lest someone might slip in and pre-empt the land from under him, he walked to Olympia and filed, where the fee was only $1.

Meeker's story was the story of every pioneer in the Valley. Most of them did not live to the age of leisure that he did and so did not write about their early life in the Valley. His memory of events may have been dimmed by the years, but his picture of the life of early Puyallup was enhanced by the writings of the few who did record their experiences.

The isolation of the settlers in the Valley had a tendency to draw them closer together, in essence creating one big family. While there was a great diversity of habits, thrift, morals, and intellectual attainments among them, there was also a feeling of brotherhood and tolerance. They were a self-reliant lot, but there was also a wholesome dependence among neighbors. In the rare times when they met along the forest paths or at the general store where the post office was established, they never failed to stop and visit.

Their social life revolved around the school, when it was established, or the churches, but most families found entertainment in their own homes. Charles Ross, who had come to the Valley with his family when he was a 12-year-old boy in 1862, wrote that he spent many delightful hours in the Meeker home, playing his flute to the accompaniment of the organ, which the Meeker girls played. This organ was probably the melodeon that Meeker wrote was so much a part of their home dances and social life. Meeker taught himself to play a violin and could give a creditable rendition of "The Devil's Dream."

His brother John who was teaching in one of the Valley schools, had a fine singing voice, and added music and choir to the school curriculum. He was also a creative storyteller and was able to think up interesting forms of entertainment. "Uncle John," as he came to be known to everyone, was one of the most beloved of the pioneers throughout his life.

3. SCHOOLS AND CHURCHES GROW

Many years later, Ezra Meeker wrote that he brought his family to live in the Puyallup Valley so his children could attend a "real" school. Up to this time, the Meeker children had only what they called "morning school," classes held in their own home very early in the morning before their father left to do his day's work.

The Puyallup School District had been organized in 1854, but no school was held until 1861, after the Indian War was over and the Valley settlers had returned to their claims. The first schoolhouse was the blockhouse on the bank of the Puyallup River, which had been called Fort Maloney. John Carson and his family were using it as a dwelling, and Mrs. Emma Darrow Carson was hired as the first teacher. Mrs. Carson was a tall, red-haired woman, intelligent and with a prodigious memory. When she was a child, she had memorized many books of the Bible and could still recite them to her students.

There were six students in this first school in Puyallup: Frank Carson, 9; Harriet Carson, 5; James Wright, 19; William Wright, 14; Annas Wright, 10; and Sarilda Helms, 6. Classes lasted for a three-month term and Mrs. Carson was paid $50, in installments over three years, because the funds were not all available that first year.

By 1862, the first real school building had been constructed on land donated by James P. Stewart. It stood on the south bank of the river that extended to Fifth Avenue Northeast at that time. It was a log structure with one small window and a fireplace, and it served the schoolchildren of the Puyallup Valley for over a decade. When classes were not being held, Stewart sometimes used it as a dwelling place.

In 1874, the population of the area was growing so fast that the little log school was no longer adequate, and a new school building was constructed, also on Stewart land and a little way east of the log school. It was covered with boards and battens and was called the "up and down boards school" until the building was painted green; then it became known as the Green School.

By the time another decade had passed, the Green School had also become inadequate, in spite of the fact that another room had been added to it shortly after it was built. Still it was crowded, as people continued to come to Puyallup to make their homes.

A story in the *Tacoma Daily Ledger* in January 1885 told of children who "suffered very much in the old schoolhouse during the recent cold weather. People hesitate to settle here because of the poor condition of the school building. Something ought to be done at once." Something was done.

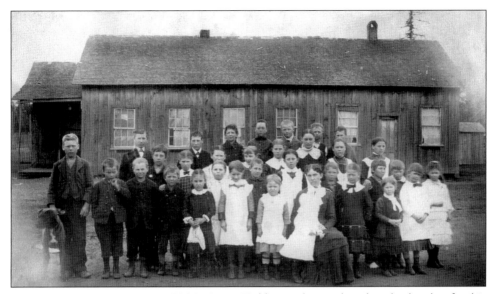

PUYALLUP SCHOOLHOUSE, 1884. Agnes Field, seated, served as the schoolteacher for this one-room school built in 1874. When the building was painted green, the school became known as the Green School. The burgeoning population soon outgrew this modest, poorly heated building, and the much more suitable Central School replaced it in 1886. (Courtesy Beta Club Collection.)

The Puyallup School Board had been talking about a new school for years. In 1883, school directors A.C. Campbell, J.P. Stewart, and Ezra Meeker visited Tacoma's Central School to get ideas about a new school for Puyallup. They even went so far as to purchase 3 additional acres of land east of the Green School for the site of the proposed new school.

The board members envisioned a school building of eight rooms that would accommodate 400 students—five times the number then attending the Green School. Unfortunately, the taxpayers thought their plan was a bit too ambitious. They voted down the idea of a new school with its $10,000 price tag.

The next year, however, the directors—who were now Stewart, William Wagner, and Meeker's oldest son, Marion—asked for another vote on a new school. And this time, the request was for a modest $3,000 building. In a February 7, 1885 election, the taxpayers approved this smaller levy.

In January 1886, a contract was awarded to J.D. Lytle, and the school building was supposed to be ready for use in September of that year. Joe LaPlante was hired to clear the school grounds, including removing stumps and logs to a depth of 14 inches. He was paid $150 for his work. By the end of June, the building was ready for the plasterers, and Robert Berenth was given a contract for the inside painting.

A new 475-pound school bell was shipped to Puyallup during the summer. A.J. Hoska, who was in town from Tacoma when it arrived, "amused the citizens by ringing it for two hours." No doubt, the fact that the bell had a "fine, clear tone" made the amusement bearable.

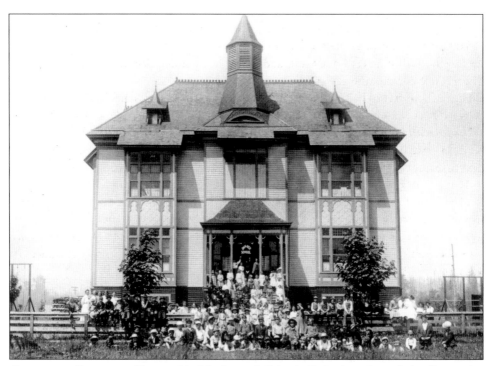

SPINNING SCHOOL. Along with Maplewood School, Spinning showed the first major growth in the Puyallup School District after the town was incorporated. Spinning is still located at Thirteenth Street and East Pioneer Avenue Southeast. Both schools have been replaced by more modern structures. (Courtesy Washington State Historical Society, Tacoma.)

F.S. Hovey was named principal of the new Central School when it opened in October 1886. A Miss Tibbitts was the second teacher, and for the first time in school district history, a janitor was hired. James Ogle was paid $6 a month to do the job.

It seemed like Central School, with its wide stairways, broad hallways, and four big classrooms, was a permanent solution to the overcrowding conditions of the Green School. Only three years later, Washington became a state, and the year following that, Puyallup was incorporated as a city. An 1889 article in the *Puyallup Chronicle* newspaper indicated Puyallup had a population of 2,500, with 10 churches and "thoroughly up-to-date public schools with 13 departments." In less than 30 years, the school district population had grown from 6 students to more than 400. Central School, only four years old, was filled to the rafters.

A new, smaller school was built on the corner of what is today Sixth Street Southwest and West Main Avenue. It was first called Meeker's School (it was located on part of the homestead claim of John V. Meeker), but was most often called "The Pink School"— probably because it was painted that color.

An 1891 school census shows there were 407 males and 412 females of school age in District 3, but only 611 of them attended school that year. Both Central and the Pink School were again overcrowded.

On May 16 of that year, a school election was held and voters approved a bond issue of $15,000 for the purpose of building two new schools: Maplewood, on West Pioneer Avenue at Twelfth Street Southwest, and Frank R. Spinning School on East Pioneer at Thirteenth Street Southeast.

High school classes had begun several years before at Central School, which had been enlarged a second time to handle the greater volume of students in the district. The first to complete the two-year high school program graduated in 1893. Nine students received their diplomas in a ceremony at the Puyallup Opera House on June 23. Helen Rogers gave the valedictory address. Two girls, Pearl Hubbard and Rosa Dudley, tied for second place and Miss Hubbard was chosen by lot to be the salutatorian.

The Class of 1902 was the first to complete the full four-year course of studies in high school. Their outstanding contribution was to establish a school newspaper, the *High School Echo*. Five students received diplomas that year. The Class of 1909 was the last to graduate from the old Central School building and the first to publish a school annual. It was called the *Amulet*.

High school students moved from Central to the new Puyallup High School on March 21, 1910, walking in a happy parade and carrying their books to the sparkling new building that occupied a spacious campus between Main and Pioneer Avenues, and between Sixth and Seventh Streets Southwest. The new school had been financed by a $35,000 bond issue. It was a substantial building. The basement included the ventilation

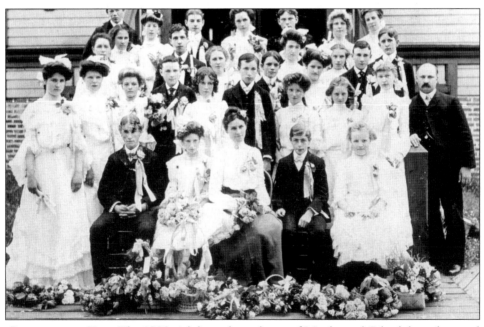

GRADUATION DAY. The 1903 eighth-grade graduates of Maplewood School dressed up and decked themselves with flowers for the special ceremonies. Professor J.M. Layhue, standing right, was Puyallup superintendent of schools and Ellen Devereaux, seated center front, is believed to have been their teacher. (Courtesy Lori Price Collection.)

and heat plant, gymnasium, manual training and domestic science departments, lockers, and toilets. The first floor had seven classrooms, the Puyallup superintendent's office, and a 50-by-60-foot auditorium to accommodate 500 persons. The second floor included eight classrooms, the gallery, and the upper part of the auditorium. It looked like Puyallup was well fixed for the education of its young people well into the future.

Churches followed schools on the heels of settlement in the Pacific Northwest, as well as in the Puyallup Valley. Although ministers of several churches came to the Valley to conduct services before 1867, that was the date the first congregation was organized in Franklin, which eventually became Puyallup. The Reverend Rudolphus Weston came from Steilacoom for an "organizational" meeting of the First Baptist Church on November 16 of that year. His efforts bore all the marks of a revival, with "backsliders reclaimed, sinners converted and everybody happy."

Twelve people were enrolled in the church register at this meeting. Due to the hardships of pioneer life, this church remained small for more than a decade. The Reverend Weston tried again to reorganize the church on March 16, 1878. At that time, he presided over a meeting of six people in the home of Mrs. O.A. Taylor. Two of the six people were the Reverend Wichser and his wife, and Wichser was chosen pastor of the new congregation.

Church services were held in the schoolhouse—the Green School—and among the pioneers who attended were Darius M. and Eliza J. Ross and Robert S. More. In August 1878, the new church was admitted into the Puget Sound Baptist Association, and trustees were Ross, A.C. Campbell, and Ezra's son Marion J. Meeker. Mrs. O.S. Hardefeldt was the church clerk.

The next spring, the Baptists began construction of the first actual church building in Puyallup. It was a one-room "box-house" structure of rough boards, about 24 by 40 feet

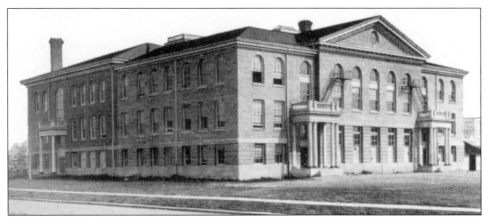

PUYALLUP HIGH SCHOOL. The first high school building in Puyallup was built in 1910 and enlarged before this 1921 photo. In 1927 the entire school was destroyed by a fire that started in the basement lunchroom. It was rebuilt with a Spanish motif and re-opened in 1930. Remodeled and enlarged many times since, PHS still stands on west Pioneer Avenue between Sixth and Seventh Streets Southwest. (Courtesy Perkinson Collection.)

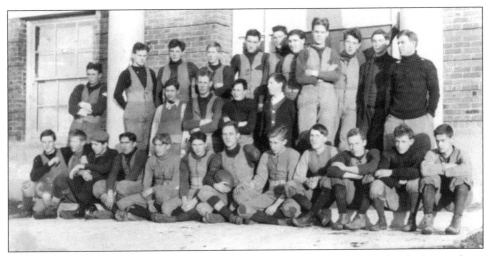

FOOTBALL TEAM. The boys of Puyallup High had a brand new school, which may have inspired them to defeat the team from the University of Washington in 1910. The circumstances are not known, but the win was genuine. (Courtesy Beta Club Collection.)

in size. It was financed by member donations, a gift of $20.80 from an Olympia church, and a grant of $125 from the American Baptist Home Mission Society.

THE METHODISTS ORGANIZE

Methodist ministers came to the Puyallup Valley to preach long before they began organizing a church here in 1882. Like other denominations, the Methodists conducted their services in the Green School for some time. The Reverend W.P. Williams was selected as the first pastor.

Ezra Meeker donated a lot on Second Avenue Northeast (then called Church Street) and a substantial amount of money for construction of a church. The building, finished in 1883, stood only 200 feet east of the little Baptist church. Its first pastor was J.B. Leach.

The church membership increased rapidly throughout the remainder of the century. By the time the church celebrated its silver anniversary in 1907, there were 400 members, plus more than 500 children in the Sunday school. The church was bursting at the seams.

Church trustees recognized the problem and had already authorized the purchase of six lots on the corner of West Pioneer and Poplar (Third Street Southwest) from Mrs. Nettie Hallenbeck, who was using the site as her orchard. Nettie was the manager of the Central Hotel. Construction of a new Methodist church was begun on June 1, 1908, and the dedication ceremonies were held in March 1909. The church cost $12,000, all of it donated or subscribed so that it was completely free of indebtedness when it opened. A parsonage and Sunday school building were soon added, and the church continued to grow through the years.

A new church was needed by 1964 to accommodate the growing congregation of more than 800 persons. The present United Methodist Church was built at 1919 West Pioneer.

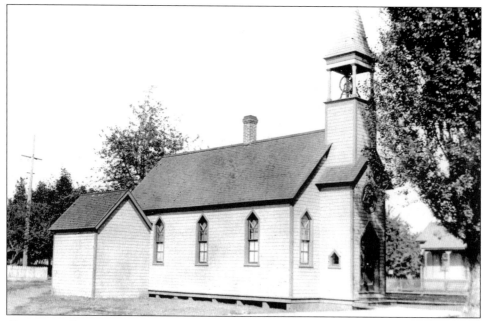

ORIGINAL BUILDING, CHRIST EPISCOPAL CHURCH. Church members completed this wooden structure on Third Street and East Stewart Avenues in 1888. Nearly 40 years later, the new church was built on West Pioneer and Fifth Street. (Courtesy Washington State Historical Society, Tacoma.)

CHRIST EPISCOPAL CHURCH

An early history of Christ Episcopal Church, written in 1936 by E.C. Schmeiser, reveals that Puyallup was still a village of only a few hundred people in 1880 when the Reverend Henry S. Bonnel rode into the community from New York. Services were held in the big, new two-story store erected by Stewart and Gibbs.

The membership grew rapidly. By 1883, an average of 50 people were attending Friday evening services. The congregation decided it was time to erect a building of its own, but with the sudden death of the Reverend Bonnel they were forced to change their plans.

Hugh and Rachael Crockett donated several lots from their hop farm for a church site on Stewart Avenue, and the members began a do-it-yourself building project. Their money ran out and the church was half-finished for two more years, being finally completed in 1888.

The congregation had bad luck with their ministers, as the first full-time pastor, the Reverend Samuel D. Pulford, died in 1892, only a year after his appointment. For the next 19 years, the church was economically unable to support a full-time pastor. Services were conducted on a sporadic basis with ministers filling in from Tacoma.

The church began to grow again in 1911, when the Reverend William J. Getty was appointed, and in 1927, a new church was constructed at West Pioneer and Fifth Street Southwest.

THE PRESBYTERIAN STORY

By the time the Presbyterian church was organized in Puyallup, the community was well on its way to becoming a city. The records of the church show that 14 Presbyterians in Puyallup called the Reverend Thomas M. Gunn, a synodical missionary for the State of Washington, to help them organize a church in 1889. The first meeting was held in the little Baptist church building and resulted in the election of a board of trustees, consisting of T.S. Hubbard, Eliza J. Meeker (wife of Ezra Meeker), and A.G. Matthews.

Ezra Meeker, as he had done for other churches in the past, donated several lots to the new church, with the stipulation that they had to erect a $3,000 building. The lots proved unsatisfactory, however, and Meeker traded with his son-in-law Roderick McDonald for more desirable ones in the 400 block of West Pioneer.

It is recorded that the new church building cost $4,800, which may have been one reason the church had financial difficulties over the next 10 years. It may also have been because of the worldwide economic depression of the 1890s. Finally, after 1900, they were able to hire a full-time pastor, the Reverend F. Tonge, and the church began a steady and continuing growth that has lasted to the present day.

ALL SAINTS CATHOLIC CHURCH

The first record of Catholic services in Puyallup took place in 1890 when the Reverend John Rollinger came from Tacoma to hold Mass in the home of Mrs. Nora Kough. Also present were a Mrs. Skannel, Mrs. Shaunassey, and two other women. Father Rollinger returned about twice a month thereafter, and each time he came there were more people attending the services. In 1891, he bought the little Baptist church building, but the parish was not officially designated until 1899. The Reverend P.C. Winter was named pastor.

During that year, the Catholics bought the former United Brethren Church building on the corner of Indiana and Walnut (Fifth Avenue and Second Street Southwest). A unique building, the church featured a vaulted ceiling and a floor that sloped down to the sanctuary.

The Reverend Anthony Fischer became pastor in 1903, and a few years later he built a rectory. The congregation grew rapidly, and Fischer began plans to build a new church, but was reassigned before he could start building. His work was completed in 1911 when the Reverend Joseph Schmitt, from Germany, finished the project, building the first brick veneer church in the Valley, at a cost of $11,000. It seated 450 persons, was Gothic in design, and featured a tower, choir loft, and organ.

All Saints continued to grow rapidly throughout its first 100 years, necessitating a new parish, Holy Disciples, which awaits its new building on South Hill.

PEACE LUTHERAN CHURCH

Settlers from Germany and the Scandinavian countries brought the Lutheran religion to the area, worshipping in their own language at various homes until churches could be established. Peace Lutheran Church grew out of the German-speaking population of the McMillan, Orting, and Puyallup communities. By 1890, pastors from Tacoma

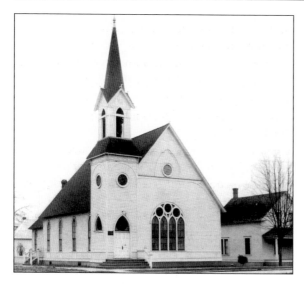

PEACE LUTHERAN CHURCH. Ezra Meeker donated the land for this church, which was built by members of the Unitarian faith in 1892. The Unitarians subsequently fell on hard times and German Lutherans purchased the building in 1900, giving it its current name. The congregation worshiped in German until the late 1930s. Today this building has the distinction of being the oldest church still used for worship in the city. (Courtesy Peace Lutheran Church Collection.)

regularly conducted services in these communities under the auspices of the German-speaking Ohio Lutheran Synod.

In 1895, Pastor J.F. Oertel became the first resident mission pastor in Puyallup, and three years later, the Peace Lutheran congregation was formed. Founding names included Baumbach, Benthien, Helmhold, Huper, Schuchart, Schultz, Stelling, and Teitzel.

The German Lutherans initially met at the Presbyterian church and later borrowed the wooden Episcopal church. A most suitable building of their own soon became available. In 1892, Ezra Meeker donated the land for a Unitarian church on the corner of Pioneer Avenue and Third Street, across from Meeker's grand new mansion.

Ezra, his brother, and A.E. Spinning formed the First Unitarian Society of Puyallup, borrowed $1,500 from the American Unitarian Association in Boston, and built a white wooden church on the donated property. But the Society failed to attract many members, and the Panic of 1893 caused the church fathers to default on their loan.

In 1900, the Boston Association offered the building and lot for $600. The Lutherans paid in gold coin, assessing members up to $10 to meet the payment. On October 14, 1900, the Peace Lutheran congregation celebrated its first service in the new church.

All services and Sunday school were conducted in German throughout World War I and into the 1930s. At the congregation's centennial service in 1998, progeny of several of the founders worshiped as their ancestors had.

The building has the honor of being the oldest, continuously used site for church services in the city.

SWEDISH BAPTIST CHURCH

Not all Scandinavians were Lutherans. On August 15, 1920, 25 Swedes organized the Swedish Baptist Church of Puyallup. Most of the members represented second- and third-generation immigrants who had settled in America or Canada. In the early days,

Clark's Creek served as the site for baptisms for this bi-lingual congregation.

In December 1920, the congregation incorporated after purchasing a lot at 316 Pioneer Avenue for $1,500. Members donated labor to build the handsome, white wooden structure. The next June, the church affiliated with the Western Washington Swedish Baptist Conference, now known as the Columbia Baptist Conference. On July 10, 1921, the church was dedicated and by 1924 had 60 members. The congregation then called itself Pioneer Avenue Baptist and later Bethany Baptist.

Bethany Baptist went through some rough times in the 1930s but continued to meet and by the 1950s had outgrown the old facility. In April 1962, a new building was dedicated at 519 Third Street. Today, the congregation is enjoying its third new building, located near the South Hill Mall.

In the beginning, many congregations reflected their ethnic heritage. Pioneer immigrants brought their Bibles in their native tongue and sought to worship with like-minded Christians. These churches and some of the social organizations provide a picture of the diversity of the area in its infancy. But over time English won out, and the melting pot absorbed Scottish Presbyterians, German Lutherans, and Swedish Baptists. Many other churches and denominations have come to Puyallup over the years since Puyallup became a city in 1890. Religion is still an integral part of the lives and history of the people of Puyallup.

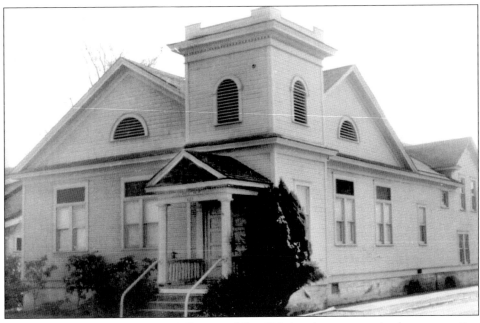

SWEDISH BAPTIST CHURCH. Offspring of Swedish immigrants organized a congregation in 1920 and built this structure on Pioneer Avenue a year later. Known as Pioneer Baptist and then Bethany Baptist, the church served in this location for over 40 years before the congregation outgrew the facility. The building has subsequently served a variety of organizations, including the YMCA. (Courtesy Korum YMCA.)

4. Hop to It

Most of the pioneers were desperately poor in the early 1860s, as they returned to their claims after the Indian War. They had to start all over again, rebuilding their homes and growing food for their families. In the Southeastern part of the United States, the Civil War was raging. Some of the young pioneer men went back to "the States" to participate. For the most part, however, the pioneers pursued the even tenor of their lives far from the hostilities of the Civil War, although they did discuss the war with great passion.

In 1865, as the Civil War was winding down, a curious phenomenon was taking place in Western Washington. It began when Charles Wood, who operated a small brewery in Olympia, imported a few hop roots from England with the hope that they would grow well in the fertile soil of the Pacific Northwest. The hop is a wild perennial of the nettle family, which climbed over hedges and fencerows in England. Its catkins are used to give beer its appetizing flavor and aroma.

Wood was interested in growing hops locally because their importation from England, and even from New York State, which was the only other prominent hop-growing region of the world at that time, made the brewing of beer an expensive proposition. He had talked to his friend Jacob R. Meeker in Steilacoom about the idea of a local crop. When he received the English roots, he sent them on to Meeker.

John Valentine Meeker happened to be in Steilacoom when the roots consigned to his father, who now lived in the Puyallup Valley, arrived. He carried the roots home to the Puyallup Valley on his back. On the way to his father's cabin, near present-day Sumner, John stopped at his brother's house and Ezra took a handful of the roots, planting them around his cabin. The rest of the roots Jacob Meeker planted in a couple of rows in his orchard. He was amazed at the luxuriant vines and rich harvest of "cones." He dried this first crop in a loft over the family living room.

When Jacob sent the first harvest to Wood, he received 85¢ a pound—about $185. That was the most cash money anyone in the Puyallup Valley had seen in a long time. All of a sudden, everyone wanted to grow hops! Ezra Meeker immediately planted 3 acres, then 5, then 10—and he continued to expand his acreage until some 20 years later, he had more than 500 acres in hop vines.

All the Valley farmers began jumping on the hop bandwagon. In 1884, a Portland-based news magazine, the *West Shore*, featured the hop fields of the Puyallup and Kent Valleys

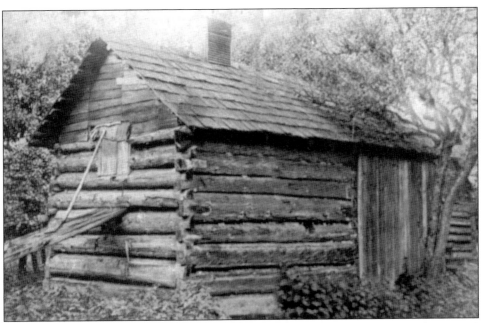

FIRST HOP HOUSE. Jacob R. Meeker planted the first hops with his son Ezra in 1865 and built this first hop-drying house in the Puyallup Valley. These early kilns were crude, but later drying-houses became large and elaborate during the 25 to 30 years of the boom. (Courtesy Perkinson Collection.)

as the "celebrated fields where the hop industry reached its highest development." More than 100 growers were engaged in hop production in the Puyallup Valley at that time.

Back in 1866, when the industry was just getting started, farmers learned the hop business by the trial-and-error method. The forests echoed with the sound of the ax and the saw as they cut down giant trees and cleared enough space to plant the hops, usually 10 root cuttings to the hill, around the big stumps.

By September, the vines were weighted down with golden cones that looked like tiny aromatic fir cones. When they were ready for harvest, they made a soft whispering sound as they were crushed in the hand, giving off an odorous powder.

At first, family members harvested the hops, but there was soon so much acreage in production that it was necessary to locate more pickers. That is when hordes of Indians came in wagons, canoes, and on horseback from as far away as northern British Columbia. Most came as family groups. The women and children picked hops; the men gambled and visited and collected their family's wages.

Farmers learned the Chinook Jargon—a trade language prevalent in the Northwest—in order to communicate with their pickers. Later on, the confusion of tongues was increased when Chinese laborers, who worked for practically nothing, came to help in the harvest.

The hops were placed in huge wooden boxes with handles on each side. They wilted quickly and settled, but pickers kept them fluffed up until the boss came in response to a

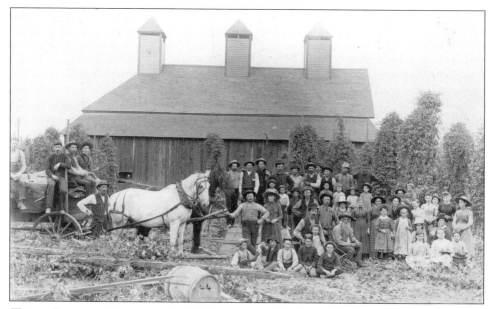

THREE BURNER HOP KILN. This kiln was most likely located on South Meridian Street on one of Ezra Meeker's early farms. Meeker is standing near the rear of his horse. Most of the pickers appear to be family members, which places this photo in the first decade of hop growing, probably about 1870. (Courtesy Ezra Meeker Historical Society.)

shout of "box full." Sometimes, using this method, they were paid a full silver dollar for their day's work.

By the time the hop boxes, jostled on the wagons, reached the kiln, they were often only half full. The hops were dropped on the drying floor and sulfur was used to bleach them and stop fermentation. Fires under the drying floor kept the fumes rising until they permeated the whole valley.

Since the curing of the cones by drying was as important as the proper cultivation, the design of the hop kilns was born of necessity. Jacob Meeker built the first hop kiln in the Valley—a small log house, 12 by 14 feet, with a ventilator in the top and a stove to provide heat. It was not a good design as the moisture condensed from the hops and formed a fog in the top of the building, keeping the hops from drying properly. A few openings under the foundation of the building corrected the ventilation problem.

Ezra Meeker built the first hop-drying house in Puyallup near his cabin home. Later on, when he gave Pioneer Park to the City of Puyallup, both the old hop house and his cabin remained there until they became so dilapidated that they had to be removed.

By the time the hop boom really started percolating in the Valley, specialized hop kilns with their tall chimneys dotted the valley floor. Meeker had several large hop kilns along South Meridian Street and a cluster of five more near the Puyallup River, which were said to be the largest in the world. After the hops were dried and cooled, they were baled and shipped to San Francisco. From there, they went to England and to many other places in Europe.

The fertile soil and temperate climate of the Puyallup Valley made this area an ideal place to grow hops. By the mid-1880s, farmers here were harvesting 3,000 pounds of excellent hops per acre, in contrast to the 600–800 pounds other leading hop-growing areas were producing. In 1883, one man sold his crop at 84¢ per pound and regretted not holding out for the $1.05 paid before the season ended.

Ezra Meeker said his crop brought more than half a million dollars that year. Always one to take advantage of an opportunity, Meeker formed his own hop brokerage company and spent several seasons in England acting as a selling agent for the Valley growers. He soon became known as the "Hop King of the World."

With their new affluence, hop farmers built elaborate new homes. Arguably the most opulent was that of Ezra Meeker, with its 17 rooms, including a billiard room and ballroom. It was said in 1890, when it was completed, to be the showplace of the Pacific Northwest.

Many temperance-minded people, however, cast disapproving eyes on this ostentation, considering the source of the wealth that brought it. The ministers of local churches preached many a sermon against the alcoholic beverage that was the final product for which the wealthy farmers were responsible.

Although their disapproval did not seem to affect hop production, a tiny insect did. Hop lice—which had previously devastated hop fields in other parts of the world—appeared

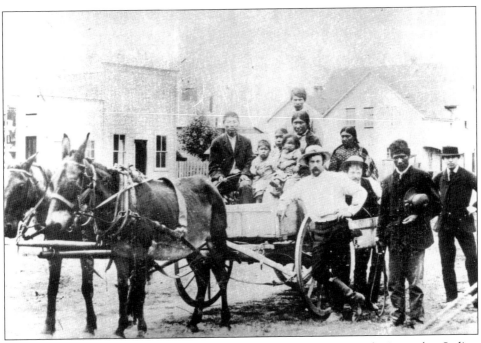

INDIAN HOP PICKERS. When hop harvest came in late August or early September, Indian families came to Puyallup from as far away as northern British Columbia. Fred Meeker, in the white shirt, gives some of them a ride in his wagon on East Main Avenue. In the background is the old Central Hotel. (Courtesy Ezra Meeker Historical Society.)

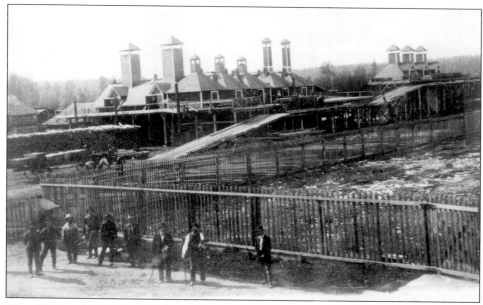

HOP KILNS, 1888. Ezra Meeker's kilns were the largest in the world at the time. They were located near the Puyallup River at the edge of town and were used to dry hops from many farmers in the valley. (Courtesy Beta Club Collection.)

almost simultaneously in every field in the Valley in early 1891, making the vines furry with aphids. Frantic efforts were made to check the spread of the pest.

Quassia wood chips from Central America and whale-oil soap were boiled in great vats over open fires, and barrels of the mixture were placed on sleds, drawn by horses up and down the hop field rows while men sprayed the vines. The aphids were killed, but a worse problem developed. The spray lingered on the vines, causing downy mildew.

Within a year, the hop boom in Western Washington was over. The bubble of prosperity burst less than 30 years after it started, sweeping away the fortunes so easily made. Hops had brought $20 million to the Puyallup Valley's economy between 1865 and 1891. They also added a distinctive architecture to the area, one that has now almost disappeared. Only one or two of the once numerous hop kilns remain, like rare monoliths to a forgotten way of life.

5. LIFE ALONG THE RIVER

Life along the Puyallup River has been interesting if not always comfortable. This largest river in the southern Puget Sound area has always been a force to be reckoned with. Born amid the eternal ice and snow of two great glaciers on the southwest flank of Mount Rainier, the Puyallup and Tahoma Glaciers, the branched river flows together near the boundaries of Mount Rainier National Park. A few miles downstream, it accepts the waters of the Mowich River coming from the twin North and South Mowich Glaciers.

By the time it reaches the Orting area and is joined by the Carbon River, flowing from the glacier of the same name, the Puyallup has become quite a respectable stream. Man took a hand in its further enhancement by deflecting the waters of the White River into the Stuck before it joins the Puyallup near the southwestern edge of present-day Sumner, adding the waters of the mountain's mightiest glacier, the Winthrop, to the river.

The Puyallup was determined by the U.S. government to be a navigable river to the mouth of the Stuck River, even before the addition of these latest waters. This determination means no person or city or county government may construct a bridge across it without Uncle Sam's permission.

None of this knowledge was available to Ezra and Oliver Meeker when they made their scouting trip of the Puget Sound area in early 1853. When they reached the mouth of the Puyallup, they saw Mount Rainier for the first time and envisioned a green valley ahead. But huge drifts of logs and forest debris clogged the river in several places between the mouth of the river and the present site of Puyallup when the Meeker boys asked some of the Puyallup Indians, who had lived along the river from times unknown, to show them the Valley. The drifts were sometimes a quarter mile or more long, and the Meekers and their Indian guides had to portage around them—a Herculean task, according to Ezra.

When they reached the approximate area where the Meridian steel bridge spans the river today, the Meekers gave up the idea of seeking farmland in the Valley. The valley floor was dense with fir and cottonwood trees, and the undergrowth of salal and salmonberry bushes was forbidding. Ezra later wrote that they thought it would take an impossible amount of labor to clear the land.

The Naches Pass Immigrants, who came to the Puget Sound region the following summer, were not daunted and many of them filed donation land claims along the river. In the early days of settlement, they found the river a temperamental neighbor. It wandered serenely around the Valley most of the year, twisting and turning wherever it

TOWN GROWTH, 1865. This early plat shows Puyallup's growth along the river in the nineteenth century. (Courtesy Pierce County Records.)

would, contributing bogs and swamps at every bend. But when the rainy season began, it became downright obnoxious.

Rominous Nix, whose claim, in part, covered the area now called the Linden Golf and Country Club, watched his difficult efforts of several years washed away by floodwaters when more than 80 acres of his land was flooded, not once but a number of times.

J.P. Stewart, whose land lay along the river at the southerly end of the big bend that once extended to Fifth Avenue Northeast and Meridian Street, spent a perilous night in the schoolhouse built on the riverbank. John Carson, his neighbor, rescued him the next morning across the rampaging river. Stewart, a shrewd and far-seeing man, some years later went to Carson and offered to pay the cost of digging a ditch across the Carson place connecting the river above and below the huge bend, where the river was eroding good farm land—which was, incidentally, Stewart's land.

A Chinese contractor brought 25 workers who dug by hand a new channel for the river for the handsome price of $300. It looked a little silly until the next high-water period

came, and then the excess water flowed into the dry ditch. When the floodwaters receded, there were two channels to the river, with a small wooded "island" between.

This island became a popular picnic area, and a footbridge was built across the original river channel that eventually became dry, as the river took the channel of least resistance. The old riverbed dried up, but a tourist camp and then Grayland Park filled its depression in later days.

The first bridge across the river was a pontoon bridge built by John Carson sometime after the Indian War and before Stewart's channel-changing efforts. Carson also operated a ferry across the river about where the west end of Stewart's channel was located. The pontoon bridge was short-lived as the current in the river was too strong for such a bridge, and one day it floated away downstream.

In 1883, a more ambitious project was planned, and Pierce County engineer D.D. Clark was requested to furnish plans for a wagon bridge that farmers could use. Clark's plans specified a bridge 13 feet wide and 162 feet long, of the Howe truss pattern. The floor of the bridge was to be 10 feet above high-water mark, and all trees, stumps, logs, brush, and other material perishable by fire were to be removed from an area 50 feet from the center of the bridge. From early maps, it appears this bridge was a little north of the present Linden Avenue Bridge between Puyallup and Sumner, but not as far north as the Meridian Street Bridge.

By 1908, the city officials in Puyallup were beginning to make greater efforts at flood control along the river. The Washington State Legislature passed an appropriation of $50,000 in 1909 to help straighten the channel farther downstream from Stewart's 1883 project. This new plan called for the widening and deepening of the channel from the river's mouth in Tacoma to the Stuck, and thence up the Stuck to the Pierce County line. Local planners believed these measures would permanently solve the problem of flooding on the river.

Later floods proved them to be wrong. Eventually, the construction of Mud Mountain Dam was completed in 1953 and provided a measure of flood control. It has been credited with reducing damage from floods by $50 million. Levees were built along the lower Puyallup, providing some security against high water to local farmers, and also providing high school seniors of the area with a "canvas" on which to express themselves during graduation week each year. Just as in pioneer days, however, the Puyallup River is still a capricious neighbor, but a major part of our everyday lives.

6. A Town Is Platted

Railroads were probably the most important factor in the development of the American West. Ezra Meeker spent many months in the East lobbying for the extension of the railroads to the Pacific Northwest. In 1873, the construction of the Northern Pacific line from Kalama brought prominence to Tacoma, then a small town, as well as a better way to market the hops that were burgeoning in the Puyallup Valley.

The railroad to Tacoma was followed some four or five years later by the discovery of coal on the upper reaches of the Puyallup River and the construction of a line through Puyallup to the mines in the Carbonado and Wilkeson areas. And with the coming of rails to Puyallup, the settlement made a sudden and steady growth.

In 1874, the Franklin post office was divided. Part of it was moved to the Clark's Creek area where Darius M. Ross received the mail at his house. Most of it was designated "Puyallup." The settlers north of the river and east to what later became Sumner still got their mail designated "Franklin."

In 1877, Ezra Meeker platted a town on part of his homestead claim, calling it Puyallup. Later, both he and A.S. Farquharson, who had erected a stave mill on land he bought from Meeker, claimed to have given the town its name. Farquharson wrote, many years later, that on the day the mill opened in September 1877, he suggested that the new town should be called Meekerville, and Meeker countered with the suggestion to name it after Farquharson. The latter wrote he then said it should be Puyallup. Since Meeker platted the town and filed the plat in February 1877, it seems probable that he was telling the truth when he wrote that he "bore the onus" for giving the new town its difficult-to-pronounce name.

The ink had scarcely dried on Meeker's plat, which included 20 acres between Main and Pioneer, when J.P. Stewart made three successive additions of 20 acres each north of Main Avenue, making the entire townsite 80 acres in size. Subsequent additions by Allen J. Miller, Arthur Miller, William Shuman, E.C. Merrill, and more additions by Meeker doubled the town size by 1888. J.P. Stewart placed 75 to 100 newly platted lots on the market at the end of that year, each ranging in value from $125 to $300.

At the same time, commercial building in Puyallup was taking place at a rapid rate, including the Puyallup Hotel, constructed by Peter Belles for $25,000, a public school building (Central) at $5,000, a $2,500 bank structure, and Johnson's opera house at $1,700.

PUYALLUP PLATTED.
This copy of the original
plat of Puyallup by Ezra
and Eliza Jane Meeker
in June 1877 shows
how the city started. The
original plat includes
only eight blocks between
Main and Pioneer
Avenues. New additions
followed quickly,
adding to the area of the
town. (Courtesy Pierce
County Records.)

A rivalry had grown up between the Meeker and Stewart factions as each strived to develop their sections of the town. Most of the business to this time was taking place along the railroad tracks, which bisected Stewart's territory. It seemed natural, therefore, that when a board of trustees was formed in 1888 to organize Puyallup as a "corporation" most of the names on the board were property holders in Stewart territory.

Stewart himself was chosen as chairman of the board. Other trustees included Arthur Miller, W.C. Gibbs, A.C. Campbell, A.G. Matthews, James Knox, C.W. Stewart, L.W. Ostrander, and John Beverly. The organizational meeting was held in the office of attorney Beverly, and Knox was appointed town clerk. Ostrander was chosen as treasurer and Carey Stewart as town marshal. A second meeting was held on August 6, 1888, with three ordinances and seven motions introduced. The first ordinance provided for the licensing of "drinking shops."

During the following year, business was carried on as if Puyallup was a real town. Ordinances were passed, property acquired by the corporation, water and sewer problems were discussed—and cussed—and attempts were made to solve them. The board agreed to condemn land around Maplewood Springs, owned by Frank O. Meeker and R.F. Radebaugh, after the committee failed to negotiate an agreeable price at which the town could buy the springs for its water source.

New streets were laid out as more new additions were added. One item of business included the leveling of Pioneer Avenue "so as to give it sufficient width to insure safety in teams passing" (March 18, 1889). Another was a claim filed for $300 damages for opening Union Avenue (Fifth Avenue Northwest/Southwest) through J.P. Stewart's raspberry fields. On December 17, 1888, the proposed deed of Ezra and Eliza Jane Meeker conveying certain lands for park purposes was referred to the Committee on Public Parks. A month later, the town had apparently accepted the gift of Pioneer Park, as the deed was received on January 21, 1889. In August 1889, the committee on streets, lights, and water

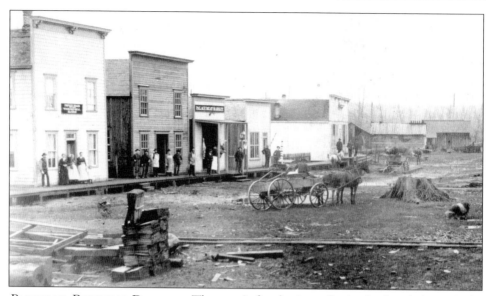

PUYALLUP BUSINESS DISTRICT. *The town's first business district developed alongside the Northern Pacific Railroad tracks after 1877. Most of these shops were destroyed in the Great Puyallup Fire of 1890. (Courtesy Washington State Historical Society, Tacoma.)*

was requested to select a site for the public watering trough. Everywhere in the town, wooden sidewalks were being built along new streets.

Then, on November 11, Washington Territory became Washington State—and everything changed. In February 1890, the Washington State Supreme Court declared the "corporation" of Puyallup illegal. Business stopped, except for the appointment of John V. Meeker as a special committee of one to confer with the town and with the State in regard to the legal incorporation of the town.

Meeker was authorized to employ Judge Galusha Parsons of Tacoma to help with the incorporation process. On July 11, 1890, at his behest, the Pierce County Commissioners held a special session for the purpose of considering and acting upon a petition filed by 71 citizens of Puyallup for the incorporation of the town and prescribing its proposed boundaries. An election was held on August 16, 1890, with the 1,500 citizens of Puyallup giving a resounding approval to the proposition for incorporation. Three days later, on August 19, when the county commissioners' order of incorporation was filed with the Secretary of State in Olympia, the City of Puyallup was born.

Selection of city officials was made at the same election, and Ezra Meeker was chosen as the first mayor. City council members elected were H.E. Barrett, C.C. Field, H.G. Matthews, Frank R. Spinning, Perry Summerfield, and L.W. Ostrander. The first order of business for the council was to approve William Seeman as city clerk.

Before the first year of incorporation ended, a second election was held and Meeker expected to be retained as mayor. His opponent was James Knox. Although Meeker was a known teetotaler all of his life, someone placed a sign in front of one of the town's many saloons, reading, "Have a drink and vote for me. E. Meeker."

Knox later said he believed the sign was intended to be a joke placed by one of his more avid supporters, but the damage was done. The good, non-drinking citizens of Puyallup had voted against Meeker. He was returned to the mayor's chair the next year for another term—but the rejection rankled for a long time.

Life in Puyallup was easy in the summertime of 1890, when Puyallup became an incorporated town. Fed on a steady diet of hop culture affluence, the town was booming. Ezra Meeker was building a shining new mansion of 17 rooms just south of the railroad tracks that carried to the world markets his hops and those of the farmers whose hops he brokered. Ezra and Eliza Jane Meeker had already donated the site of their first cabin in Puyallup to the town for a park, which Ezra specified would be named "Pioneer Park."

Across Meridian Street from the park, Ezra had his hop brokerage office, the busiest spot in town, with buyers from all over the world coming in to inspect and order the Puyallup Valley hops. North of Meeker's office was a store owned by his brother, John V. Meeker, and a fine new two-story restaurant that had been built to accommodate the patrons for the imposing Park Hotel, slated for construction on the block north of the park.

Beyond the restaurant was O.W. Johnson's exotic new opera house, with its Arabian-style dome. All the glittering road shows stopped there, playing to packed houses in the second-story auditorium. During the intermissions, the first-floor saloons offered a place for the men in the audience to relax.

North of the Opera House, the newly established First National Bank of Puyallup was putting up a new building, also topped by an onion dome, as was the style in 1890. The bank would occupy the corner office, and Charles Hood had already contracted to open his hardware store in the first-floor rooms that faced Meridian Street. In 1898, Citizens State Bank was incorporated in this building.

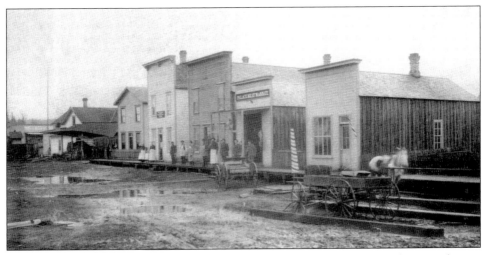

PUYALLUP BUSINESS DISTRICT. This is another view of Puyallup's first business district, including such businesses as the Palace Meat Market, a barbershop, and a lunchroom or restaurant. (Courtesy Washington State Historical Society, Tacoma.)

Across Pioneer Avenue, another new building erected by Frank R. Spinning in the best turreted style of the times housed the Puyallup Mercantile Company, established by E.R. Rogers. Upstairs were the offices of several Puyallup physicians, including the beloved Dr. Thomas McCracken. Truedson's Drug Store also was located in the Spinning Block.

A cluster of small, one-story frame buildings spread from there to Meeker Street. Bloomfield's Beanery occupied one of them, but the tenants of the rest of them moved in and out with regularity. Later, when telephones came to Puyallup, the Pacific Telephone and Telegraph Company was located in one of the buildings. A millinery shop opened in the corner spot—no self-respecting woman went out without a hat in Puyallup in 1890!

Between Meeker and Main was another line of small buildings, including the little square cottage where Ira Pearsall lived. Snider's blacksmith shop was next, and on the corner of Main Street was Puyallup's current hospitality center, the Central Hotel, with its deep veranda and its modern corner entrance. Ezra Meeker had the hotel built in 1879 as a boarding house for the laborers at a stave mill across Meridian Street. The factory burned in 1883, and J.H. Hallenbeck converted the boarding house to a hotel, which his wife, Nettie, managed until 1911 when it was razed to make way for the Pihl Brothers' Grocery Store.

The Pihl's first store, which started life as E.E. Samson's general store, stood north of Main Street. Between it and the Northern Pacific Railroad tracks were a couple of small

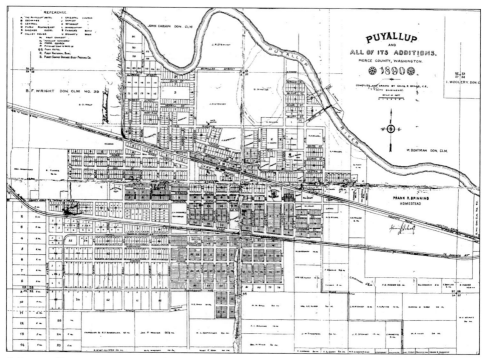

MAP OF PUYALLUP, 1890. *This map, drawn by a city engineer, shows the Puyallup River (with its original loop to the south indicated), the railroads, the bridges across the river, and the expansion of the town. (Courtesy Karshner Museum.)*

MAIN AVENUE WEST. *Ezra Meeker stands near the Jeffery Brothers' cart on West Main Avenue, just west of Meridian Street, in 1882. (Courtesy Washington State Historical Society, Tacoma.)*

frame buildings. One of them was a men's furnishings store run by A.E. Lovejoy, and the other was another of Puyallup's abundant saloons.

The tall building north of the railroad tracks was Puyallup's newest and most ornate hotel, just beginning to compete with Nettie Hallenbeck's operation. Pete Belles had the Puyallup Hotel built at a cost of $25,000. Its lavish furnishings included a huge mirror in the bar and restaurant, and the fine Southern-style hitching post outside.

D.A. Whitman's shoe store was located north of the Puyallup Hotel, and beyond was a small building that had housed the Puyallup Post Office until just recently, when C.C. Field's term as postmaster had expired. The next building housed Charles H. Williams's drugstore, and on the corner of Stewart Avenue was Charlie Mathias's meat market.

Across Stewart Avenue, on the northeast corner of the intersection, the new three-story brick building called the Stewart Building, was just being completed. The Farmers' State Bank, a cooperative banking venture organized by J.P. Stewart and some of his friends, was set to occupy the corner offices. A.C. Campbell, August Gardella, W.J. Bowman, Willis Boatman, and Rominous Nix were the principal stockholders, along with Stewart, in this new bank.

A.C. Campbell's grocery store stood on the northwest corner of the intersection of Meridian Street and Stewart Avenue. He had come to Puyallup from Canada about 10 years earlier and was now one of the most prominent businessmen in Puyallup.

Much of the business of Puyallup took place north of the railroad tracks in this summer of 1890. From Meridian to the Northern Pacific Railroad depot, about two blocks west, many small wooden buildings fronted on the tracks with their back doors on Stewart

BRICKYARD GANG. This is believed to be a photo of the Atkinson Brickyard on the western edge of Puyallup during the late nineteenth century. Bricks from this yard furnished the building material for many of the structures in the town during one of its greatest construction periods, which coincided with the hop boom. (Courtesy Perkinson Collection.)

Avenue. Among them were Kincaid's saloon, James Knox's real estate office, Gardner's saloon, and Ed Avery's drugstore. The first corporate city council meetings took place in the back rooms of George Edgerton's real estate and insurance offices near Stewart and J Street (now Second Street Northwest). The new red-brick Ball building, which the recently established First National Bank would occupy, was also under construction at this same intersection. South on Meridian Street, along the west side, past Avery's drugstore was Robert Grainger's livery barn and Dan Igoe's blacksmith shop. The rickety old Exchange Hotel bordered the tracks.

All of these buildings, from the depot to the hotel, would meet a fiery fate in September when the "great Puyallup fire" took place. From the ashes of that fire, the second ultra-modern Stewart Building would rise on the southwest corner of Meridian and Stewart. It first housed Stewart's hardware store, then a number of other retail businesses. The upper hall served a patriotic purpose as a dance hall, where soldiers from Camp (now Fort) Lewis were entertained during both World Wars.

South of the railroad tracks was Ezra Meeker's general store, later to become the Blue Front Grocery under the management of C.C. Field. Farther south were Frank McAlpin's store and Gabrielson's meat market. On south, where the barrel stave factory had been, W.H. Elvins had opened his shoe store, and Charles Ross and Frank O. Meeker constructed a large building that they used as real estate offices. The Puyallup Post Office was located in what had been the stave factory offices at one time.

Between Meeker and Pioneer Avenues was a corral where businessmen and shoppers kept their horses while they were in town. A livery stable also faced Meeker from the

middle of the block. When the traveling carnival came to town, it was on this block that it set up shop with its merry-go-round and sideshows. And on the northwest corner of Meridian and Pioneer was that curious little building everyone in town called the Spite Building. Beyond it, the ill-fated Park Hotel was just beginning to rise.

THE SPITE BUILDING

About the time in the early 1890s when the hop growers in the Puyallup Valley were facing ruin because of the infestation of hop lice, at least one minister in one of the Puyallup churches preached about the evils of drink and gave his opinion that God was punishing the hop farmers in general—and Ezra Meeker in particular—for their involvement in the production of beer.

Ezra Meeker was a recognized teetotaler, but that did not stop the local clergy from castigating him. They also disregarded—or didn't know—that Meeker had donated the land for many of the churches built in Puyallup during the past 30 years.

One of these churches owned the property adjoining an 8-foot strip along the north edge of Pioneer Avenue just west of Meridian, which was still owned by Meeker. Just why the property lines were laid out in this form is not known. Perhaps the strip was left over when he sold the "factory lot" in the 1870s.

These church officials, so the story goes, were sure Meeker would donate the strip of land to the church. After all, what could he do with an 8-foot strip of land? They soon found out.

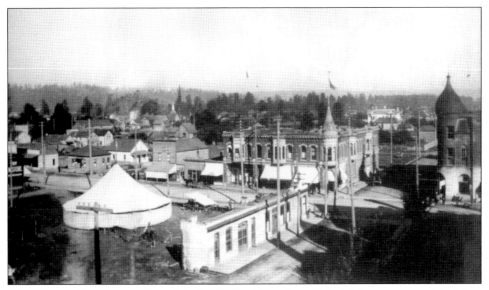

THE SPITE BUILDING. Ezra Meeker built this curious little brick structure at Meridian Street and Pioneer Avenue about 1890. Across the street is the Spinning Block building, left, and the Citizen's State Bank building. The Meeker Mansion is the white building in the background. (Courtesy Beta Club Collection.)

The *Seattle Post-Intelligencer* (*P-I*) had reprinted most of the minister's scathing remarks about Meeker. The doughty pioneer, who was quick to anger and often parsimonious, wrote a letter to the editor of the *P-I* claiming that he had "beat God" by finding a cure for the hop lice, which of course didn't work out as planned.

That did not keep Meeker from being vindictive where the minister and his flock were concerned. He was determined they would never have his 8-foot strip of land, and he had a narrow little brick building constructed on the site. Only 8 feet wide and 40 feet long, it was used first as a bicycle shop and later became Ed Watts's soda shop—an ideal use of the space. It was even used as a hop office by A.C. Campbell and his sons. No matter who the tenant was, it was always called the Spite Building, until it was incorporated into a larger store built on the site.

SLEEPY TOM

One hundred years ago, a remarkable horse lived in Puyallup. Owned by Pete Belles, proprietor of Hotel Puyallup, which stood in modern splendor just north of the railroad tracks on Meridian Street, Sleepy Tom was most often used between the shafts of his little

BUILDING A STREET. It was a slow and tedious process to build a street in Puyallup before the advent of motors and machines. Here, manpower and horsepower are utilized to make Fifth Avenue Northwest a smooth and efficient thoroughfare. (Courtesy Washington State Historical Society, Tacoma.)

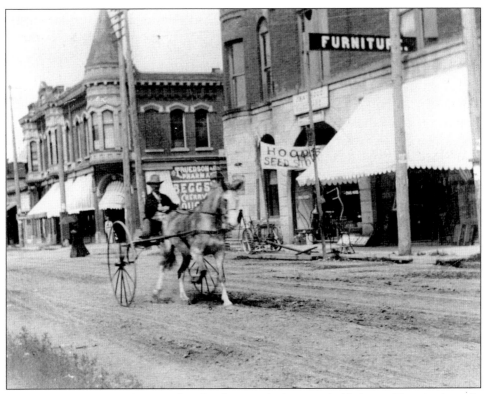

SLEEPY TOM. Pete Belles, Puyallup hotel owner, had a remarkable horse, Tom, in the early 1900s. Here he struts down Meridian Street with Belles at the reins in front of the Spinning Block building. (Courtesy Lori Price Collection.)

sulky, with Pete or Mrs. Belles, dressed "to the nines," driving. Pete was known as a fine hotelman and a fine citizen, but his real interest in life was his horse. Everyone knew that.

In 1899, a *Tacoma Daily Ledger* story reported that Sleepy Tom was past 22 years of age, but that the sporting fraternity of Tacoma had been laying for Belles for some time, with the hope of defeating his horse in a harness race. Apparently, Pete had been laying for them, too. When a match race was finally arranged between Sleepy Tom and the crack pacer Combination George, the Puyallup horse scored a complete victory.

Sleepy Tom also raced at the Puyallup Fair when it began in 1900. Pete always brought his horse up in front of the bleachers after the race and fed him a pumpkin pie.

When Sleepy Tom eventually died around the age of 28 years, his owner held a public funeral for him. Many Puyallup Valley citizens attended, and a bounty of flowers graced his burial site. About 80 years later, another remarkable horse came out of the Northwest—one named Seattle Slew. But, in the Puyallup Valley, people still say there has never been one like Sleepy Tom.

7. Was There Life after Hops?

The ending of the hop boom in Puyallup was followed closely by a worldwide economic depression. Those who experienced it as well as the Great Depression of the 1930s said the 1893 depression was much the worse. People in the Pacific Northwest were still feeling hard times when the 1897 discovery of gold in the Klondike brought a rebirth of opportunity and hope to their world. Many husbands, fathers, and sons (and even some daughters) departed for the Yukon by the first ship they could get on, seeking an upturn in their fortunes.

Ezra Meeker, always the entrepreneur, canned and dried vegetables and fruits in the kitchen of his mansion in Puyallup, with the help of Eliza Jane, and took them to Dawson. He also took along cattle, chickens, eggs, tools, and other necessary items to the gold miners. He ran a store in Dawson and was assisted at times by his son Fred Meeker. Ezra made a tidy fortune of $19,000 from the store. Unfortunately, he invested the money in a gold claim venture and lost it all. About the same time, Fred was stricken with pneumonia and died suddenly, so Meeker came away from the Klondike poor and sad.

Other people took other paths. The seeds of the industries that followed in the wake of the hop boom were already planted in the Valley—the berry industry and the lumber industry. The first blackberries in Puyallup might have come from the huge evergreen blackberry vine that grew over Ezra Meeker's chicken coop. It must have been something special to be remembered in historical records.

The first crop of blackberries was probably that of an Alderton farmer named T.F. Patton, who said he set out the first blackberry "yard" in 1876. He enjoyed bountiful yields through 1887. Patton sold enough blackberries from his first 2-acre crop to buy 600 pounds of sugar, with which he made 200 gallons of wine—enough to supply his own family and sell the rest to his neighbors at $1.25 per gallon by the barrel. His profits, he indicated, were $125 per acre.

The recognized beginning of blackberry production as a fresh fruit industry was attributed to E.C. Meade, a son-in-law of the pioneer William M. Kincaid. Meade planted "a few roots of improved varieties" on his farm south of Sumner in 1885.

Perry Summerfield said he planted the first acre of raspberries on land he rented from J.P. Stewart north of Stewart Avenue in Puyallup in 1882, although there is some evidence that Stewart was already harvesting and selling raspberries before that time. The first crop from Summerfield's fields was a small one, coming in 1884, but it was enough to send

IT'S THE BERRIES! Puyallup Valley families took to the fields in summer 1916 to help pick the berry crops. Here, mothers and youngsters check in at a blackberry field. Hats protected them from the summer sun and long stockings protected forearms from the thorns. (Courtesy Beta Club Collection.)

fresh raspberries to the Seattle and Tacoma markets. During the next three years, bumper crops resulted, and he made a profit of more than $1,000 per acre.

His rental agreement with Stewart resulted in $266 of that amount going to Stewart, so it was not surprising that Summerfield soon filed a homestead claim of his own. In 1886, he chose a tract on the valley floor just north of the present Good Samaritan Hospital, and there, he developed the largest and finest market garden in the Valley, including an excellent raspberry planting. He was still raising splendid crops of fruits, berries, and vegetables more than 10 years later when the Western Washington Fair started as the Valley Fair. For a number of years, Summerfield walked away with a majority of the blue ribbons with his produce exhibits at the Fair.

Soon, the former hop farmers were looking at berry production. By 1903, when the first issue of the *Puyallup Valley Tribune* was printed, the industry had grown to such proportions that a marketing association was a necessity and the Puyallup and Sumner Fruit Growers Association was formed.

The lumber industry had a toehold in the Puyallup Valley long before the hop boom dissipated. The first lumber mill was a small one near Maplewood Springs, which Frank Meeker, nephew of Ezra Meeker, started in the early 1870s. It was run by waterpower and had a capacity for sawing about 14,000 board feet of lumber daily.

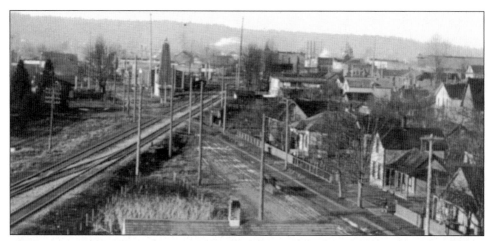

ON THE RAILROAD. *The Northern Pacific Railroad was built through Puyallup in the late 1870s. Here, it bisects East Main Avenue on its way west. (Courtesy Perkinson Collection.)*

In 1889, the Stevenson brothers—Frank, Walter, John, Jim, and Charles—opened a steam-powered mill on the north shore of Surprise Lake in the Edgewood area. Later, they moved to a spot near Meridian Street just east of the present Woodbine Cemetery. In 1897, Walter and Jim bought a quarter section of land near Crocker, southeast of Orting, and started a sawmill there. They had a successful operation but, a few years later, they returned to Puyallup, where they rejoined their brothers in a lumber mill in downtown Puyallup. Lumber from the Stevenson mill was used in the covered wagon constructed for Ezra Meeker in 1906 for his famous trip to mark the Oregon Trail.

In the meantime, William Patterson was entering the lumbering trade in Puyallup. His brother-in-law, George Stevenson—yes, one of the Stevenson brothers—owned a small sawmill that he sold to Patterson, who had come to Puyallup at the urging of his three sisters in 1905. It is believed that this mill stood beside the "Old Grape Vine Line," an electric railway between Tacoma and Puyallup, about Fourth Avenue Southwest west of Meridian Street. Certainly, it later came to be known as the Patterson Mill.

Patterson was a very outspoken man, especially when it came to the rights of the working man. He was a popular mill owner until his mill was destroyed in a 1927 fire. Walter Stevenson sold his holdings in the Stevenson brothers' mill in 1916 and became a lumber inspector.

Both Stevenson and Patterson were musicians in their spare time. Stevenson and his brothers, all of whom played musical instruments, formed a band to provide music for dances held in hop barns, where the smooth wooden floors made ideal dance floors. Patterson also was involved in local bands and played for the entertainment of his family and friends.

About this time, Walter and Charles Stevenson joined with four other local musicians to play a regular program on radio station KVI. Brother John joined them in 1930 in a program of country and Western music by request. They were known as the "Pioneer Steppers." Walter, who composed many of the songs they played, invented a device he

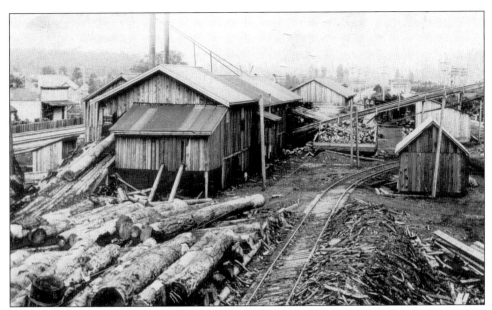

PATTERSON LUMBER MILL. *Located on Fourth Avenue and Third Street Southwest, this mill provided lumber for many homes and businesses in Puyallup from the 1890s to 1927 when it was destroyed in a fire on the same night the high school burned. The school was rebuilt; the mill was not. (Courtesy Beta Club Collection.)*

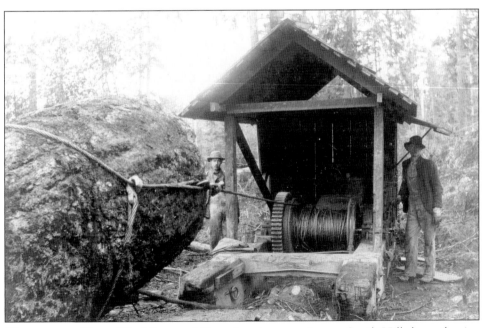

HERCULEAN TASK. *The Morse and Brew Logging operation on South Hill shows the size of logs cut for the sawmill in the early days of the twentieth century. A good man with a good winch could get the job done. (Courtesy Ezra Meeker Historical Society.)*

called the piano-corder, which allowed him to play the violin and accompany himself on the piano.

Frank Morse came to the Puyallup Valley shortly after 1884, locating first in Sumner, where he operated a planning mill and a sash-and-door factory. He had been a mill operator in Cuyahoga County, Ohio, before bringing his family to Washington Territory. In 1890, he moved to Puyallup and established the F.W. Morse Manufacturing Company. According to W.P. Bonney's *History of Pierce County*, Morse did most of the millwork on the Ezra Meeker mansion. In 1898, Morse took Thomas H. Brew as a partner in his operation, and the scope of the plant steadily expanded. It soon became the Morse and Brew Manufacturing Company and was located on Stewart Avenue just east of Fourth Street Northwest.

Brew was born on the Isle of Man and immigrated to the United States when he was about 20 years of age. He participated in the California Gold Rush, then moved to Idaho, to Oregon, and later to Washington, where he went into the lumber business. The Morse and Brew operation was named as the largest of five lumber mills in Puyallup in 1903, with invested capital of $40,000 and 75 employees. In addition to the large sawmill, there was also a shingle mill, veneer plant, box factory, and woodworking establishment in Puyallup and two large logging camps and a small sawmill in Summit. The company also had a lumber products department in Yakima.

In 1911, Brew bought the interests of his partner and the business was subsequently known as Brew Manufacturing Co. In 1920, the main plant was destroyed by fire, along with several homes along Stewart Avenue. Brew then purchased several acres east of Puyallup on Pioneer Avenue and a new plant was started there in 1926.

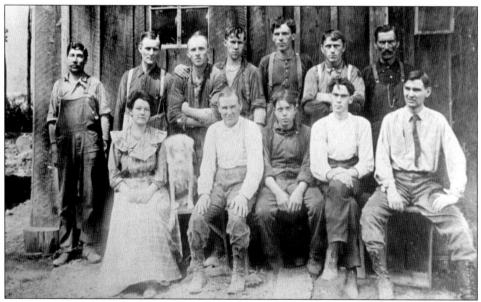

A FAMILY AFFAIR. The Brew logging and mill operation seems, from this photo, to be a family affair for Thomas H. Brew's family. (Courtesy Beta Club Collection.)

8. A Dream of a Hotel

It was a dream born of the hop boom in Puyallup—a dream that *almost* came true. It was the Park Hotel, and it dominated the skyline of Puyallup for a brief period, but never fulfilled its destiny. It sheltered only one relatively small group of "guests" and they were unwelcome.

The dream began in 1889 when the following story appeared in the December 11 edition of the *Tacoma Daily Ledger*:

> It is practically settled that the thrifty suburban town of Puyallup is to have one of the finest hotels in the Sound country. Architects Daniels and Cook of this city [Tacoma] have been engaged on the plans during the past week, and have them about completed. The hotel is to be erected by a stock company composed of Tacoma and Puyallup gentlemen, and nothing will be spared to make it one of the most attractive and perfectly equipped hostelries in this section of the country.
>
> The structure will be located directly opposite the [Pioneer] park in Puyallup and will possess two fronts, one facing the park and the other the business part of town. A name has not been definitely decided upon, but it will probably be called the Park Hotel.
>
> The plan calls for a structure three stories high with an attic and basement. The ground dimensions are 90 x 216 feet. In the basement will be a billiard hall, 37 x 90 feet, which will also include the barroom, the boiler room, laundry and cold storage room.
>
> The first floor will be divided off on the most modern hotel plan. It will include a main hall 40 x 46 feet, parlor 37 x 38 feet, public dining hall 37 x 30 feet, private dining rooms, reception parlor, reading room and offices.
>
> A reception parlor 24 x 32 feet, 41 sleeping apartments, bathrooms and closets will consume the space on the second floor. The third floor will be divided off into 42 sleeping apartments, bathrooms and closets. The attic will not be finished at present, but if necessity demands, 40 more commodious sleeping rooms can be provided on this floor.
>
> The sleeping apartments on the second and third floors will be arranged in suites, with a fireplace for each suite of rooms. Steam will be employed in

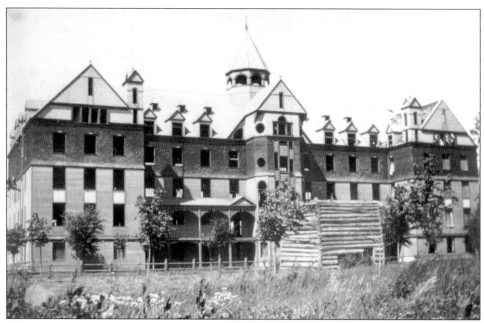

THE GRAND PARK HOTEL. Built with hop profits, the hotel was a magnificent structure for its time, but never fulfilled its destiny. This south side faced Pioneer Park and Ezra Meeker's first hop-drying kiln. (Courtesy Washington State Historical Society, Tacoma.)

heating the building throughout; therefore those rooms which will not be supplied with fireplaces will, at all times, be comfortable. Three flights of stairs will lead to each floor, and an elevator shaft will run from basement to attic. The interior will be handsomely finished in redwood and cedar and luxuriously furnished from top to bottom.

Verandas will cover both the main entrances. The main feature of the park front will be a large window eight feet wide and 36 feet high located in the center of the building. No window in the structure will be less than five feet in width.

A two-story verandah 14 feet wide and 60 feet long will ornament the city front, affording a beautiful promenade. A large tower, 106 feet in height, will be constructed on this front, from which a magnificent view of Mount Tacoma [Rainier] and the surrounding landscape can be obtained.

Both fronts will be broken up with gables, towers and other adornments, giving a pleasing and artistic effect. The building will cost about $40,000 when completed and it is expected to be ready for occupancy about March 1, 1890.

This building project was the dream of, among others, Ezra Meeker and probably other affluent hop growers as well as civic leaders. By March 1, 1890, the only progress on the Park Hotel was the site clearing. The completion date appeared to be an ambitious one.

Much too ambitious. The date came and went, and the hotel not only was not completed, it was not yet started. It was not until April 8, 1890, that the *Tacoma Daily Ledger*

carried a story that workmen had begun raising the frame. A month after that, on May 8, the same newspaper reported the annual meeting of the Park Hotel stockholders had taken place in the office of the Puyallup water and light company the previous night, and holders of 245 of the 350 shares of stock in the hotel had been present. They elected new officers for the coming year: Ezra Meeker, president; Alexander C. Campbell, vice-president; Charles R. Ross, secretary; and Frank O. Meeker, treasurer.

By early June, the fourth-story frame was being put into place, and two weeks after that, the contract for the millwork for the outside finishing was let to the Sumner Lumber Co. By mid-July, the ambitious Park Hotel Company had leased the Park Restaurant, which had been operating for some time in a building across Meridian Street from Pioneer Park. A painter was put to work redecorating the inside of the building that, according to a newspaper story, was divided into one large dining room and "numerous convenient boxes."

Work on the hotel, meanwhile, had been "resumed," according to another *Ledger* story, with the west wing of the Park Hotel to be finished as rapidly as possible so that it could be opened in conjunction with the opening of the restaurant. This would make a "complete establishment in every particular for the use of guests until the whole of the hotel itself can be completed," the newspaper reported.

What happened to the ambitious project? Perhaps its cost, like many projects today, became prohibitive. Perhaps the booming hop economy of the Puyallup Valley was already beginning to slow down. It was only a few months later that Ezra Meeker stepped outside his office, next door to the restaurant, and found his hop fields crawling with aphids.

VIEW FROM THE TOP. This view of northwest Puyallup from the roof of the unfinished Park Hotel shows the First Baptist Church on West Pioneer and Second Avenues. (Courtesy Beta Club Collection.)

It was the beginning of the end of the hop industry, and of the hotel. Meeker and most of the other affluent hop farmers lost the considerable fortunes they had made, and along with their fortunes went the lavish homes and their business ventures, including the Park Hotel. Meeker later said he retained ownership of his mansion in Puyallup only because it was built with Eliza Jane's funds and the deed was in her name.

Without the funds to finish the Park Hotel, construction stopped. It was never finished. Three years later, it sheltered its only "guests." Members of Coxey's Army, an organization of men out of work during the Great Depression of the mid-1890s, agreed they would meet in Puyallup and form a permanent organization to march on the national Capitol. "Jumbo" Cantrell, a former bouncer at the Theatre Comique in Tacoma, led the rag-tag "army " that camped out in the unfinished hotel. It was said that they "terrorized" the 1,800 citizens of Puyallup into giving them food and money, until Governor John McGraw came from Olympia and persuaded them to go home again.

There were a number of suggestions for the use of the hotel. One political group agitated for the Washington State capital to be moved to Puyallup, with the hotel to be used as a legislative building. That suggestion died a-borning. After that, the hotel was sometimes used to store baled hops and hay, and the town boys found it an intriguing place to play. Parents of the boys, however, and business leaders of the town considered it a dangerous place, and some time after the turn of the century, a group of the latter got together and bought the site. They hired E.P. Truedson to spearhead the demolition of the building and the salvaging of the lumber in it. It was a sad, inglorious end to a dream.

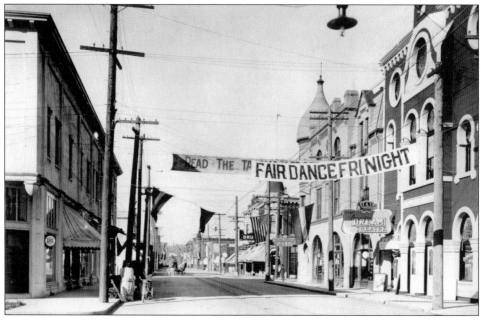

MERIDIAN STREET. In this c. 1910 view looking north from Pioneer Park, the Park Hotel has been razed and replaced with the large building on the left. (Courtesy Washington State Historical Society, Tacoma.)

9. The Great Fire of Puyallup

The Puyallup Police Department was established when the first city council of the incorporated City of Puyallup passed an ordinance creating the department on September 10, 1890. Two men had been nominated for the position of city marshal on August 20, Samuel Grafton and Philip Keating, but the council vote ended in a tie and the election of a marshal was postponed until the next regular meeting, when A. Clarke was elected.

At the September 10 meeting, Mayor Ezra Meeker appointed M.B. Kelly as the day policeman, and E. Duvaul, Philip Keating, W.L. Oldham, and Jerry Smith as night policemen. The appointments were confirmed. Ten days later, however, Kelly resigned, and it is not clear who took his position.

The "corporate" city of Puyallup had a city marshal and a city jail north of the railroad tracks before the city was incorporated. The corporation was declared unconstitutional after Washington became a state, and the jail was one of the structures destroyed in the great Puyallup fire of September 17, 1890. Even before the fire, Meeker had offered to donate two lots to the City of Puyallup for the purpose of building a new jail.

On September 10, John Young's bid for a brick-veneered building was the low bid and was accepted. Construction began almost immediately. The jail was finished and accepted on December 9. It stood on Pioneer Avenue just west of Second Street Southwest, where the Puyallup Municipal Building is located today.

In 1891, with hard times coming to the hop-producing Valley, the staff of the police department was cut in half. By 1894, things really got tough. With the hop bust followed by a worldwide economic depression, there seemed to be no money at all to pay law enforcement officers.

Charles Hood, one of Puyallup's leading citizens, helped to organize a volunteer police force. Keeping the peace seemed to concentrate on three main themes: rounding up the drunks on the city streets; coping with the annual influx of hop pickers, mostly Indians; and dealing with the hoboes who found their way into town.

The Northern Pacific Railroad's main line bisected Puyallup, and brought both prosperity and problems. Destitute men rode the rails in the 1890s as they did during the later Great Depression of the 1930s. Without visible means of support, they often found themselves temporary residents of the new Puyallup jail.

The railroad also figured in the first tragedy in the Puyallup Police Department. William Jeffery, a longtime resident of Puyallup, had served as marshal, deputy marshal, and

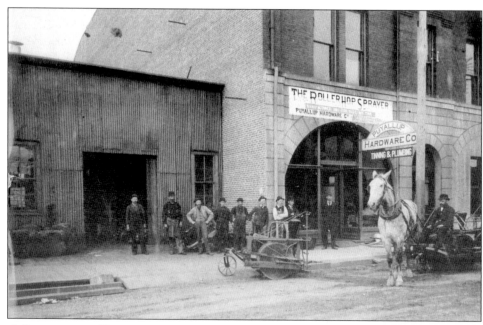

A REMARKABLE HARDWARE MAN. Charles Hood came to Puyallup in 1889 and went into a partnership with several leading Puyallup businessmen in establishing the Puyallup Valley Hardware. Hood bought out the interest of his partners and continued the business under his own name, Hood's Hardware. (Courtesy Ezra Meeker Historical Society.)

constable at various times. On September 30, 1894, he was shot and killed by an unknown assailant at Meeker Junction on the eastern edge of Puyallup. Jeffery was walking to Puyallup from Alderton, where he had been visiting with his mother on that Sunday afternoon. With him were Thomas Alexander and Thomas Bowley, both of Puyallup. As they were passing the depot at Meeker Junction, Jeffery noticed two men acting in a suspicious manner. They ran from the northbound train as it slowed while passing the depot. When they reached a storehouse for the Hastie mill, one of the men placed a bundle inside the building before running toward the mill.

Jeffery investigated, found the bundle, and discovered a .45-caliber Colt revolver in a leather holster. He was examining the weapon when the man called to him, saying it was his gun. He returned to confront Jeffery, grabbed the gun, and fired at the police officer.

Jeffery died within moments. Alexander and Bowley rushed to Jeffery, and other men in the vicinity gathered, while the shooter and his companion ran into the nearby brush and disappeared. The next day one of the fugitives, a youth named Fred McMurray, was captured near South Prairie. He told that he had met the man who did the shooting the day before on the train from Ellensburg. McMurray said the man's actions frightened him and he took the first opportunity to get away from him.

A few days later, a man walked into Goldrick's Mug, a Seattle tavern, and attempted to hold up the bartender, Charles M. Bridwell. When Bridwell ducked behind the bar, the stranger fired one shot, killing the bartender. On October 4, Seattle police found and

arrested the stranger, who refused to give police his real name. "Just call me Tom Blank," he said. "That's as good a name as any."

McMurray was brought to Seattle and identified Blank as the man who shot Jeffery. Blank was tried, convicted, and sentenced to be hanged. In March 1895, he engineered a jailbreak, using a wooden gun he had carved in his cell. But his luck was running out.

A few days later, a farmer near Orilla sent word to police that he had seen the murderer, thin and evidently ill. Near Kent, law officers accosted the man, and in a shootout, he wounded one of the officers before being shot full of holes. His body was taken to Seattle, and there the mystery deepened. A salesman from California identified it as that of Tom Brown, a well-groomed but quiet guest of a San Francisco hotel. But no one knew any more about Tom Brown than they did about Tom Blank. Unfortunately, William Jeffery would not be the last police officer killed in the line of duty in Puyallup.

Only one month after it was incorporated, the City of Puyallup began to organize a fire department. Unfortunately, that was two days after the Great Puyallup Fire of September 17, 1890. The fire was believed to have started in a paint store, one of the many little buildings that fronted the railroad tracks and backed up to Stewart Avenue west of Meridian Street. That area was the heart of the Puyallup business district of 1890.

The fire spread quickly eastward. Bucket brigades were formed from the city well on Stewart Avenue. When it went dry, so the story goes, the men trying to subdue the fire grabbed watermelons from a railroad car on a nearby spur and tossed them onto the roofs of the burning buildings, where they smashed and helped put out the fire.

The late Dr. Warner M. Karshner, then a boy, often related that he and his friends liberated a few of the watermelons and hid them under a wooden sidewalk about a block

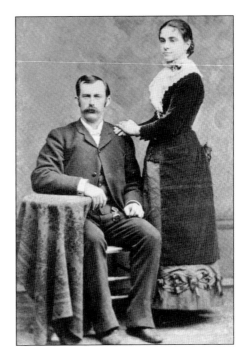

KILLED IN ACTION. William Jeffery, a constable in the Puyallup Police Force, was the first local law officer to be killed in the line of duty. Shown with his wife in 1890, he was shot and killed on Sunday, September 30, 1894 at Meeker Junction. His assailant was later killed by a posse, but his true name was never discovered. (Courtesy Lori Price Collection.)

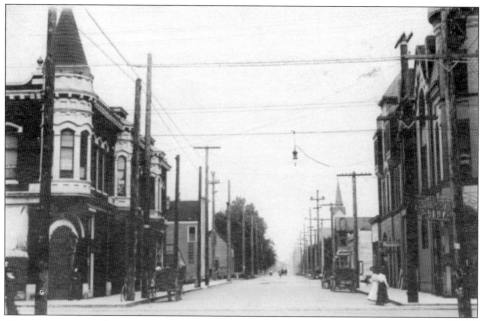

VICTORIAN-AGE STREET SCENE. Pioneer Avenue East, from Meridian Street, was a wide thoroughfare in 1890. (Courtesy Ezra Meeker Historical Society.)

away. They had a continuous watermelon feast for some days afterwards, the good doctor used to say.

All but two of the buildings between the tracks and Stewart Avenue were destroyed by the fire, which turned south once it reached Meridian Street. It was only stopped by the railroad tracks that crossed Meridian at that point. The largest building to be burned was the rickety old Exchange Hotel, which Pete Belles had managed before building his modern brick Hotel Puyallup across Meridian Street. As it was, Pete and some of his employees spent the night on the roof of the new hotel, using wet blankets to keep the hotel from catching fire from the blowing sparks.

Buildings destroyed by the fire, in addition to the Exchange Hotel, were the paint shop, harness shop, livery stable, drugstore, office building, millinery shop, candy store, stationery store, and grocery store, as well as Puyallup's first jail and three saloons.

When the city council met on September 18, an ordinance concerning fire prevention in Puyallup was passed. It called for the erection, extension, repair, or removal of buildings within the fire limits. The fire limits for the town had been established in the council's first meeting on August 29.

While the city fathers were still stirring the ashes of the big fire, on October 20, the council authorized the construction of cisterns at convenient intervals for the storage of water to be used when fighting fires. The ordinance further directed the City to purchase an approved make of fire engine, a sufficient quantity of fire hose, a hose cart, and a hook and ladder truck. Such other fire apparatus as the city needed to "protect itself from the ravages of fire" was also approved.

A week later, the council approved bylaws and a constitution of the Puyallup Hose Company No. 1. By the next February, the Puyallup Light and Water Co. proposed to furnish the city with water for fire protection for the sum of $5 per month. The matter was referred to the Fire Committee.

The first fire department was an all-volunteer force of 25 men. They were given a fire barn at Main Avenue and Sycamore Street (Second Street Southeast), where they sponsored dances and other events to raise money to buy uniforms and build a meeting place above the fire barn.

Hose Company No. 2 was formed on October 28, 1891, and J.P. Stewart donated land for a hose house. It was in use by May 1892.

Benjamin A. Berry was the first chief of the fire department. For some reason, the department organization was short-lived. When it was reorganized in the late 1890s, the new chief was E.B. Nichols.

When the fire alarm sounded, local farmers competed with each other to be first to arrive at the fire station with their teams of horses. The first team to arrive was hooked to the hook-and-ladder rig to make the fire run. The owner was paid for his services. Other volunteers grasped the hose carts and ran all the way to the fire.

During the 1890s, the usual way the fire department was called was through the Puyallup Trading Company store on Meridian and Main. It had one of those new-fangled telephones. Someone from the store then ran the block to the fire barn and let the volunteers know where the fire was located.

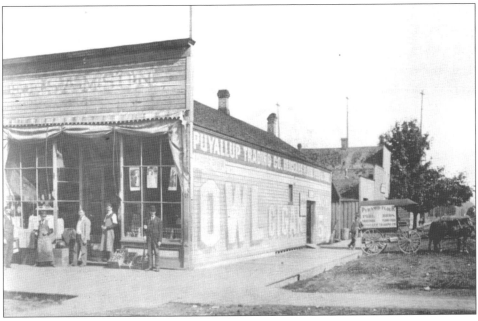

PUYALLUP TRADING COMPANY. *E.E. Samson first ran this early general store on the northeast corner of the Meridian Street–Main Avenue intersection. The store was later the Pihl brothers' first grocery store. (Courtesy Lori Price Collection.)*

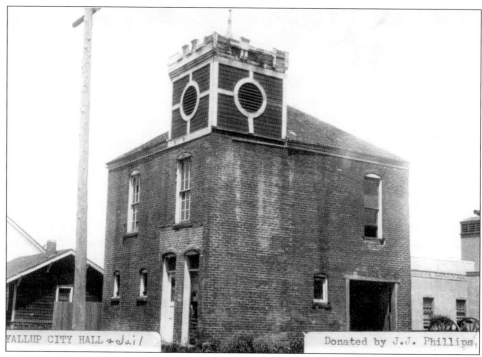

PUYALLUP CITY HALL + Jail

Donated by J.J. Phillips.

PUYALLUP CITY HALL AND JAIL. This square brick building stood on the corner of Second Street Southwest and Pioneer Avenue and was used as both the city hall and jail prior to 1919. To the right was the Puyallup Fire Department, now used as the Puyallup Senior Center. (Courtesy Beta Club Collection.)

About the turn of the century, a new alarm was adopted. When a fire broke out, someone called the Morse and Brew Mill on Stewart Avenue at Harrison Street (Fourth Street Northwest) and someone at the mill would blow the mill whistle. The number of times the whistle was blown would tell the town in which quadrant the fire was burning.

In 1904, the council discussed the practicality of adding a chemical wagon to the fire department equipment. During the discussion, an alarm came in that Councilman D.M. Snyder's home was burning. There was immediate approval of the chemical wagon.

Until 1914, all equipment was manned by volunteers and drawn by horses. The department had just undergone a shake-up, when Mayor Mark Graves dismissed more than half of the department's personnel and appointed new ones plus a new fire chief, Les Asher. Some bitterness resulted when the dismissed men took all the records and burned them, including reports of old fires, minutes of early meetings, rosters, and other papers.

In 1914, the city council, heading by Mayor Lucien Dean, decided it was time to modernize the Puyallup Fire Department, and it has since become a thoroughly modern and efficient organization.

10. THE END OF THE TRAIL

Life in Puyallup had returned to a more normal pace by the beginning of the twentieth century. After the catastrophic wiping out of the hop industry, followed by the worldwide economic depression of the early 1890s, Valley residents took many paths to recover. Some went to the Klondike to recoup their fortunes in the gold fields; others began new farming ventures, such as berries.

There still seemed to be an aspect of opportunity hovering over the Puyallup Valley like a benign spirit, attracting new people to its beautiful, fertile acres. The population of Puyallup swelled, as it did throughout the entire Pacific Northwest. The pioneers were mostly gone by the turn of the century, except for a hardy few.

J.P. Stewart had died at a comparatively early age of 61 in 1891, but Ezra Meeker still lived. Back in his mansion in Puyallup after his sad experience in the Klondike, he turned his attention once more to writing. He had published a book on hop culture in Western Washington during the glory days of that industry and had produced a pamphlet about the flora and fauna of the area that Jay Gould had used to promote his railroad to the Pacific Northwest.

Now Meeker began a book on the history of the Puget Sound region, including the story of the Indian War of 1855–1856. Although it contained some inaccuracies, it was the most important of the 14 books and booklets Meeker wrote. *Pioneer Reminiscences of Puget Sound: The Tragedy of Leschi* was self-published in 1905.

In 1906, Meeker began what he considered to be his life's most important work. He had long been talking about the Oregon Trail as the most important route across the country during the pioneer era, and he determined that it needed to be marked for posterity. Settlement along the trail was already beginning to obliterate the historic route.

So Meeker, at the age of 76, contracted with a Puyallup wagon builder for a covered wagon to be made, using as many parts of original pioneer wagons as he could find, and he set out on a reverse journey over the Trail. He left Puyallup, the "first camp on the monument expedition," on January 29, 1906. This time, Eliza Jane was left behind in the mansion in Puyallup. She had been in ill health for a number of years and could no longer participate in Ezra's adventures.

He planned to stop in towns along the way, give lectures, and sell postcards of his odyssey, which he counted on supporting him and his entourage, and paying

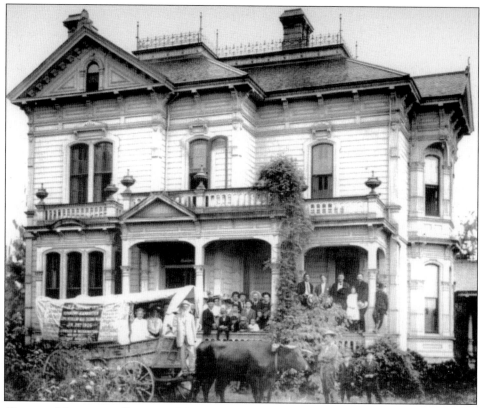

OFF TO MARK THE OREGON TRAIL. From 1906 to 1908, Ezra Meeker traveled back along the Oregon Trail. This photo was taken in front of the Meeker Mansion in Puyallup. (Courtesy Ezra Meeker Historical Society.)

for monuments he would then erect along the trail. It all went as planned. He was quite a curiosity.

He did not make as much money as he expected, however, but he persisted. Members of his family tried to deter him, calling his plan a foolhardy adventure, but Meeker, stubborn as always, would not be deterred. When he reached the eastern terminus of the trail at Independence, Missouri, he decided to continue his trip to New York and Washington, D.C., where he planned to petition Congress to establish a cross-country highway to memorialize the Oregon Trail.

President Theodore Roosevelt came out of the White House to meet the intrepid pioneer and see his ancient contraption. It caused quite a stir—just what Meeker liked.

Over the next 20 years, he crossed the country several more times in his quest to permanently mark the Oregon Trail. Once more, after the death of Eliza Jane in October 1909, he made another covered wagon trip, following that by train, automobile, and finally, when he was 94 years old, by airplane. He also appeared as a pioneer ox-team driver in the famed Buffalo Bill Wild West Show and took any opportunity he could find to seek publicity for himself and his work.

Meeker and some of his backers formed the Oregon Trail Memorial Association, with headquarters in New York City. He was the organization's first president. He also headed the Washington State Historical Society in its early days and was in charge of exhibits for the State of Washington at various expositions and fairs around the United States. He was, perhaps, better known nationally than he was in his own hometown.

In 1926, more than a decade after Meeker had sold his mansion to the ladies of the Grand Army of the Republic for a retirement home, the citizens of Puyallup decided to commission a statue of him and place it in Pioneer Park, the original site of his first cabin home in the Valley. They also planned to build a pergola to support the luxuriant ivy vine that Eliza Jane had planted at one corner of the cabin nearly 50 years earlier.

Meeker came back to Puyallup for the dedication ceremony. He was, at the age of 95, a short, stooped old man with long, flowing white hair and beard, but still full of ideas and still interested in publicity. He had just published his first and only novel, *Kate Mulhall, a Romance of the Oregon Trail*.

Two years later, Meeker was preparing for another cross-country trip. This time, Henry Ford was building a special automobile for the trip, but Meeker became ill in Detroit, and Ford sent him home to Seattle in his private railroad car. There, in his room at the Frye Hotel, he died on December 3, 1928. Shortly before Meeker's death, he whispered to his daughter Ella Meeker Templeton, "I can't go. I have not yet finished my work."

Meeker was eulogized in newspapers all over the country. His body was brought back to Puyallup in a procession from Seattle, with small airplanes showering flowers on the cortege along the way. After the procession paused at the statue in Pioneer Park, it continued on to Woodbine Cemetery, where his body was laid to rest beside Eliza Jane's. Their grave monument proclaims his trail-marking work and reads, "They came this way to win and hold the West."

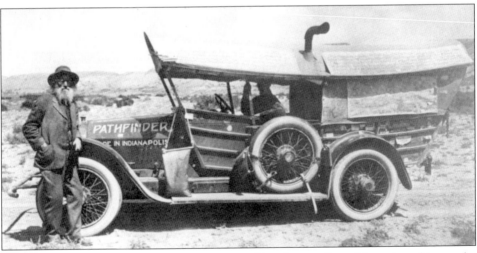

EZRA'S ADVENTURE. Ezra Meeker on one of his four trail-marking trips, this one by automobile. The vehicle was fitted out especially for his journey—possibly the first "camper" ever made—and was named the Pathfinder. (Courtesy Ezra Meeker Historical Society.)

11. THE FRUITS OF THEIR LABORS

Berry production increasingly fueled the area's economic engine in the early part of the century. The rich valley soil yielded from $1,000 to $1,500 per acre when planted in fresh fruits, including blackberries, raspberries, strawberries, loganberries, currants, cherries, blackcaps, gooseberries, apples, and crab apples. By 1913, more than 15,000 pickers, many of them women and children, filled the fields every summer, brimmed hats hiding warm faces, nimble fingers dropping ripe fruit into boxes or baskets.

By 1912, the Puyallup and Sumner Fruitgrowers' Association was touted as the largest cooperative association of fruit growers in the world with 1,300 members. Their cannery had preserved nearly 3 million pounds of fruits and vegetables bringing an income approaching a half million dollars.

That June, William H. Paulhamus, head of the association, announced, "For the information of the girls and women who desire to work in either one of the canneries, we . . . have decided to blow three blasts of the cannery whistle when they are wanted. . . . It is an invitation to you to put on your hat, roll up your apron in a newspaper and start to the cannery for work." Those who arrived first got the work and those not needed were turned away.

Paulhamus also teamed up with H.A. Baker of Denver to establish the first plant in the Northwest for cold-packing frozen fruits. Later, he established a cannery dedicated to producing quality berry jams and jellies, sold under the label "Paul's Jams." In 1920, Paul's Jams won honors at a pure food show in Brooklyn, New York.

Transportation difficulties frequently frustrated the Fruitgrowers Association. In season, if the rail cars were available, Chicago housewives could buy fresh Puyallup berries. Unfortunately, the railroad didn't always cooperate.

Not all of the local cultivated products could be eaten. Every year Charles Hood, who owned and ran a hardware store, among other business dealings, harvested a ton of English Holly clippings from the trees on Ezra Meeker's place and from 40 trees Hood owned. He shipped the prickly greenery to the East Coast in time for the Christmas holidays. One year Hood's holly decorated the White House, prompting a gracious thank you from President Calvin Coolidge.

Dairy farms and poultry farming also contributed to the Valley's economy. In November 1915, the Western Washington Experiment Station director invited Mr. and Mrs. George and Hermie Shoup from Whatcom County to take charge of the poultry

Refrigerated Berry Shipment.
C.J. Stuart, shown here, invented these
cold shipment containers for berries.
Packed fresh and chilled, the fresh
berries could be shipped as far as the
Midwest. (Courtesy Ezra Meeker
Historical Society.)

plant, a relatively small effort at the time. The Shoups introduced many new laborsaving devices and new ways of housing poultry. Long before others used artificial lighting, George advocated it for fall and winter months, a practice that greatly increased off-season egg production. For many years Puget Sound hens won regional and national awards for most eggs laid. Sadly, George died at 54 in a one-car rollover accident and Hermie retired not long after.

J.P. Rowley arrived from Canada in 1920 and took courses in poultry from the Experiment Station. Rowley established a unique laying house, which became the industry standard until mechanization arrived. Vast quantities of eggs ensued.

Berries and other agricultural products brought big bucks to the Valley, and increasing numbers of businesses sprang up in town to support the farmers and cannery workers. After Henry Ford's vehicles made their way west, Pierce County Auto Company was established in 1912 to sell his automobiles. From this and all of the other automobile retail companies that sprang up in the early 1900s came the legacy of Puyallup's claim to have the most and cheapest cars in the area.

The State initiated vehicle licensing in 1905, and city automobile permits arrived in 1914, but it wasn't until 1921 that individual driver's licenses became mandatory. By 1916, a Ford sedan cost $645, an affordable price for a machine that could be dangerous standing still. Many an owner could empathize with the local confectioner, whose crank on his Ford flew up and hit him in the ear, giving him a nasty cut.

In the early 1900s, roads and utilities received considerable attention. Periodic contracts were awarded to oil city streets to keep the dust down, at a cost of $82 per mile.

Controversy surrounding the regrading of South Hill used up columns of newsprint. The City required homeowners to bear some of the costs, which prompted a few to

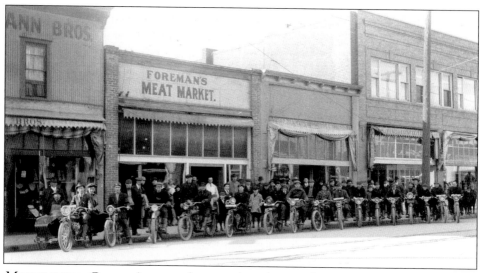

MOTORCYCLE GANG. A group of motorcycle enthusiasts lines up on Meridian in 1915. Debolt's Sporting Goods Company sold the motor bikes in the store next to Foreman's Meat Market. (Courtesy Ezra Meeker Historical Society.)

declare they would have to sell their homes. Those who favored the paving agreed with John King, who said, "The same people who protested would not have their old, muddy streets back again if you returned their money and 10 percent interest."

Wherever the street, early cars couldn't get much speed up in the city—only 12 miles per hour on business streets and 20 on others. For those without cars, public transportation remained a more viable option than was the case decades later.

With much fanfare, the Seattle-Tacoma Interurban Railway commenced electric rail service between Tacoma and Seattle on September 25, 1902. Highly polished wooden cars with varnished benches greeted the traveler who paid 60¢ one-way for the 100-minute service. In the cities, the line, powered by overhead wires, ran on tracks along streets. Most of the line, though, ran through private, fenced right-of-way powered by an electrified third rail.

The Tacoma Railway and Power Company operated what came to be called the Old Line, which entered Puyallup downhill near Maplewood Springs. The line then passed through Summit en route to Tacoma. When floods washed out the tracks, the Old Line had to be abandoned.

The Short Line, established by Puget Sound Electric Railway on December 12, 1908, ran on the Old Line tracks for a ways, diverging at the Puyallup junction at Eighth and A Streets. Once on its own rails, the Short Line passed through communities that no longer exist, such as Ardena and Berryton, terminating in Puyallup 9.94 miles out of Tacoma.

In the early years, the lines did a thriving freight business, carrying the farm produce of the Valley, freight from coal mines, brickyards, lumber, and the like. During World War I, the rails ferried soldiers to and from Camp Lewis. In 1919, the entire Puget Sound Electric Company hauled 3 million passengers. But weather caused many disruptions, and with

the advent of increasing numbers of personal automobiles and paved roads, usage plummeted. The Puyallup Short Line was abandoned in 1922, and five years later the company went bankrupt. On December 31, 1928, the last trains rolled between Seattle and Tacoma on the interurban lines.

In 1913, the Puget Sound Transit Company, newly established with six 40-horsepower buses, established a route along the hill road between Tacoma and Puyallup. Roundtrip fare on this long, if scenic route, cost 25¢.

Five electric companies merged power, light, and railway services in 1912 to form Puget Sound Traction, Light and Power Company. When this occurred, electricity rates went down to 10¢ per kilowatt-hour for the first 20 hours. Later the Puget Sound Power and Light Company emerged as the prime provider.

Homes and businesses were charged flat fees for water. Barbershops were charged $1 a month for the first two chairs; each additional chair cost 25¢. Bakeries paid $1.50 for up to four barrels of flour used; each additional barrel used accrued a cost of 50¢.

P.W. Milburn, George W. Woodbridge, and J.A. Colby incorporated the Puyallup Valley Home Telephone Company, which began operating an exchange with 200 subscribers on November 1, 1909. When the Sunset Telephone Company acquired the Home Company of Tacoma in 1912, an agreement was made to connect the Puyallup Home Company to Sunset at a cost of 5¢ for 3 minutes of service. Merchants and the city council constantly grumbled about pricing and complained that marathon talkers were delaying business transactions over the phone line.

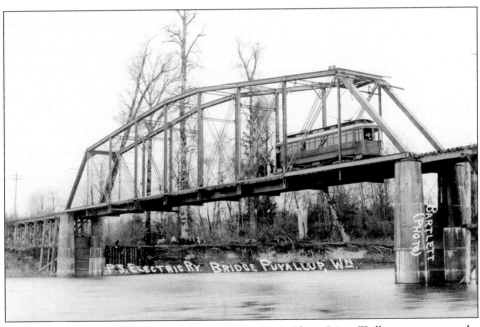

PUGET SOUND ELECTRIC RAILWAY BRIDGE. A Short Line Trolley appears on the Eleventh Street railway bridge crossing the Puyallup River. (Courtesy Ezra Meeker Historical Society.)

After a nasty flood in 1906, the legislature passed a law in 1913 whereby Pierce and King Counties could each create a fund to be known as the Inter-county River Improvement Fund. General taxes authorized $250,000 each year for six years with Pierce County's share at 40 percent. An upkeep fund of $50,000 per year was authorized for 99 years. The fund would prove its utility many times.

In 1912, in a bid to make things easier on the post office and the fire department, the Puyallup City Council decided to rename the streets by numbering them. Senior pioneer Ezra Meeker positively fumed—to him the old pioneer names were sacred. He pleaded his cause before the council, garnered support from the Pioneer Association and the Puyallup Women's Club, and persuaded the council to add the issue to the November election ballot.

Citizens voted 1,042-149 to restore the names Pioneer, Stewart, and Meeker, but the council refused to enact the will of the people. The street naming issue brewed for three years before the council in 1915 quietly revived these old names.

The city council budget for 1912 amounted to $35,580. Firemen extolled the virtues of the first motorized firetruck, which arrived that year. At a cost of $1,500, it achieved over 30 miles an hour on all straight stretches and "didn't skid at all on its first calls."

The next year tested the fire department's mettle. The Knight Livery & Transfer barn at Stewart and Second Street burned and damaged the Jacobs Building. Later that year the old Victor Hotel on Stewart Street succumbed. Subsequently, a more robust fire

PUYALLUP POST OFFICE. *This photo shows the post office when it was in the Arcade Building on Meeker Street. George Edgerton (right) served as the postmaster, and next to him is Alva B. Ammerman. (Courtesy Perkinson Collection.)*

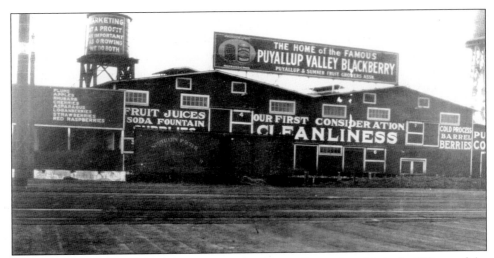

FRUITGROWERS' CANNERY. *The sign on the front indicates that this is the "Home of the Famous Puyallup Valley Blackberry." (Courtesy Ezra Meeker Historical Society.)*

department was created and the system revamped. A lumbering town replete with mills and a myriad of wooden structures virtually ensured the city's firemen would not go wanting for action.

Indeed, fires were popular events, prompting Mayor Dean to charge in 1916 that the practice of "every Tom, Dick and Harry jumping on the fire truck under the pretense of volunteering their services has to stop."

By 1914, in addition to the cannery, which employed an average of 200 persons, eight sawmills and woodworking plants in the area employed another 400. Many commercial businesses sought their share of the net earnings: two funeral parlors, Spurr & Osborne and Hill & Chase; Hood's Hardware; Perfield Hardware; Puyallup Ice Cream Co.; Valley Drug Store; People's Meat Market; the Pastime Club; Truedson Drug Co.; Puyallup Cash Market; Gerstmann Brothers Men's Furnishings; W.H. Elvins Department Store; Puyallup Furniture; Pihl Brothers Groceries; and two banks. At the Puyallup State Bank, in 1915, investors reaped 4 percent on savings accounts.

Puyallup merchants continually chastised residents for buying in Tacoma instead of making local purchases. An unnamed citizen summed up their concerns in the following poem:

> We love our home and city
> And love to sound its praise,
> We work for its culture and morals,
> In various and divers ways.
> But when it comes to our dollars,
> 'Tis sad, but it is so,
> We take them to Tacoma
> And help that city grow.

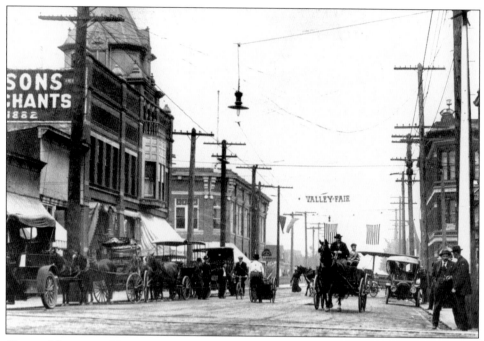

EVERY MODE OF TRANSPORTATION, C. 1915. Trains, pedestrians, hand-pushed street cleaners, bicyclists, horse-drawn conveyances, and horseless carriages converge on city streets. (Courtesy Washington State Historical Society, Tacoma.)

Ever attempting to lure more people to the productive valley, a reporter for the *Puyallup Valley Tribune* gushed, "Nowhere in America are there so large returns on the money invested in small fruits as in this Valley. And the future is absolutely secure. The industry is permanently established."

Acme Realty in 1915 offered a 120-acre valley ranch 2 miles from town with 35 acres cleared, a five-room house, barn, silo, outbuildings, orchard, running water, cows, sows, chickens, tools, machinery, and hay and grain. The asking price—$11,000 total.

After a hiatus of several years, the Board of Trade, established in 1892, reconvened in 1901 and changed its name to the Commercial Club. The club remained active in virtually every facet of life in the city, changing its name in 1927 to conform to the accepted national name, chamber of commerce.

Virtually from settlement, churches, clubs, and fraternal societies, some with local origins, others with ties to national bodies, convened somewhere in town. Given that many citizens worked long hours in agriculture, an impressive amount of time was given to social and cultural causes. In addition to churches, some of the organizations had their own meeting halls. The Masons, for example, laid the cornerstone for their brick home on South Hill in 1913—a property that would play a major role in Puyallup's future.

The late Police Court Judge Robert Campbell, who resided in Puyallup most of his 94 years, noted that until it really began to grow, Puyallup seemed more like a society than a town. "Because of all the things there were to bring people together, we knew nearly

everybody in town and people relied on each other, which made a big difference during the bad times," he said.

Folks may have gone to Tacoma to shop, but they had plenty of entertainment at home, in addition to the annual fair. On June 24, 1916, the first Puyallup Valley Day attracted 4,000. Although this festival did not occur with regularity until much later, the first celebration was in many ways a precursor to Meeker Days, which are still held each June.

The Opera House featured traveling companies, and Stahl's Music Store generated interest in a "Jass" band. Over the years several city bands and choral groups established themselves and then faded away.

Sports have always played a prominent role in Puyallup—beginning with the schools. In the spring of 1916, representatives from seven cities met in Tacoma and organized a Valley Baseball League. Later, the Commercial Club and city council squared off, donning crazy attire and playing by outrageous rules. After the game, a complaint was filed against the mayor for tearing up the scorecard of the game he and the council so soundly lost.

Moving pictures arrived at the Stewart Theater in 1916. A member of the Puyallup Choral Society promptly resigned after learning fellow singers had attended one of the shows. She announced that witnessing the film had disrupted the morals of the rest of the choir.

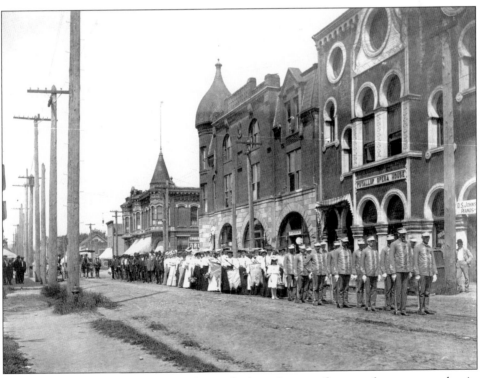

PARADE OF UNKNOWN ORIGIN. A smartly dressed group of men and women marches in front of Puyallup's ornate Opera House sometime in the late 1890s. (Courtesy Beta Club Collection.)

PUYALLUP WOMEN'S CLUB, 1919. The women of this formidable club appear in "Follies of Fashion" in this photograph. (Courtesy Beta Club Collection.)

Registration for the primary election in November 1912 stood at 1,733. A full 50 percent of the eligible voters were of the "gentler sex," who had gained the right to vote in Washington State in 1910, ten years before the Nineteenth Amendment to the U.S. Constitution granted women's suffrage.

In Puyallup women ran hotels, owned millinery shops, served in the medical profession, and taught in the schools. The Puyallup Women's Club, founded in 1909, helped form the first parent-teacher circles, precursor to the Parent-Teacher Associations, and supported building a library. Members originated and managed a baby show at the annual fair, helped raise funds for a bronze plaque placed in Pioneer Park commemorating Eliza Jane Meeker, and worked to establish the first Young Women's Christian Association (YWCA).

In May 1912, the 200 members of the Puyallup Women's Club declared their intent to the city council to locate and furnish a downtown restroom. A headline in the *Puyallup Valley Tribune* of May 25, 1912, reads, "Can't Sit Down in Puyallup." The article reported that the women wanted a restroom and were going to have it right away "so they say." A week later, the paper reported that the restroom, located next to the library, was ready.

The Women's Christian Temperance Union (WCTU), which was organized to halt the production and sale of alcoholic beverages, gained an early foothold in Puyallup. Local women attended national conventions, established regular meetings in town, and lobbied for liquor control laws. In 1917, residents voted for prohibition as did the state and nation,

thus establishing the Eighteenth Amendment to the Constitution. The margin in Puyallup was low, as was turnout; many residents didn't want to give up their legal spirits.

Women did have an argument against alcohol's impact on marriages. While the Valley had a lot going for it, marital bliss apparently wasn't among its attributes. By 1915, the reported divorce rate was 22 percent of marriages. One marriage that had survived was that of Dr. and Mrs. J.H. McDonald, who had come to Puyallup in 1900. Dr. McDonald served as a surgeon at the Old Soldiers' Home and his wife had a famous grandfather—Confederate General Robert E. Lee. When the dry law entered into effect, sweethearts could meet at Valley Drug, whose proprietors, Harry Bader and Streeter Beall, installed a sparkling new soda fountain in their store on Meridian.

As early as the 1860s, Eliza Jane Meeker kept a reading room in their cabin for local bookworms. Later the accumulated books and periodicals were moved to the Unitarian Church that Ezra helped to build on the corner of Second Street and Pioneer (now Peace Lutheran Church).

By 1909, private citizens had raised enough funds to establish a real library in a room of the Stevenson Building on Pioneer Avenue. Miss Francis McCoy, the first librarian, reported that 1,700 patrons had used the small collection the first year. With a budget of $800, there wasn't much opportunity to buy new books, so the Commercial Club and the Puyallup Women's Club established rental bookshelves that paid for themselves.

In February 1912, the city council approached East Coast steel magnate Andrew Carnegie, who was financing libraries all over the United States. Thinking the more money the City appropriated the better the chances for a Carnegie gift, the City offered

CARNEGIE LIBRARY. The 1912 rosy brick building faced east on Meridian in Pioneer Park. This photo dates from the early 1940s. When a new library was built in 1962, the building was unfortunately razed. (Courtesy Perkinson Collection.)

83

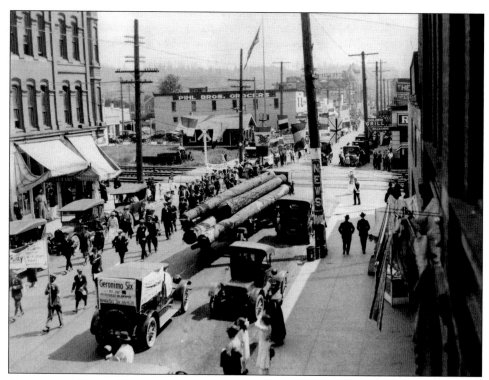

PARADE TO RAISE MONEY FOR CHAUTAUQUA. Summer educational and entertainment events were held from 1914 to 1921. This parade appears to be going both directions on Meridian. (Courtesy Beta Club Collection.)

$3,500 for its share and future maintenance. They didn't know that Carnegie's agreement with towns was to provide $10 for every $1 the City appropriated. Back came Carnegie's response that he would build a $12,500 library if the City approved only $1,250. The council quickly authorized the lower sum.

The stately two-story building constructed of rosy brick and cement was dedicated on February 13, 1913. The library graced Pioneer Park, facing east on the west side of Meridian Street. For many years its upstairs served as the library, while the first floor held an auditorium, small kitchen, and storage area. Later, the downstairs would become a surrogate city hall, but that's getting ahead of the story.

From its inception in 1874 as a religious training ground, the Chautauqua movement became a nationwide educational and recreational series of events. Puyallup's Chautauqua events began on July 25, 1914, when the first of a seven-year run was launched. Organizers erected a mammoth tent in Pioneer Park, and townspeople thronged to the various sacred and secular musical and dramatic productions.

One of the most memorable events of the pre-war years occurred in July 1915 when the Liberty Bell came to town. This iron gray symbol of freedom normally resides in Independence Hall in Philadelphia, but on eight separate occasions the bell was placed on a specially configured rail flatcar, and transported to various parts of the country.

On its eighth and last journey, the bell left Philadelphia bound for San Francisco, via Seattle, for the Panama-Pacific International Exposition. When the city council learned the train would stop in Auburn, Mayor Dean and other dignitaries drove up to board the train and accompany the bell to Puyallup. On the appointed day, hundreds of citizens milled about the downtown station, eager for the train to arrive for its 5-minute stop.

At last the precious cargo came in sight. The mayor and his entourage jumped down, and the ladies of the Grand Army of the Republic draped the American flag around the bell in commemoration of men who had died defending America. The cannery and other businesses rang their bells in commemoration, and a delegation from Philadelphia distributed literature.

When the first Liberty Bell pealed out independence 139 years before, not only Puyallup, but the entire western part of the country had been unknown territory. Now Puyallup was fast becoming a respectable town. The downtown retail area and growing residential sections testified to a robust economy, and a citizenry intent on putting their city on the map. Given the number of small towns in the West that hadn't succeeded, Puyallup was doing quite nicely. With 8 miles of paved streets, concrete sidewalks, a Carnegie Free Public Library, annual fair, and the Chautauqua, Puyallup had arrived, in time to participate in World War I.

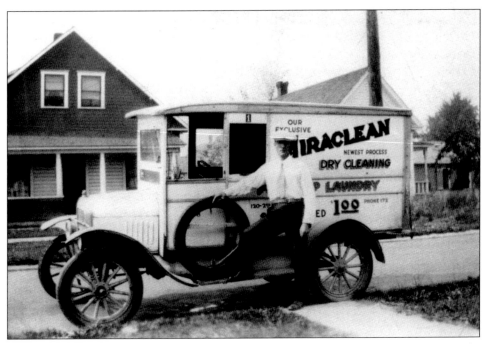

PUYALLUP LAUNDRY TRUCK. This was one of the services available in 1916. Note the three-digit phone number on the side of the truck. (Courtesy Ezra Meeker Historical Society.)

12. From Berry Fields to Flanders Fields

In January 1917, voters in Puyallup joined others in the county to authorize $2 million in bonds for the Army post that would become Camp Lewis. In February, a movement began to organize a local militia company under the authority of the Washington National Guard.

By April, flags and bunting were flying from many buildings. Farmers were urged to "plow now and raise crops that will keep." The City made vacant lots available for cultivation, and no charge was made for watering the crops.

Puyallup initially operated its own draft board. Several officer candidates went off to schooling, and by the end of June, 289 young men had registered for service, but many more had already enlisted. Roy Seitsinger hadn't waited for the draft. Before the United States was involved, he volunteered with the Canadian forces and was gassed at the Front. After recovering, he returned to the battle lines only to become Puyallup's first war casualty in November 1917. Unfortunately, he wouldn't be the last to die.

When William Paulhamus was elected president of the state canneries, he informed the National Council of Defense that every cannery in the state was at its disposal. His patriotism paid off when the U.S. government placed the largest order for jam ever received by the Puyallup-Sumner Association. Earl Chapman May in his book *The Canning Clan* described Paulhamus as "Blue-eyed, bullet-headed, kindly but positive, stocky and aggressive." On more than one occasion that aggressiveness paid dividends, not only for Paulhamus, but for the community as well.

Puyallup Valley Tribune editor Robert Montgomery published a letter from a local soldier serving in France, who wrote, "When I first entered the messhall of the camp where I am now located, hundreds of cans of Puyallup blackberries were the first things I noticed on the tables." He must have enjoyed telling his fellow soldiers how to pronounce the town's name.

The Citizens State Bank lent two rooms for the Red Cross, the Puyallup Furniture Company donated the use of two sewing machines, and the library board loaned 50 chairs. From this site, women from various churches kept the machines humming, stitching needed items for the military. Merchants occasionally donated a day's profits. Over the course of the war, residents more than met their Liberty Bond subscription; the names of individuals and businesses that contributed were listed in the newspaper.

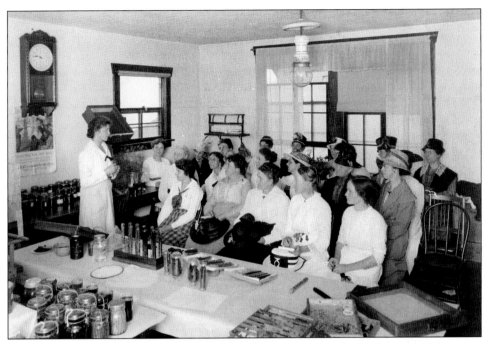

HOME FOOD DRYING DEMONSTRATION. *Inez Armstrong, home demonstration agent, explains to a rapt audience how to preserve fruits and vegetables. A poster on the wall reads, "Food will win the war . . . waste nothing." (Courtesy Beta Club Collection.)*

In addition to the war's impact, in December 1917, Puyallup experienced its worst flood in many years. All communication and transportation between the town and the outside were cut off for two days. Most threatening, the rivers carried masses of logs and debris that began piling up against all the bridge supports. Men with dynamite at the ready carefully guarded the Sumner-Puyallup Bridge all one night. Had they used the dynamite on the logjams, one observer noted, the bridge might have gone too, but thankfully their good intentions weren't tested. A great deal of property was lost in the worst flood since inter-county improvements had been in work.

After a year of U.S. active participation in the war, the Council of Defense decided that Puyallup needed a "liberty hall." Local mills provided free lumber, and millworkers and carpenters donated their time to complete Victory Hall on Labor Day Weekend, 1918. A local German-American resident donated a flag, which marked the building's location on Meridian near the railroad tracks. Perhaps to entice visitors inside, a bulletin board listed the names of citizens who made no effort to help in patriotic campaigns. Today, this building used by various civic organizations stands in a small park on the former tennis court owned by Robert Montgomery.

Spanish influenza raged around the world during and immediately after the war. Puyallup at first experienced few cases, but as a precaution, schools, churches, and theaters were closed for a time. Later, the flu came with a vengeance, taking the lives of many, including five members of the S.P. George family.

In November 1918, Paulhamus received a long-awaited telephone call with the cheering news that the Allies had won the war. He immediately activated the cannery whistle, which was quickly followed by every other whistle and bell in town. Kids soon assembled a parade, and the German kaiser was hung in effigy. Pedestrians with flags, bells, trumpets, and horns formed a long serpentine. Millworkers pounded wooden mallets on large logs, creating great booming sounds. Automobile owners located their noisiest horn or bell and fell in line. That evening a large bonfire was lit, the signal for all the celebrants to gather at Victory Hall.

As they had during the depression of the 1890s, citizens rallied together to survive the war years. Farmers planted wherever bare ground permitted, women accrued calluses from knitting, and everyone sacrificed to meet the nation's demands. There is no record of how many Puyallup men fought in World War I. At least nine paid the ultimate price, never to return to the Valley's berry fields. Rather, they lie buried in battlefields such as Flanders Field in Belgium. Canadian military Doctor John McRae's famous poem "In Flanders Fields" poignantly memorialized these early warriors of the bloody twentieth century.

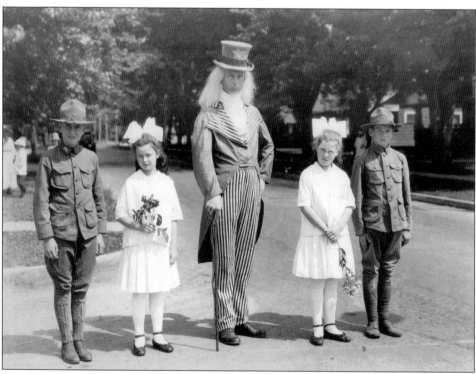

PATRIOTIC QUINTET. *Uncle Sam, personified by Jim Perfield, led his daughters and two of their friends in a World War I parade. (Courtesy Beta Club Collection.)*

13. PROSPERITY TO POVERTY

The war set in motion an economic boom in the area. Many young men who had learned of the money to be made in the lumbering, maritime, and agricultural industries relocated to the Valley. The 1920 census counted 6,323 residents—a 39 percent increase over 1910. Real estate prices reflected the pressure on housing. In 1919, a nine-room house at 417 Second Avenue, sitting on two lots, sold for $3,000, a princely sum for those days. The more elegant home of Frank Griffin of Cooper's Studio at Sixth Street and Fifth Avenue cost $11,000.

As the city grew, so grew the government, which had no dedicated space to call its own. After examining the coffers, the city council decided to purchase and renovate the Opera House on Meridian. Traveling shows were becoming passé, and the facility was still in reasonable condition. In May 1919, construction workers created their own music, transforming the old edifice into a city hall, fire hall, and civic center. Dr. Henry Suzallo, president of the University of Washington, dedicated the remodeled building, proclaiming, "If every community in the United States were in the robust condition of the Puyallup valley, the whole country would be in a splendid condition."

Occupants planned that the space would be their home for the next 25 years. In fact, it would take another 34 years, an earthquake, and many arguments before a brand-new building would appear.

In early September 1920, fire wiped out the Brew Manufacturing Company's plant and a half dozen homes near the heart of Puyallup. In the aftermath of the fire, a bond was passed to add more fire equipment. The new firetruck arrived in 1921, and the part-time fire chief declared that the city would now have real protection. Unfortunately, the rig didn't save the Sundown Lumber Company, which built a mill on East Pioneer Avenue at Meeker Junction in 1919. For five years Sundown manufactured crates and veneer, employing about 50 people, until the mill burned to the ground in November 1924.

The Brew Plant was rebuilt north of Puyallup along the river. By 1925, it was manufacturing all of the Sears and Roebuck Company beehives that were sold west of the Mississippi River as well as a large quantity of the fruit baskets and veneer products for the Northwest.

Initially after the war, the market for fruit products plummeted, due to the curtailment of government contracts and a worldwide shortage of sugar. In August 1922, the Pacific Northwest Canning Company (PNCC) bought the Puyallup and Sumner Fruitgrowers'

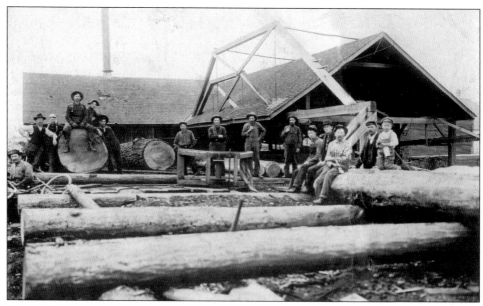

Paul Bunyan Days. Lumberjacks and laborers wrestle huge logs at the Brew Manufacturing Company mill. The Brew operation ranged from felling the trees to converting logs to lumber. (Courtesy Beta Club Collection.)

Association at public auction for $270,000. Two years later, Hunt Brothers purchased the canning plants. In the process, Paulhamus lost most of the fortune he had accumulated during the war.

However, England began buying barreled berries for jam, and to meet demands, the Puyallup Packing Company and the Sunshine Plant Cannery opened to pack strawberries and fruit. By 1924, thousands of pounds of berries were headed for jam makers in England.

Daffodils grow well in most kinds of soil and it is safe to presume that some had made their way west in covered wagons to be planted in front of small cabins as a reminder of gardens left behind. But pioneer farmers needed to eat and to raise cash crops, so their early efforts went to vegetables and hops. Around 1910, George Lawler planted some daffodils on the site of what is now the Poodle Dog Restaurant in Fife. That spring he hosted buggies of visitors, who ventured out of the towns to see the field of bright yellow blossoms, stopping to buy the cut flowers to take home.

The next year Lawler planted 9,000 bulbs on that site and eventually increased his plantings with 15 acres of beds in north Puyallup. In 1924, Lawler planted 2 million bulbs on his farm in north Puyallup, confined to two varieties. From his site he sold only bulbs, not cut flowers, but his success wasn't lost on fellow farmers.

Lawler eventually became a wealthy man, selling bulbs to California and Midwest flower brokers. The Fortune daffodil, which he purchased in England for $75 per thousand, was early and pretty. Along with King Alfred, it became a mainstay of the bulb industry in the Valley.

While Lawler gets the credit for starting the bulb-growing business in the greater area, a much smaller but more colorful garden in Puyallup achieved fame virtually as soon as it was planted in 1916. O. Max Pudor emigrated from Germany as a youth, eventually starting a nursery business in Puyallup. The 6-acre garden and home were located on West Stewart. Pudor at first grew berries and fruit, but soon planted irises and delphiniums with a few other flowers.

Reportedly, Luther Burbank, the famous American horticulturist, saw a white delphinium that Pudor had hybridized and declared it a "rare find." Pudor's roots and seeds made their way to gardeners throughout the United States, England, and other countries. At 82, the master flower gardener died from injuries received when a young woman struck him with her automobile while he was mowing his parking strip. The garden subsequently succumbed to neglect and is since lost to all but memory.

In addition to the Lawler and Pudor success stories, representatives of the U.S. Department of Agriculture (USDA) advised local farmers that the Puyallup Valley offered ideal conditions for growing bulbs. Daffodils love a wet spring and local farmers were very familiar with their muddy spring fields. At the time, most bulbs were being imported from Holland, some at very high prices, and some with unwanted pests. Hence, the USDA clamped an embargo on the Dutch bulbs, which enticed farmers to grow them here.

Ever the man on the lookout to create opportunities for increasing the marketability of the Valley's rich land, William Paulhamus gathered a group of farmers together in 1924 and encouraged them to think about planting narcissus bulbs. Having lost their hop crops, several farmers brokered in. Brothers Charles and Ed Orton, Frank Chervenka, Hamilton Gronen, and L. Hatch all planted various varieties of bulbs that fall. All of the bulbs, strong and healthy from their new soil, sold for good prices and another new industry was born.

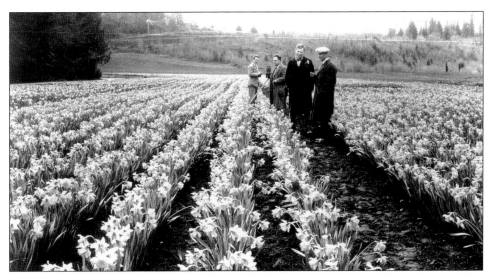

BULB INDUSTRY BLOSSOMS. Hamilton Gronen, second from the right, and other bulb growers, examine the results of their efforts, c. 1930. By this time, 150 acres—over 11 million bulbs—had been planted in the Puyallup Valley. (Courtesy Kay Gronen.)

In 1926, the farmers formed the Puyallup Valley Bulb Exchange to market their bulbs more efficiently. By 1927, the Valley was producing 23 million bulbs and by 1929, 60 million. Of all the varieties planted, King Alfred, a hearty, full-flowering variety, seemed to be the favorite.

Hamilton Gronen, an engineer who had shepherded the flood control project along the Puyallup River, served as manager of the Puget Sound Bulb Exchange from 1932 to 1946. During several of those years, he was president of the American Bulb Growers Association, spending considerable time in New York City.

Simon Van Lierop, a noted bulb grower in Holland, arrived in the Valley to advise the budding bulb farmers on all matters related to growing healthy daffodils. In 1934, he sent for his fiancée, and after marriage, they settled on a farm that today is one of the last bulb farms left in the Valley.

Valley products grew even more diverse when Fred Gable and his family arrived from Tennessee. They named their acreage Fox Acres and began raising Daltan and Tuplin strains of silver fox. A pair of silver foxes carried a value of $1,000-$1,500; offspring pelts could fetch $150-$300 each.

The year 1923 ushered in the greatest building boom since the town was incorporated. Nearly a million dollars of construction projects were on the drawing boards. On the residential market, 75 homes were under construction. Residents were proud that most buildings were constructed of materials produced in Puyallup.

The Pioneer Public Market started up in February 1923 offering a grocery, butcher shop, fish market, fruit and vegetable shop, and a confectionery. The Tribune Building at

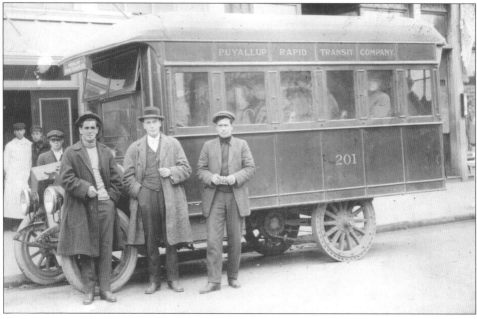

RAPID TRANSIT BUS. *The Puyallup Rapid Transit Company carried passengers to Tacoma in a little less than an hour on this bus, c. 1915. (Courtesy Ezra Meeker Historical Society.)*

FLAGS WAVE. This view, looking south from Stewart Avenue, captures Meridian Street during World War I (Courtesy Washington State Historical Society, Tacoma.)

the corner of Meridian and Meeker was readied for Scott's Drug Store and Johnson Jewelers. F.H. Hoff Shoes on Meridian offered a sale on shoes under the catchy phrase, "Hoof it to Hoff's." A Piggly Wiggly grocery store started up in the Nix Building at 213 Meridian.

Elks Club members selected a site on Meridian Northwest between Fourth and Fifth Avenues for their new home. This once elegant facility has been the scene of many a banquet and reception. The graceful Liberty Theater, built by D. Constanti for $55,000 in 1924, has likewise earned its place in the city over the years.

The Meeker Mansion appeared in radiant glory in May 1924 as the Empress of China tree, planted some 30 years before, fully exploded in bright blue blossoms for the first time. Telephone poles were moved from Meridian to improve the look of the street, and ornamental street lamps were installed throughout the business district. Beautified Puyallup was aglow by day and night.

J.H. Pohlman purchased the Pihl Building on the corner of Meridian and Main in 1925 and opened a variety store. With its red front, large window space, good lighting, and wide aisles, Pohlman's considerably enhanced the appeal of shopping in the small town. That year, the Sunbeam Mining and Reduction Company came to town. The company manufactured metallic paints and paint pigments, one of the first chemical plants in the area.

Well-known contractor William Blackadde constructed the multi-story Knight-Montgomery Building on Meridian in 1927. Fourteen suites occupied the facility, including Dickey and Hoyt Insurance, Pacific Savings and Loan, Real Estate Exchange, Mirror Barber Shop, Puyallup Hemstitching Parlors, Helen Hat Shop, Thwing Music shop, a drugstore, and assorted professional offices.

PUGET SOUND POWER AND LIGHT CO., 1929. The billboard behind this fleet of service vans urges rural residents to use electrical power. The company sent servicemen into homes to hook up electrical appliances. (Courtesy Perkinson Collection.)

When the Pacific Telephone and Telegraph Company bought the Puyallup Valley Home Company, the new managers increased the number of trunk lines between Puyallup and Tacoma. The year 1926 commenced with the good news that the new switchboard, located in the post office on West Pioneer, would take 400 calls an hour versus 200 in the old system.

In the mid-1920s, the State and County constructed the concrete bridge over the Puyallup River on Meridian. At the time it was the largest single structure built by the State. However, to the considerable consternation of residents, the sturdy span stood virtually unused for many months as the Puyallup City Council wrangled over paving the approaches. In the end, both the city and adjacent property owners coughed up the $1,500 needed to open the city to north-south traffic, using this narrow bridge still crossed daily by thousands of commuters.

On May 9, 1927, two bad fires wiped out the Patterson Mill garage, dry sheds, office, and blacksmith shop, and gutted the high school. The Pioneer Puyallup Lumber Mill went up in flames in June 1929 about the time a Seattle conservationist began urging the State to protect forest reserves. He reported that one-third of the original Douglas fir had been depleted.

A private holding company comprised of local citizens had purchased 10 acres of land in 1895 and established Woodbine Cemetery. In 1929, the company sold the cemetery to the City, noting that 10,000 more graves could be placed in it with improvements. With the rate of growth, the gravesites would be needed.

Among the many businesses operating in 1929 were Hill's Funeral Home, W.P. Fuller Paint Company, Puyallup Auto Wrecking, Puyallup Floral Company, Puyallup State Bank, Mueller & Harkins Motor Company (selling Buicks), E. Luger Company (selling musical instruments), Engh's Meat Market, Puyallup Steel and Welding Works, New Lotus Café, Kem's Super Service Station, and Valley Feed Company.

Booming Puyallup did attract a less noble businessman as well. A man called C. Cross arrived in town and announced he was establishing an auto-polish factory. Later described as silver-haired and dignified, Mr. Cross opened a checking account and procured numerous supplies on credit—typewriters, sewing machines, even a Nash car on trade in with a rebate. With a tongue to match his hair, he persuaded several future salesmen to deposit $150 each to sell for him. All told, C. Cross picked Puyallup's pockets to the tune of $3,500 before he vanished with the take. It turned out that he was wanted throughout the state and as far away as Denver for similar swindles. A reporter for the *Puyallup Valley Tribune* noted that when asked about the nature of the auto polish, Cross had replied, "There's nothing like it in the country." He was right, the reporter sheepishly admitted, there was nothing like it.

Initially the 1929 stockmarket crash had little impact on local businesses or their customers. But on Christmas Eve, 1929, 50–mile-an-hour winds whipped through Puyallup's streets. As it turned out it was an ill wind that blew no favors from the east.

The 1930 census recorded 7,085 residents in Puyallup, a gain of 12 percent over the 10-year period. Unfortunately, many of the newcomers as well as the old timers found themselves jobless as the Depression that raged across the nation slowly settled on the Valley. But Puyallup had a long tradition of caring for its own; clubs and churches soon started charity drives.

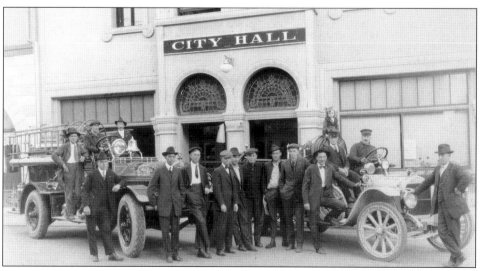

Fire Department, 1920s. The engine on the left was a 1926 Seagraves that was used for many years. In 1934 the city hired a full-time fire chief and bought a more powerful Ford V-8 truck. (Courtesy Beta Club Collection.)

The American Legion launched a campaign to persuade employers and employees throughout the town to contribute at least one day's wages per month for two months toward a relief fund. Within a few months over $1,300 had been collected and paid to 177 men for various projects, ranging from school grounds maintenance to the clearing of additional land for Woodbine Cemetery.

The Active Club began holding "smokers" at the Liberty Theater featuring boxing and wrestling bouts. Students, amateurs, or semi-pros, some from Fort Lewis, danced and punched in front of crowds, teary-eyed from cigar smoke. (In 1927, Camp Lewis became Fort Lewis.) The proceeds of these popular events went into a milk fund for undernourished children. This boxing and wrestling activity went on for many years, sometimes at the Liberty, sometimes at Puyallup High School, providing milk for countless children at no expense to taxpayers.

Perhaps because the present and future appeared bleak, three efforts to honor the past occurred in the midst of the Depression years. In commemoration of the bicentennial of the birth of George Washington, Mrs. Hamilton Gronen spearheaded a program to plant linden trees between Puyallup and Sumner. Lovely lindens still line this stretch of road.

To honor Eliza Meeker and other pioneer women, the Pioneer Association dedicated a bronze plaque in their honor in Pioneer Park. The Ladies of the Grand Army of the Republic (GAR) monument was unveiled at Woodbine Cemetery; the three remaining members of the GAR in town were honored on the occasion.

The Arts and Krafts Club remained true to its purpose to study and learn about art, music, and literature. This group discussed hot topics, such as "Will the Fascism of Italy confer greater benefits on its citizens than does the democracy of Great Britain?"

On August 29, 1933, citizens of Puyallup voted with the nation to repeal the liquor prohibition. In town the vote was 3 to 2 to repeal; in outlying areas an overwhelming margin of 7 to 1 was recorded. Perhaps it was bouncing around on all those unimproved roads that drove people to drink. It took several years for the road from Graham to

LUMBER MILLS. W.C. Stevenson built the Evergreen Lumber Company on Fifth Street Northwest in 1907. The large building in the background is Puyallup High School. The Morse and Brew mill was located across the railroad tracks on Stewart Avenue Northwest. (Courtesy Beta Club Collection.)

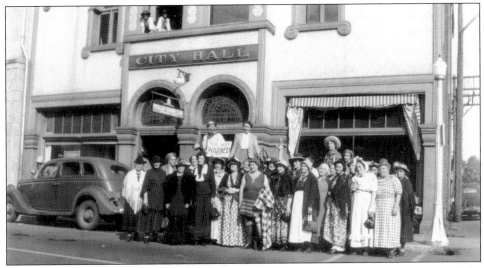

MEEKER DAYS. This may have been the first Meeker Days celebration in 1938. The armored police car can be seen to the left. (Courtesy Beta Club Collection.)

Puyallup to be paved, but only one-way. After all, farmers needed to get the eggs to market unbroken. Who cared what they endured on the way home?

The year 1933 marked the first time Puyallup went on Daylight Savings Time (DST) as a city. For years the decision to go on DST was left to local jurisdictions, which caused considerable confusion.

As if the economy weren't enough of a problem, December 1933 brought natural disaster to the area. A worse flood than the one of 1917 caused considerable damage to roads and farms. Roiling waters completely washed away the bridge at McMillan. By referendum in 1935, the overwhelming majority of residents approved establishment of a flood control district as protection against the wild winter rushes of the Puyallup, White, and Carbon Rivers. Citizens also approved the construction of the Mud Mountain Dam to help with flood control.

In his last action of 1933, Mayor Floyd Chase appointed the first full-time police chief. This lowered theft insurance rates and moved Puyallup up to a fifth-class town. Two years later the city was "shaken to its foundations." A robber held up the bank in Orting on July 15, 1935, then gunned down Puyallup Police Chief Frank Chadwick and Officer Harry Storem on a road near Sumner. The gunman sped away and townspeople were again sorely grieved to lose their top policeman as well as an officer.

In a bid to provide more protection for police officers, a 1935 Ford Sedan was outfitted with bulletproof glass, two gun ports in the windshield, and ports on the side windows. Heavy boilerplate, topped by an inch of wood, covered the vehicle. Armed with good intentions and a bulletproof car, the police had only two problems: the car was so heavy that it wouldn't go faster than 50 miles per hour, and the abysmally low gas mileage blew a hole in the police budget. In due course, the car was scrapped for a faster, more efficient model.

OLYMPIAN GERTRUDE WILHELMSEN AND THEO LAST STAR. In 1936 at the age of 23, married and a mother, Wilhelmsen made the American Olympic team in javelin and discus. Here in Montana, she gets pointers on throwing the javelin from Native American Theo Last Star. At the Berlin games, where athletes were given no time to warm up, she did not win medals, but placed higher than any other American. (Courtesy Jean [Wilhelmsen] Glaser.)

It took five years for justice to be served in the killing that had rocked the city. Roy Willard Jacobs, 40, of Tukwila went to his death on the gallows at the state prison in Walla Walla, on April 6, 1940.

In July 1934, the City had hired its first full-time fire chief, A.J. McCarthy from Auburn. For several years the town had had only one large fire engine. The decision had been made not to let it go out on rural runs for fear it would experience some problem that would leave the town vulnerable.

It took a few years for Chief McCarthy to rectify this situation. In 1936, the Fire Department acquired a new $3,200 Ford V-8 fire engine. However, the new truck couldn't control a night blaze in late November that again destroyed Brew's Mill in town. The fire covered two blocks and the heat broke windows in Hunt Brothers' Cannery across the railroad tracks.

That same year, River Road, linking Tacoma and Puyallup was completed and dedicated by Governor Clarence Martin. This provided a much-needed fast link to the Port of Tacoma. Another link to Tacoma was reached on September 26, 1941, when Seventy-second Street was joined to Pioneer West. Downtown, diagonal parking on Main Street and Meridian Avenue ended. Henceforth, drivers would park parallel.

The first permanent U.S. post office, erected on Second Street, was dedicated on January 28, 1936. George Edgerton, originally selected as postmaster in 1904, held the

position all but a few years and had moved the post office facility four times. Edgerton was a well-respected community activist who served as director of Citizens State Bank and in various other capacities.

Another citizen gained fame in 1936. Puyallup High School graduate Gertrude Wilhelmsen competed in javelin and discus at the fateful Berlin Olympics. She was very popular, for she was the only member on the U.S. team who spoke German.

Times remained very tough throughout the Depression years, but by the mid-thirties, Citizens State Bank gained authority from the National Housing Act to make mortgage money available under its terms. Bank president J. Jones reported that business activity was up about 15 percent. "With a $200,000 increase in Puyallup bank deposits in a year's time, the pendulum is swinging back to slow, steady recovery," Jones said.

The dwindling number of families on relief bore Jones out. President Franklin D. Roosevelt's Works Progress Administration (WPA) was responsible for much of the employment. Good use was made of the men receiving pay for city projects. Private investment in the town soon followed. In 1938, Harold Wilen founded a company selling Pontiacs and Buicks. It changed its name to Cornforth-Campbell Motors in 1993.

Unions began arriving in the Valley in the mid-1930s. Local union employees of the Spruce Mill were the first to affiliate with the American Federation of Labor (AFL), receiving a charter as the Box Shook and Veneer Workers' Union, local No. 2605. The next year, the AFL granted a chapter to the cannery workers, following which Hunt

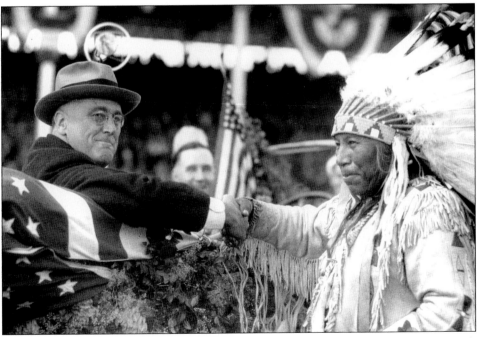

ROOSEVELT VISITS FAIR. *In 1932, presidential candidate Governor Franklin D. Roosevelt of New York visited the Puyallup Fair. He is seen here shaking the hand of a Native American chief in ceremonial dress. (Courtesy McCutcheon's Studio, Puyallup.)*

Brothers Packing endured a two-day strike. At the end of the walkout, the company announced that women's salaries would rise from 30¢ to 32.5¢ an hour and men's from 40¢ to 42.5¢.

As the town filled up, real estate prices soared and land became more valuable. The City acquired 80 acres on South Hill and dedicated Wildwood Park there in June 1938. Puyallup's Days of Ezra Meeker celebration began in 1938. The next year attendees celebrated the Washington State Golden Jubilee. In 1940, residents celebrated Puyallup's 50th anniversary as an incorporated city.

The mild earthquake that struck near midnight on Sunday, November 12, 1939, seemed anticlimactic after heated political exchanges of the previous few months. The quake did cause some minor damage—windows broken, plaster dropped from buildings, and the like. Ten years later its successor would bring large buildings down.

In May 1940, the State established automobile test facilities. Each car was tested twice a year at a station at East Main and Linden Drive. The Sumner and Puyallup Blue-Gray bus lines merged that year to offer 42 round-trips to Tacoma daily. In August, the new bus terminal at East Stewart and Second Street opened, incorporating a bright soda fountain and service station.

As a reflection of the difficult times, the 1940 census reported an increase of less than 1,000 over the decade. In the city limits, 7,937 were counted with 12,023 throughout the area. The decade witnessed the slowest growth rate in Puyallup's history.

GOLDEN JUBILEE. In 1939, Washington celebrated its golden jubilee with the help of German brothers Karl and Fritz Gerstmann, shown wearing period hats for the occasion. The Gerstmanns operated their men's store from 1911 to 1987. (Courtesy Ezra Meeker Historical Society.)

14. Waging War Near and Far

When Europe had again been at war for a few months, its impact began to be felt in the Valley. Previously profitable exports of fruits and fruit products to England practically ceased by April 1940. Many portage companies sold their ships to belligerent countries in Europe, leaving little transport capacity left for the few markets that could be found.

Nevertheless, the Depression and its aftermath soon faded into history as the nation geared up for war. The Valley had weathered the worst years well, but reliance on agriculture would inevitably end. Acreage in berries was land unavailable for housing for industrial workers.

In September 1940, when the U.S. Congress instituted the draft, the U.S. Army formed the 103rd Anti-Tank Battalion under the auspices of the National Guard. Lieutenant Phil Dickey assumed command, and 35 men promptly signed up from Puyallup and Sumner.

Actual draft registration began on Wednesday, October 16, 1940. At the first gathering in Puyallup, 922 young men registered, a number less than anticipated. Recruiting offices sprang up rapidly in town. The U.S. Navy and U.S. Marines seemed to press harder for draftees than did the U.S. Army, perhaps because the local boys could see the Army in action at Fort Lewis.

In 1942, the draft board began posting evaders' names, and newspaper editors listed them in their papers. The FBI helped track down the dodgers.

When the U.S. government required aliens to register at the post office, more than 250 did so, the largest numbers being Japanese and Canadian. Failure to register brought a fine of $1,000 and a jail term of six months; it paid to comply.

Virtually overnight unemployment plummeted as young men signed up or were drafted for military duty, some to be called away, while others constituted local units. In November 1940, The Boeing Company (referred to locally as Boeings) announced that 7,500 additional workers would be needed to meet government contracts.

The Boeing recruitment and increasing numbers of shipyard workers permanently altered the labor scene in Puget Sound. You couldn't keep anybody down on the farm when real salaries were to be found nearby.

A nationwide drive for aluminum began in the summer of 1941. Boy Scouts canvassed the entire city house-to-house, asking housewives for old cooking wares and whatever else they could spare. Paper was recycled for gypsum board for housing, and food containers and cardboard, for shipping war materials.

Dr. Charles H. Aylen perhaps got a little carried away with the scrap drive. He had "appropriated" a British helmet, French 75 gun, and German sword during service in World War I. All went into the foundry for the next war's efforts.

A Home Defense Unit was organized under the leadership of Tom Montgomery, who had succeeded his father as owner of the *Puyallup Valley Tribune*. Both men and women were involved—the men as infantry, the women as ambulance drivers and administrators.

After the Japanese struck Pearl Harbor in December 1941, Defense Commissioner Montgomery issued instructions on blackouts. Radios were to be tuned to KIRO. In the event of a threat of aerial or sea bombardment, residents were to black out their windows, keep calm, and follow instructions. Each residence and commercial outlet were to keep one bucket filled with sand, another with water, and a long-handled rake or shovel to extinguish incendiary bombs.

Residents flocked to volunteer at the Home Defense Unit. Montgomery organized an aerial observation and listening post atop the Hunt Brothers Packing Plant. Over 100 volunteers manned the post 24 hours a day, men at night, women during the day, on 12-hour shifts. The town was split into nine air raid precincts and schoolchildren were given instructions. The threat of an aerial attack was real. Japanese balloon bombs reached several inland locations on the West Coast.

The city council established an emergency fund of $27,500 for wartime fire and police equipment. The police and fire departments established auxiliaries and a decontamination unit. A new firetruck was procured and all businesses were inspected for fire hazards.

The aircraft observation post was manned until the fall of 1943 when the Allies began to drive the Japanese back toward their homeland. Fortunately, no bombs had fallen, as they had in Oregon, but the town would have been prepared had Japanese aircraft managed to fly over Puget Sound.

The Kiwanians planted Victory gardens in vacant lots, much as Ezra Meeker had organized during World War I. Mike Barovic, then owner of the Liberty Theater and other theaters in the area, headed up the Pierce County Army/Navy Relief drive being conducted at the theaters. Considering the town had barely recovered from the Depression, the residents' 1942 pledge of $262,534 for the sale of war saving stamps and bonds was rather remarkable. In mid-1942, a 10 percent payroll plan for bond purchases got underway. Puyallup's fifth bond drive yielded a whopping $1.2 million, and earned the city a new B-29 bomber with a plaque that read, "This plane was made possible though the efforts of the City of Puyallup." The town also had a claim on a new Liberty Ship. The SS *Meeker*, named for Ezra, launched from Portland in late 1942. Before war's end, the *Meeker* had docked at 44 different harbors.

Shortly before Christmas, 1941, 30 cars of soldiers from Texas landed at the north Puyallup train station. The men were to form the 260th Coastal Artillery Anti-Aircraft Regiment at the Fairgrounds. With no food on board the train, the hungry soldiers appeared doomed to miss a meal or two. But nobody goes hungry in Puyallup, the land of generous people. Residents and merchants soon learned of the plight, and women fled to their kitchens, producing enough chow to literally feed an army.

CAMP HARMONY, 1942. The Army Corps of Engineers hired local labor to build these temporary quarters at the Puyallup Fairgrounds for the Japanese residents of Western Washington. After the Japanese were moved to a permanent camp in Idaho, an Army unit occupied the barracks for a few months. (Courtesy Tacoma Public Library Collection.)

The unit remained at the Fairgrounds until March 1942, and throughout that period, citizens would stop at the main guard post on Meridian at all hours of the day and night, offering baked goods and pots of steaming coffee.

"World War II landed in Puyallup with both feet this week with the establishment of an evacuation center for alien and American-born Japanese at the fair grounds," read a front-page article in the *Puyallup Valley Tribune* of April 3, 1942. That the site of so much fun and frolic over the years could become an internment camp reflects the drama and turmoil pervading a nation at war.

On February 19, 1942, President Roosevelt signed Executive Order 9066, which resulted in the internment of 120,000 Japanese and Japanese Americans from the West Coast states. The Puyallup Fairgrounds were selected as a staging site for Seattle and Alaskan Japanese. Those affected south of Tacoma were interned in Pinedale, California.

The U.S. Army Corps of Engineers took over the Fairgrounds to erect temporary housing for 8,000 internees. Under the Corps' direction, a civilian labor force numbering nearly 1,000 hastily hammered together wooden barrack-type buildings throughout the grounds and on the adjoining parking lots.

The first 2,000 internees arrived at "Camp Harmony" on April 21. A poignant letter appeared in the *Puyallup Valley Tribune* on May 29. Signed by the officers of the Japanese-American Citizens League, the letter stated that the writers looked forward to returning to the Valley and that nothing would rob them of their sense of belonging in this, "our America."

Local students were stunned to discover their classmates behind the fence, unable to attend class or play ball with them. Laurie Minnich recalls suddenly having classmates

103

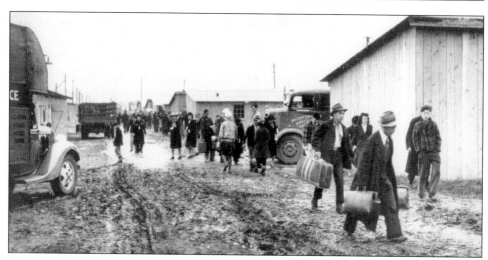

JAPANESE ENTER CAMP HARMONY. The first 2,000 internees arrived at their muddy new home April 22, 1942. (Courtesy Tacoma Public Library Collection.)

taken away. "We questioned our parents and grew very frustrated because there was nothing anybody could do and it seemed so unfair." Bob Ujick, also then a high school student, working for a local meat market, said, "The Japanese had access to a telephone and they would call our store and ask for certain items to be delivered. I would get on my bicycle and take the groceries to the gate and wait while the persons who placed the order were located. It was a bit of a gamble because we weren't supposed to have anything to do with the camp, but we felt so sorry for them."

Not all held these concerns for their fellow citizens; there had been plenty of anti-Japanese sentiment in the Valley over the years. In 1943, members of the Washington Farmers' Products Control Board voted unanimously to oppose return of the Japanese to the Valley after the war. They cited the fact that the Japanese had taken over the best land and lived frugally, thus driving down prices. Some asserted that their berries were of inferior quality, although little proof was forthcoming. Having lived with the Japanese as neighbors, the Board declared, "We find they are undesirable for the future prosperity of this community, the state and the whole nation."

It wasn't the Japanese farming record that worried the federal government. Rather, the decision to intern them arose because of the overt pro-Japanese, anti-American sentiments and actions of some Japanese living on the West Coast. The President also feared that innocent Japanese Americans might be set upon by local citizens.

The internees got on with their lives as best they could in cramped conditions, having left behind, and in many cases lost, their homes and furnishings. Judge Robert Campbell was detailed to document the assets of the interned. "Their land was confiscated and some of their belongings sold to local citizens. I'm afraid the Japanese lost most of what they had before they came to the camp," he said.

For the local Japanese Americans who were interned, the move out of the Fairgrounds after only a few months was bittersweet. On the one hand, they no longer were confined

in their own backyard as it were, while on the other hand, Minidoka, Idaho, where most were sent for the duration of the war, was built atop barren ground quite unlike their beloved green Valley. By the end of August 1942, the last were on their way to Minidoka, where the majority remained until war's end.

It was too late to contemplate holding the Fair in 1942 and none was held until 1946. Following the Japanese internment, a battalion of the U.S. Army Signal Corps moved into the barracks, but they vacated by December. It took nearly two years before the camp buildings at the grounds were razed.

By the summer of 1942 with agricultural production soaring, farmers realized the downside of their considerable efforts—fewer pickers to harvest their crops. When the draft board tripled its quota, the town was soon bereft of young men as well as many young women, who volunteered for the military services or went to work in place of men at The Boeing Company or the shipyards.

Crop losses that first year ran into the thousands of dollars. Weather played a role, but so did inexperienced and insufficient help. On July 29, 1943, all businesses in town closed for the day so that people could harvest. An estimated 2,500 tons of beans went to waste in the fields. Some itinerant laborers arrived, but many more were needed. School traditionally started later during the war years so that students would have more time to pick and work in the canneries.

A statewide sales tax of 3 percent was imposed in 1943. Many expressed discontent when they discovered that the tax would also apply to sales of used cars. In 1945, the first State Patrol presence came to the Valley. A building was erected for the patrolmen on Second Avenue Southeast.

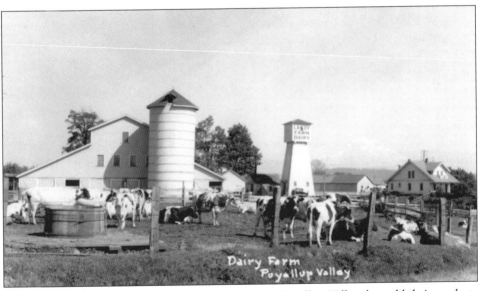

DAIRY FARM. *There were several dairy farms in the Puyallup Valley that sold their products in the region. Most other farms kept dairy cows for their own use as well. (Courtesy Perkinson Collection.)*

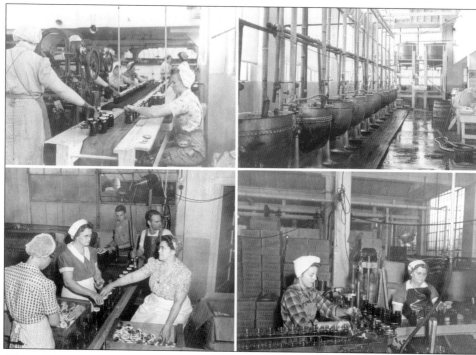

HUNT FOODS CANNERY WORKERS. *When women were needed in the canneries, the boss would have the whistle blown, signalling them to grab their aprons and get to work. During the early war years, volunteers manned an aircraft observation tower on top of the plant. (Courtesy Beta Club Collection.)*

Chester (Chic) Hogan opened a supermarket at the corner of Stewart and Meridian in 1942. Totem Grocery sold out to Safeway, so two Safeway stores served the community. In 1945, The Music Shop opened on West Main, offering records. There may have been a war on, but Nettie's Dining Room featured crab cocktails, steamed haddie, fresh sautéed mushrooms, roast leg of lamb, veal, and homemade pie, among other gourmet fare.

In March 1944, fire again destroyed the Brew Manufacturing Plant. This time, tragically, two people perished. Flames fanned by a high southwest wind spread embers for several blocks. A dozen homes or more caught fire, but were quickly extinguished by garden hoses and a roving firetruck dispatched to the north end of the city. The factory, which employed around 200 workers, was completely destroyed and closed until after the war. It marked the fourth fire for the company.

Throughout the war years, Thanksgiving and Christmas were observed in town without lights and fanfare. The Daffodil Festival parades ceased after 1941, as did Meeker Days. By Easter 1945, it was becoming quite evident that the Allies were winning both the Atlantic and Pacific wars. For the occasion, daffodil growers placed thousands of their golden blooms in military hospitals, mess halls, and chapels in the local area in celebration of both the religious holiday and the promise of peace.

To the great sorrow of the community, at least 50 Puyallup servicemen lost their lives in the war. Let one of those who returned represent this brave generation. Albert Tresch was a young soldier sent to the South Pacific in 1942. In January, his parents received word that he had been seriously wounded in the Japanese offensive in the Philippines. Subsequently, he was healed and returned to duty, only to be taken prisoner and become a Bataan Death March victim. The U.S. Army informed his parents that he was dead. But when the few remaining prisoners were released at war's end, there was Albert Tresch, who had survived the march, a bayonet wound, and internment of three years and seven months. Survivor and hero Tresch subsequently received the Silver Star.

Puyallup's fallen heroes and returned veterans deserved to be remembered. In 1946, a group began planning to construct a $100,000 memorial building downtown. However, by June 1948, with less than $20,000 collected, plans were revised to erect a much more modest structure than originally envisioned. It was decided that the Living War Memorial would be constructed of concrete block in Grayland Park. At last, in May 1951, Dr. R. Franklin Thompson, president of the College of Puget Sound, dedicated the Living War Memorial Building.

Returning servicemen joined local firms or businesses, or went to work at The Boeing Company, where they replaced many of the women who had stepped into the breach in their absence. Veterans had the grateful thanks of their countrymen and the higher paying jobs. Women, not always happily so, returned to housewife duty or traditional jobs as secretaries, nurses, teachers, or retail clerks.

The Puyallup that awaited the returnees looked a little different from the one they left. A few new businesses had arrived, expansion was creeping onto South Hill, and the population had increased, but not like it did after the boys came back. In 1946, 369 babies were born compared with births under a hundred at the beginning of the decade. Puyallup couples did their share to create the "Baby Boomer" generation.

GI's with money in their pockets needed places to spend it. In October 1946, Engh's Market, called one of the most modern supermarkets on the Pacific Coast, made its debut at 610 North Meridian. The same month, the Puyallup Motor Company at Second Street and Pioneer Avenue East conducted a grand opening.

In April 1946, the police reported that the Puyallup traffic accident rate was three times greater than the national average. River Road in particular was the second hottest spot for accidents in Pierce County. In part this reflected the relative affluence of the area. Nearly every adult had access to an automobile.

The post-war years ushered in an era of increasing governmental power and influence at the federal, state, and local level. The Puyallup City budget offers a glimpse of this phenomenon. The 1946 budget was $141,544. The next year the budget totaled $183,635. Virtually each year from that time the budgets have risen incrementally.

In an attempt to make some money for city coffers, parking meters were installed in July 1947, costing a user a nickel for an hour or a penny for 12 minutes. Not everybody was happy with the system. One woman parked her car, dutifully put a nickel in, and in the process realized she had left her purse at home. Returning to the spot after having driven back to retrieve the purse, she became quite distraught to discover that someone

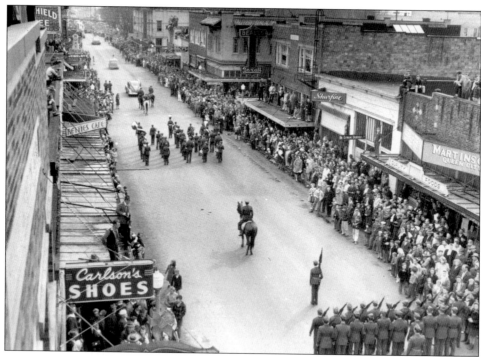

DAFFODIL PARADE, 1946. The Daffodil Festival and parades began in 1936. Here citizens line the streets and peer from rooftops for the first parade after World War II. (Courtesy Tacoma Public Library Collection.)

else had parked in the slot. She declared to all who would listen that the nickel was for her hour and no one else should use the space until that hour was up.

In May 1947, more than 5,000 shoppers attended the three-day grand opening of the Newell Hunt Furniture store on West Stewart. Mike Barovic erected a one-story building on the corner of Second Street and Meridian in 1948 and J.C. Penney moved in. The Porter-Manning-Forbes Building rose on the corner of Second Avenue and Second Street Southeast. Divided into three sections, the tile on the front of the building made it one of considerable charm.

Direct dial telephone service arrived in 1948. Two years later Citizen's Bank was the first bank in town to open a drive-in window. Richter Drug Store opened on North Meridian, as did the Karl Jones Men's Store. Clemans Furniture built a store on Third Street Southeast, and Rube and Dave Larson established Larson's Paint and Glass.

The city council concentrated on street improvements, which were made with State-matching funds. Both Meridian and Stewart were widened and improved. A new sewage treatment plant was built at a cost of $700,000. City planners wisely proposed a main pipeline sewage trunk that would accommodate a city of 15,000 as they were "looking to the future." It wouldn't take long to surpass that number.

Power generation needed improvement, but that was a complicated task. Households now displayed a variety of electrical appliances that flooded the markets, tantalizing the

homeowners. Some came with big price tags. A Bendix floor model radio cost $229 in 1948. The first ad for a Philco Television set appeared in March 1949. Hogan's Market had received them and was giving one away in a drawing.

The Army Corps of Engineers announced the completion in 1949 of the $3-million effort begun in 1925 to widen, straighten, and deepen the Puyallup River for 2.2 miles. Bridges had been relocated and more than 1 million cubic yards of dirt had been moved in the process. Capacity of the channel had been increased from the flow of 30,000 feet per second to 50,000. Proudly, the Army engineers declared there would be no more floods. They hadn't learned never to say "never." In the winter of 1951, the southwest part of the town was flooded after receiving heavy rainfall.

Puyallup can be proud of the men and women who served in uniform, of citizens who manned the Home Defense Unit, and those who toiled to keep the mills, farms, and canneries going during the long years of war. The small town and Valley had done their share and then some to defeat the country's enemies. Yet the loss of so many young men and the unforgettable memory of the internment of fellow citizens restrained the joy of having the war end. And soon new challenges lurked—growth, Mother Nature, and another war.

DAFFODIL PARADE, 1948. This view of the parade looks north up Meridian. The large building on the lower left is the Carnegie Library, and the twin-towered building to the right is city hall. (Courtesy Ezra Meeker Historical Society.)

15. SHAKING THINGS UP

On Wednesday, April 13, 1949, as kids sat in classrooms and their folks went about their labors, the ground suddenly began to shake. A 7.1 Richter scale earthquake, centered east of Olympia, struck before noon. Miraculously, only three people were injured in Puyallup, but eight were killed in the Puget Sound area. Resting on alluvial soil, Puyallup's many older brick buildings suffered extensive damage.

The corner of North Meridian and Stewart was hardest hit. Brick walls and roofs caved in throughout the city, windows shattered, and several cars were demolished. The stage in the high school auditorium crumpled, surprisingly without injury. Several other schools were also damaged. In the aftermath the Opera House/City Hall had to be razed, as did the Stewart Apartments. The fire chief alerted residents to check their chimneys, many of which had cracked.

Damage assessments reached a quarter of a million dollars. Several businesses had to be reconstructed and sewers needed work where streets caved in on them. For decades the city council had been planning to build a real city hall to replace the old Opera House. After the earthquake, the council put out bids, but it would take some time to reach their goal.

In his era, Ezra Meeker had donated a lot for a city hall adjoining the city fire hall on the west. The city council in 1949 decided to sell that property to purchase a larger piece of property for the new city hall. But they couldn't sell the property without getting the consent of all the Meeker heirs, a daunting task. In the meantime, city offices were moved to the public library to save rental. Yet again, the administrative offices of the city were in cramped conditions.

The 1950 census counted 9,955 residents, a large increase over 1940. No wonder traffic was increasing. A survey revealed that nearly 30,500 cars were passing through the town daily.

Civil defense remained an issue for the town, especially after the Korean War began in June 1950. Concern that the Soviet Union might launch atomic attacks brought exercises to the public schools. At a drill signal, children filed orderly from their classrooms, secured their coats, and crouched down on the floor in the hallways of the school. To provide warning, an aerial observation tower was installed on Seventh Street Southeast.

The latter months of 1950 taxed town politics. Police Chief Cecil Archer insisted on additional funding, and the city had to take over garbage collection when the low bidder

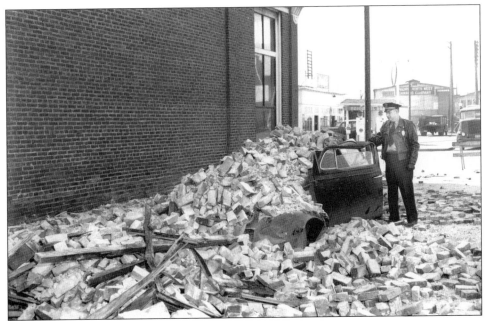

EARTHQUAKE DAMAGE, 1949. Brick moved on brick as much as 3 inches on many buildings, leaving wide cracks and shaky foundations. Another quake struck in April 1965, but it did less damage. (Courtesy Tacoma Public Library.)

they had contracted with failed to meet his obligations. When new city hall bids exceeded the budgeted price, open warfare broke out. Three council members blocked the provision of additional funding to start the building.

At the height of the battle, prevailing council members voted to adopt the city manager plan of governing. Under the plan, approved by the voters in 1951, the council appoints a city manager, and a mayor is selected from among the council membership to act as spokesman and political head. Two council members are elected from each existing ward and one at-large. The 1951 election brought the first woman to the council—Laura Bunn, a widowed pharmacist.

E. Frederick Bien, a 29-year-old assistant city manager from Pittsburgh, Kansas, was hired to put together a city government for the growing town. He arrived in 1951 with a starting salary of $7,700 to oversee a budget of over a half million dollars for a town nearing 10,000. Bien swiftly proposed streamlining the government into five departments to prevent duplication: Public Works, Safety, Financial Affairs, Law, and Public Services. He also proposed the first business licenses, which the city council agreed to in September 1951. While some grumbled at the licensing scheme, plumbers sought and achieved a raise in fees for their city licenses from $10 to $75. They wanted this steep fee to keep "fly-by-nights coming in to do one job and running," to quote one of their members.

Residents apparently approved of the changes being made. In December's special levy, they agreed to spend an additional $50,000 to build a new city hall, which had been needed since 1910. Mayor James Wilson presided over the new city hall dedication on

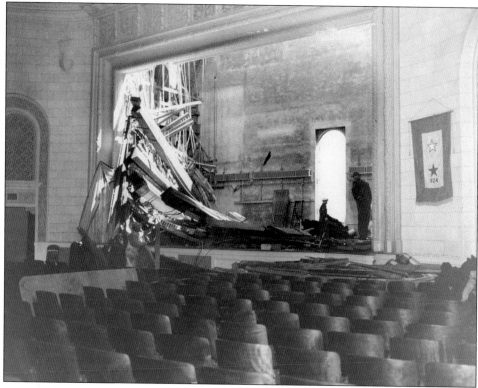

HIGH SCHOOL AUDITORIUM DAMAGE. The 1949 quake caused the roof and ceiling beams over the auditorium to collapse onto the stage. Students were in class at the time and no one was injured. (Courtesy Lori Price Collection.)

February 7, 1953. Residents admired their new building with its Roman brick front, planting boxes, and wide entrance hall paved in red square tiles. The city jail incorporated in the building was said to be the envy of other municipalities.

By spring of 1956, Bien was gone, replaced by Harris Green. Lucky for Green, street numbering didn't figure in his duties, so residents couldn't blame him for the new county system. County commissioners decided that for new subdivisions, which were fast being planned and developed, Puyallup house numbers would be used as a guide. Where extensions occurred toward Tacoma, the Tacoma street number would take effect. So, for example, Seventy-second Street East (of Tacoma) became Seventy-second Street in Puyallup, since it was actually west of the city. The houses on Seventy-second extended from the Puyallup city limits to the postal service limit. The new system required the use of quadrants to differentiate among the many intersections with like street numbers. New arrivals still shake their heads when attempting to locate an address.

The Korean War didn't attract the kind of attention the previous world wars had. Young men were again drafted and sent off, but the town wasn't on a war footing. The first apparent Puyallup casualty came in August 1950, when Marine Private Albert Spencer was killed after being in Korea only two weeks. Verle Hatch was taken prisoner in 1950 and

returned home three years later when the war ended. At least four local men weren't fortunate enough to return.

In 1952, Puyallup poultryman Percy B. Rowley, who had followed in his parents' footsteps, took 72,000 eggs to South Korea for hatcheries under a plan paid by the Council of Churches. Rowley predicted that 80 percent of the eggs would hatch in their new home in Pusan. By 1969, Rowley was producing 250,000 hatching eggs, many sent to Japan.

A heightened interest in science resulted from World War II and the Korean War. When Puyallup High School junior Gary Torgeson launched a successful rocket with no adult help, his science teacher said, "We think some of these boys will go far. We just don't want them to go far this way."

At the start of the Christmas holiday season in 1952, residents on Seventh Avenue Northwest decided to decorate the 35 homes in their neighborhood. The first year, they put up lights at each home and a Christmas tree at the entrance to their community. "Twinkle Lane" soon became a holiday tradition. A tall, illuminated tree at the intersection of Twelfth and Stewart greeted visitors who slowly drove in long lines of cars past the dazzling scenes. Twinkle Lane endured for 20 years until youth began stripping the lights and some residents moved away. When the energy crisis hit in 1972–1973, this annual holiday tradition became a memory.

The canning industry underwent considerable change in the early 1950s. In 1952, the National Farmers Union Service Corporation announced that it would operate a large canning and freezing plant for berries for the Birds Eye division of General Foods. A scant few months later, the corporation folded because there weren't enough berries to process. The Kelley Farquhar Company consolidated two plants formerly owned by the Washington Packers, which had gone out of business.

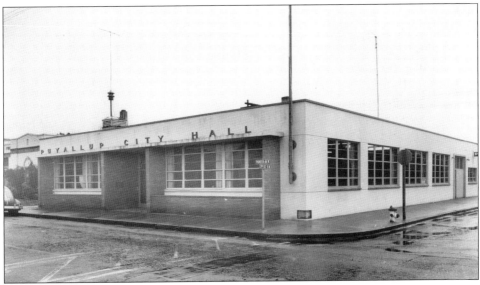

NEW CITY HALL, 1952. This was the first permanent city hall building in Puyallup. The police department occupied the rear of the building. (Courtesy Beta Club Collection.)

CITY HALL INTERIOR. City workers sit at their new steel desks from Miller's Office Supply. (Courtesy Beta Club Collection.)

In 1956, the Puyallup-Sumner Fruit Sales Corporation purchased the equipment of the North Puyallup Packing Company and began the first combined fresh market-processing operation. The next year the Hunt Brothers Cannery closed its doors.

Residents celebrated the centennial of the Washington Territory for three days in August 1953. Instead of a youthful king and queen for the pageantry, old-timers were selected—Nellie Decoursey and Ronnie Nix, son of the pioneer.

In February 1954, the new Puyallup Armory for the National Guard on Fourth Avenue Southeast was dedicated. In the 1960s, the armory sponsored teen dances, but neighbors petitioned to stop them due to excessive speed, drinking, littering, and vandalism in their residential neighborhood. To keep youth busy during good weather, various clubs pooled their resources and created a baseball field at Grayland Park. The high school team used the field, as well as many community baseball leagues, both adult and juvenile.

The 1949 earthquake considerably altered the look of the town. Gone was the signature Opera House and with it the seat of government. A new city hall and a reformed style of governing emerged from the dust. Except for the families who lost men in the Korean War, the town was little affected by the Asian conflict. Residents were busy modernizing their homes, businesses, and the city's infrastructure, while farmers continued to produce, but for how long?

16. Farms to Bedrooms

The first migrant workers in the Puyallup Valley hailed from British Columbia. Through an arrangement with both governments, the migrant Indians maintained dual Canadian/American citizenship as they made their way down through the Skagit Valley, harvesting as they came before spending the summer picking hops or berries. At first the British Columbian Indians, later joined by members from Yakima and Western Washington tribes, lived in camps. When the hop era ended, they came to harvest berries and truck gardens, living in cabins provided by farmers.

As some of the migrants lived in the area from May to September, local concern arose over their health and welfare and over the potential for conflict in the nighttime streets.

In the summer of 1957, for the first time, family groups from Texas settled into the Valley to help with the harvest. Approximately 200 of the Texas natives (Americans of Mexican background) came to work in the raspberry fields to the great delight of desperate growers.

That year a group of concerned citizens, led by the Reverend Arthur A. Kirk, pastor of the Presbyterian church in Puyallup, established the Puyallup Valley Migrant Ministries Association, with a mission to provide resources to cope with the summer influx of migrants and their families. Georgia Stickney served as the secretary of the group throughout its 17 years. "At first we raised all private funds for our work," she recalled. "We had a Ministries Board, located volunteer doctors and nurses to conduct weekly clinics, and conducted an adult education program."

Soon government agencies began cooperating with the successful ministry. In 1963, the Pierce County Public Health Department provided a full-time nurse for the summer months. Lillian Landoe, who served as the last public health nurse for the program said, "I provided hygiene education and referrals for doctors and dentists. The work was rewarding, although cultural and language differences did cause me some concerns."

Initially school and church services were conducted on the grounds of the Alderton School. In 1965, funds were sufficient to erect a building in Alderton for the association to hold all of its activities, including school and the clinic.

The berry industry began to take big hits about the time the Mexican laborers arrived. The glut in the berry market stemmed from both the increased production of fruit in California and low tariffs, which encouraged foreign growers to flood U.S. markets with cheaper fruits.

Berry growers appealed to the entire Northwest community to spread the word about the excellent quality of Valley berries. The Army and Air Force added fresh Puyallup raspberries to master menus and procured jams and jellies. However, when the strawberries came to harvest, farmers were doomed. Washington growers incurred costs of 14¢ a pound to produce the berries, and they wanted 20¢ a pound on the market. Oregon growers accepted 10¢ a pound as did some California growers. The old supply and demand problem caught up with Valley growers and fewer canes and vines would be seen in the coming years.

Pressure on farmland began in the early 1950s. Land values in the Valley rose an average of 90 percent as a result of 1953 tax appraisals. Some land escalated over 300 percent. A front-page advertisement in the *Puyallup Valley Tribune* in March 1959 summed up the farmers' future. "Wanted farms and homes. We have buyers," the real estate ad read. But the buyers for the farms would have little interest in the plow or the harvest. Developers saw dollar signs in housing tracts.

Some of the land was being put to good use for rhubarb fields. In 1960, rhubarb sellers organized the Washington Rhubarb Growers. The tart, rose-colored fruit was shipped all over the nation from the Valley. And it wasn't only fresh rhubarb; the association was also processing about 20 percent of the nation's frozen pack.

Blueberry growers once experimented with a high-tech method to dry the bushes so that pickers could continue harvesting after a heavy rainfall. A helicopter from the Chem-Air Helicopter Service flew low over the fields, back and forth. Sure enough, the whirling blades dried the bushes and the pickers returned. But this is the Northwest. Later in the day it rained heavily again and the pickers hastened from their harvest.

By 1960, the end of hop growing was in sight when mildew again attacked the plants. At the time, Ben Gonter's 1911 double kiln was still in use near McMillan, but it wouldn't be needed long.

Francis Chervenka, one of the Valley's most enterprising farmers, planted 100,000 rootstock for dwarf and semi-dwarf apple trees. His year-round farm produced rose stock, which peaked in November and December, apple tree stock in February and March; and bulbs in the summer.

By the mid-1960s the overall number of migrant workers began to decline due to several factors: the number of large farms decreased as berry prices failed to match the cost of growing them; some farmers mechanized their picking; and under new government regulations, farmers were required to provide better housing with more amenities than the migrant labor was worth to the farmer.

The Migrant Ministry Association disbanded in 1974 and donated the building to the Kiwanis Club, which installed the Kiwanis Boys Home on the property. The Puyallup Valley Migrant Ministry Association stands as a testament to the sharing spirit that had sprung from the very soil of the Valley.

Despite the increasing disappearance of the traditional farm community, grange organizations remained strong in the area. The Fruitland Grange for many years was the largest in the county.

New businesses arrived practically on a weekly basis in the 1950s—Buster Brown shoes, Sears and Montgomery Wards Catalogue stores, remodeled drugstores, and

automotive centers. The Pioneer Bakery began selling its tasty treats on Meridian in May 1954. Bill Nix, grandson of pioneer Rominous, became manager of the new Piggly Wiggly on East Main. The modern facility featured pearl countertops and a moving checkout belt.

Several merchants got together in 1954 and created the Off Street Parking Association. They bought a lot facing Second Street Southeast between Meeker and Pioneer and installed parking meters. In 1955, the association created another lot at the corner of Second Street and Second Avenue opposite the post office. More lots were planned and built, and the meters paid for them.

Puget Sound Power and Light Company dedicated a new 5,000 KVA substation for Puyallup on Twelfth Street in 1955. In 1956, the new sewage treatment plant off River Road began operating, and natural gas came to town.

Mel Korum and associates purchased the lease of the Dodge Plymouth Company and the B and Y Motor Company. Puyallup's claim on car sales continued unabated.

Throughout the 1950s, the Puyallup Laundry and Dry Cleaners kept many local workers busy handling large contracts for Northwest Orient Airlines and Western Airlines. In those days real napkins were used for meals, and when one boarded the aircraft, an attendant offered a warm towel to wipe a tired face.

One of the last mills in town, Sorenson Brothers Mill on Thirty-seventh Avenue Northwest burned in June 1954. The eight-year-old mill suffered a $20,000 loss. The Brew Manufacturing Company continued in operation until the 1960s, when all operations were discontinued, effectively ending the lumber industry in Puyallup.

In 1955, a major transportation omnibus highway bill was passed that finally placed Meridian in the State Highway program. The new bill also authorized paving of all four

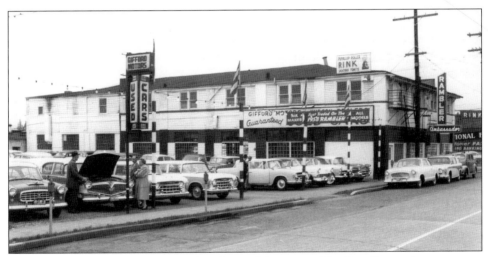

GIFFORD MOTORS, 1958. From the advent of the automobile, Puyallup outlets sprang up to sell the various models. Over time, the dealers began advertising that the best car deals in the region could be found in town. While Gifford Motors didn't survive, a few of the early car dealers did. Today, second- and third-generation car salesmen, such as the Korum family, purvey all makes of cars. (Courtesy Tacoma Public Library.)

lanes of River Road, and funds were allocated to reduce the steep South Hill grade. The bill also authorized right-of-way for a new road from South Meridian to McChord Field and Lakeview, to be located a little north of the then Airport Road (112th Street). It would take another 20 years before State Route 512 would link Puyallup with the interstate.

Hoping to make Puyallup the "Evergreen Capital of the World," a new division of the G.R. Kirk Company started up in 1958 at the old Farmers Union Cannery on East Pioneer. Within a few years Kirk became America's largest producer of Christmas trees and greens. Nearly 100 workers toiled yearlong with an extra 50 added at holiday time. Elsewhere, 1,000 were employed during peak season. Another new industry that year, North Shore Cedar Products on Seventh Street Southeast, put the finishing touches on cedar shingling and siding.

J.C. Penney's arrival foreshadowed the closure of some locally owned retail businesses. In addition to offering better prices on a wider choice of merchandise, Penney's was among the first nationwide companies to offer credit for customers. Local merchants had long offered credit in this farming community, and more than one debtor would cross the street rather than encounter a creditor. Owing a national company was considerably less personal.

In May 1957, the *Puyallup Valley Tribune* published its 70-year anniversary edition, which included a highly appropriate congratulatory telegram on the front page:

> As you review the record of your first seventy years as reported in the pages of the *Tribune*, you will be impressed by the strength and ambition of your early settlers. They established your heritage and you give it modern application as you join in the fullest development of your valley. Congratulations and best wishes, Dwight David Eisenhower.

Modern application didn't work in October 1957 when a loaded logging truck lost its brakes on South Hill and careened all the way down Meridian before crashing into a taxicab waiting for a red light. The truck then smashed into Elvins Department Store, spilling logs all over the street and leaving a trail of damaged cars, two injured persons, and a crowd of gaping onlookers. The driver couldn't believe his bad luck—it was the first day he had driven the truck.

Vernon Hill, retired from his years of distinguished service with the U.S. Army and the Central Intelligence Agency, built a new Hill Funeral Home on East Pioneer in March 1960. Vernon's father had opened the first one in 1908.

The Old Fifth Street Northeast Bridge was taken down in 1960 to make way for a new one. In November heavy rains caused a logjam that seriously threatened the pilings of the new bridge, but that disaster was averted. The next month would prove unbelievably eventful.

On Friday, December 23, 1960, an anxious merchant patrolman phoned the Puyallup police at 3:57 a.m. to announce that he had seen a hot box on the twelfth car of a long freight train as it entered the east end of the town. No sooner had he made the call than the overheated journal box caused the wheels of the car to freeze, catapulting 14 freight cars off the tracks between Fifth Street Southeast and Seventh Street. Luckily the majority

118

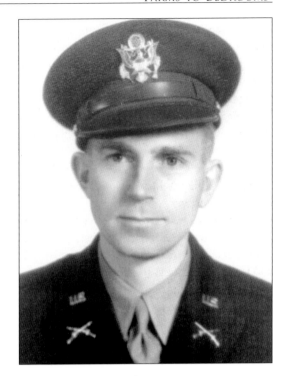

VERNON HILL. During World War II, Hill, a Puyallup son, was assigned responsibility for locating and saving American airmen who had gone down behind Japanese lines in China. Hill went on to work in the Central Intelligence Agency before returning to Puyallup and taking over his father's mortuary business. Undercover agent, decorated war hero, mortician, filmmaker, author and community leader, Hill died in 1992 at the age of 83. American Legion Post 67 in Puyallup proudly bears his name. (Courtesy Vernell [Hill] Doyle.)

of the cars landed in a vacant lot north of the tracks, next to a garage building. Given that the Great Northern freight train carried 98 cars, the derailment of only 14 was most fortunate, as was the hour. Nobody was around to sustain an injury.

As it turned out, this derailment served as a prelude. On Thursday, December 29 at 1:22 p.m., the diesel engine of a Northern Pacific passenger train veered off the tracks at Seventeenth Street and Pioneer and settled on its side. The baggage car and four or five others sailed on past the upturned engine, but the sixth and seventh cars jackknifed. This time, 17 people were treated for minor injuries.

Several victims made calls from a nearby home. Ruth Sulkowsky, director of the chamber of commerce, hurried an order for coffee from Nettie's Cafe, and soon she and others were circulating among the 125 passengers, serving coffee and offering moral support. Mrs. Arlene Gibson sent two large pots of soup from her shop on Meridian near the tracks. Ruth Sulkowsky, who organized this and so many other civic efforts, subsequently became president of the Washington State Association of Chambers of Commerce.

At this point Puyallup had suffered a fire at the Firgrove School and two train wrecks in the period of one week, which wasn't over. On Saturday, the Valley Paint Store and Snappy Sign Company on East Stewart burst into flames. People living in Puyallup the last week in 1960 have not forgotten the two fires and two train wrecks that considerably spiced up their holiday season. Considering all the mayhem, serious injury was avoided.

Unfortunately, the train wrecks wouldn't be the last for the town. In December 1979, a Burlington Northern train derailed, blocking three major through-streets. And shortly

before Christmas 1981, 13 cars of a Burlington Northern grain train derailed near Stewart Avenue.

An extraordinary amount of effort took place over the next several decades aimed at making Puyallup look better. Had a few of the projects originally envisioned been allowed to come to fruition, the town would now have a very different appearance. A group of citizens and city staff met in November 1961 to focus on sprucing up public works facilities, parks, the cemetery, and approaches from highways entering the city.

The new library, dedicated on February 11, 1962, may not have been the most appealing building in town, but it was more functional than its predecessor. Sadly, the more attractive Carnegie building was razed.

City beautification began in earnest in April 1962 with the planting of 135 trees in the downtown area. The next February the city council hired the Seattle-based Graham Company architectural and engineering firm to conduct a survey of the business potential of the Puyallup area.

The Graham firm labored for over a year before proposing a shopping mall for Meridian downtown. It was to run from Third Avenue Northwest on the north to Fourth Avenue Southwest on the south. A roof-like structure would extend from the fronts of buildings on one side of the street to the fronts on the other. Few of the Graham recommendations were realized.

TEA TO HONOR PIONEERS. *This 1958 event was sponsored by the Puyallup Women's Club to honor the pioneers and provide resources for the historical collection of the library. Pearl Cassie "Tot" Bigelow (center) was a major activist in town throughout her life. (Courtesy Beta Club Collection.)*

The early sixties evoke a time of great international tension. Even before the Cuban Missile Crisis, the Puyallup City Council accepted its responsibility to adopt measures to protect the city from possible attack by the Soviet Union. In January 1962, civil defense experts marked shelters that could hold a minimum of 50 people and be protective against radioactive nuclear fallout. During the missile crisis, Fire Chief Paul Parkhurst announced that the fire department was in a state of high readiness for a civil defense emergency. A few residents built fallout shelters on their property.

The Valley Amateur Radio Club became so proficient in providing communications support that it was acclaimed first in the nation. The club had proved its mettle during a heavy snowfall in 1960 by providing uninterrupted communications for Eatonville, Orting, and Buckley. In 1964, the Radio Club served as a primary communications link with Alaska following the devastating earthquake there.

Flags lined the streets in late November 1963, but not in celebration of better international relations. The flags dipped in tribute to President John F. Kennedy, felled by an assassin. Many residents had been in attendance a mere few weeks earlier when the President spoke at Cheney Stadium in Tacoma. If such a tragedy had to happen, all were glad it hadn't happened in Washington State.

With no overall land use plan in effect for the county, when the issue of commercially developing the Brew Mill property located at River Road and Meridian came to the Pierce County Commissioners, they had little to hang their hats on when they recommended the best use would be agricultural and residential.

After years of indecision, in 1960 Hi Ho Market vice president Gordon Lockhart announced the grocery had purchased the property for $75,000. The new Hi Ho one-stop shopping center on River Road opened for business on February 4, 1963. Elvins Department Store, with a greatly enlarged selection of merchandise, moved out to Hi Ho the next year, as did the First Union National Bank.

Other stores joined the complex, and in 1966, the shopping center owners sponsored construction of an underpass, which to this day carries northbound shoppers to the site.

Not to be outdone, the Thriftway store also underwent a complete redecoration and a new meat market was established. Not long after, Albertson's Corporation bought the Thriftway. Takeover grocery transactions have a long tradition in town.

Fire again attacked the town in February 1964, when nearly $200,000 in damages accrued to the Puyallup Laundry and Dry Cleaners, causing its destruction. That June, fire destroyed Larson Rambler on East Main Street and also gutted Walker Garden Center on Linden Drive.

The Puyallup Fish Hatchery on Fourteenth Street Southwest, which opened in 1948, became one of the largest in the state. In 1963, it produced 3,500,000 trout and 95,000 steelhead.

The right to harvest traditional fishing grounds figured prominently among other promises of the treaties that "settled" land and resource issues in Western Washington. From the Native American perspective, these guarantees included their right to unregulated gillnet fishing in local rivers.

By 1964, the salmon runs were being depleted at a rapid rate and non-Indian sports fishermen, among other interested parties, placed blame on the gillnet fishing practices.

PUYALLUP FISH HATCHERY. The state of Washington opened this facility on Fourteenth Street Southwest in 1948. By 1963 it was one of the largest producers of trout and steelhead in the state. (Courtesy Beta Club Collection.)

The State of Washington sued local tribes to cease the gillnet operations and to abide by state regulations for all fishermen. The State's lawsuit riled the Nisqually Tribe and Robert Satiacum, activist member of the Puyallup Tribe. Actor Marlon Brando even appeared in the river with Satiacum, lending his voice to the tribal cause.

After long years of litigation, on February 12, 1974, State Superior Court Judge George H. Boldt found the U.S. government's promise to secure Indian fishing rights central to the treaties. He ruled that tribes had an original right to fish and it was not up to the State to tell the tribes how to manage something that had always belonged to them. The so-called "Boldt Decision" mandated that tribes had a right to 50 percent of the salmon harvest running through traditional, off-reservation fishing grounds. Another important ruling of the Boldt Decision granted tribes a major voice in the management of state fisheries.

The Boldt Decision forever changed the way the states manage relations with their indigenous tribes. While the Nisqually Indian leaders received great credit for the decision, the plucky Puyallup Tribe deserves merit as well. They may have been generous people, but they weren't about to give up their rights to the fish that had so long sustained their people.

At 8:28 a.m. on Thursday, April 29, 1965, the ground in Puget Sound again rumbled and shook, sending folks diving for cover. Residents and businesses reported toppled chimneys, broken glass, and scattered furnishings from the earthquake, which registered between 6.5 and 7 on the Richter scale. The top story of the Spinning Block, on the

northeast corner of Meridian and Pioneer, later had to be removed. The 1949 quake had done more damage, but the 1965 quake did its best to batter the town. Six people in the region lost their lives, but none in Puyallup.

By the spring of 1965, local servicemen were seeing duty in Vietnam. Private Lance J. Cleveland probably didn't get any of the birthday cards he was sent. He was killed on his 20th birthday in July 1966, the second recorded Puyallup son to die in the war that would last seven more long years. At least 10 Puyallup sons did not return to their families.

Heretofore, the twentieth century section of this history garnered information from the *Puyallup Valley Tribune*, which followed the *Puyallup Commerce*, established in 1886. In April 1966, Frank Franich and John VanDevanter published the first edition of a free weekly paper, *Pierce County Herald*. Tom Montgomery, suffering from health problems, sold the *Tribune* to the *Herald* owners, who merged the two papers. From this point onward, the *Pierce County Herald* serves as a primary research medium.

Cable TV arrived in Puyallup in March 1968 courtesy of KTNT, which secured the franchise for the bulk of Pierce County. Subscribers paid $7.50 for installation and $5.20 monthly for all available television channels, plus two educational channels.

The towns of Fife and Milton moved from the 25th State Legislative District to the 27th in 1965. The Northwest boundary of the 25th District went up the Puyallup River to Seventieth Avenue East and north to the King County line. This meant that Puyallup became the chief metropolis in the southern part of the 25th District.

In the spring of 1966, the chambers of commerce of Puyallup, Sumner, Orting, and Buckley united under the name Puyallup Valley Chamber of Commerce. Governor Daniel Evans called the new chamber one of the first breakthroughs in the state in getting people of neighboring communities working together. In 1982, the Puyallup Chamber of Commerce joined with the eastern business groups to create the Puyallup Valley-Eastern Pierce County Chamber of Commerce. Membership then stood at 550.

The City continued to annex more land. City limits were extended as far south as East 112th Street, to the east of the Puyallup River and west to Woodland Avenue. This occurred all the while the downtown resembled a deflating balloon. Pacific Northwest Bell announced that the number of business phones had declined while residential phones had increased. Puyallup was fast becoming a bedroom community, whose workforce commuted out of the city.

The last year of the sixties commenced with the dedication of a new $450,000 public safety building. Fire and police were housed in the two-story facility, built by Jardeen Brothers on Pioneer Avenue.

January 1969 was not yet over when the Piggly Wiggly Supermarket at Tenth Street and East Main succumbed to fire. Owner Hogan rebuilt a new center that featured Pay N Save Drugs, Ernst Hardware, and Malmo Nursery next to the new 30,000-square-foot Piggly Wiggly. Later a Safeway grocery occupied the main store.

Puyallup reportedly became the first city on the Pacific Coast to establish the new "911" emergency telephone number. Pacific Northwest Bell installed the local system in 1969, one of the first 14 in the nation.

A family counseling service opened downtown that year, paid for by the United Good Neighbors fund. Counselor Ruth Wiltz set up shop just in time. Police Chief Frank Vasey

123

informed parents that "pot"(marijuana) and LSD tablets had arrived in Puyallup. Six years later, the Puyallup Drug Task Force was established to deal with growing problems. In the 1980s, the Puyallup schools instituted a Drug Abuse Resistance Education (DARE) program, an offshoot of a Los Angeles effort.

The Puyallup Valley Alcoholism Information Referral Center came to West Main, as did a credit counseling service. It took some nationally affiliated organizations longer than others to reach the town. "Parents Without Partners," begun on the East Coast in the early 1940s, made its way to the Valley in the sixties.

After several years of parking meter experience, merchants petitioned for their removal in 1967 and the city council agreed. Downtown merchants deemed themselves in an unfavorable position vis-a-vis the Hi Ho Shopping Center and the malls being built in the region. Customers of those concerns park free for as long as they choose.

In August 1965, the city celebrated its 75th birthday. Bands, parades, and a carnival highlighted the multi-day event. After a hiatus of 17 years, the Jaycees reinstated Ezra Meeker Days in June 1968. (In 1948, a shaven man, running from the "beard police," had fallen to his death, causing the city council to cancel Meeker Days celebrations.) The highly successful four-day carnival convinced the town that the event again merited annual observation, and the celebration occurs to this day.

Unemployment remained stubbornly high in the late sixties, at up to 20 percent for unskilled laborers in the county. At the same time taxes rose at an impressive rate due to increases in property assessments. To help offset the effects of rising unemployment, the Pierce County Food Concern Committee established a food bank in the city. After being in operation for four months, 60 families were relying on the service.

Robberies go up when the economy takes a dive, which happened in the early 1970s. Late one night burglars hit the rebuilt Piggly Wiggly, broke a large, plate-glass window, and stole the safe. The 1970 census didn't surprise anyone living in the increasingly congested Puyallup environs. Census takers had located 14,717 citizens, including a growing number of seniors. That May, the Senior Center opened.

To ease travel through town, the city council decided to construct a bypass to divert traffic from Meridian, to the extent that the central business district could survive. With help from the federal government, the City purchased 14 sections of property from the River Road to the Fairgrounds via Second Street Northeast and Third Street Southeast. To the baseball players' great regret, the diamonds at Grayland Park had to be sacrificed. Temporary ball diamonds were established in unpaved Fairground parking lots.

The Lige Dickson Company won the bypass contract, and by November 1971, motorists had two options to traverse through town. Six months later, Meridian Street was designated one-way heading south, and the Second Avenue bypass one-way going north. And so they remain to this day.

Merchants were generally pleased with the new street as the arterial road enabled the traffic to flow better, and parking restrictions on Meridian could be lifted. Police were not at all happy, though, when teenagers discovered the joy of racing around the "loop" created by Meridian and the bypass. Weeks of weekend encounters with drunken and reckless youth, many from out of town, led police to close parts of Meridian and its feeder streets. This rather Draconian action brought the cruising to an end, according to then Police Chief

MEEKER DAYS, 1977. The "Beard Police" wait beside the Ezra Meeker wagon to fine local men who did not grow a beard or mustache during this annual three-day festival. (Courtesy Ezra Meeker Historical Society.)

Larry Nash. But the young drivers found other locations to congregate. The K-mart Store on River Road, built in 1978, served as a magnet for hundreds of youth after hours.

State Route (SR) 512 construction, begun in Tacoma in the late 1950s, continued from Canyon Road to the State Route 161 interchange. With the Rogers High School Band performing, that section of the vital link to Interstate 5 opened in April 1972. In December 1973, the Puyallup High School Band helped dedicate the opening of SR 512 from Willows to Pioneer Avenue. Motorists could now travel from one end of Puyallup to the other without enduring a stoplight—or using a downtown business. In 1976, the remaining section of SR 512 was completed to the intersection with SR 410.

With increasing links to major highways, nine Puyallup real estate firms formed the Valley Multiple Listing Service (MLS) in the early seventies. Valley Upholstery, in business for over 45 years, opened in a new location on Valley Avenue Northwest. Burke's Office Supply occupied a handy location on East Main.

Out at the Hi Ho Shopping Center, Tiffany's Skate Inn debuted. The huge roller skating complex featured teen dances on Fridays. A new gymnasium was installed at the back of the Memorial Building for youth and others desiring to stay fit or play a game of basketball. In 1972, the City was awarded $600,000 in state and federal funds for development of DeCoursey and Clover Creek Parks, a 55-acre site southwest of the city.

The Puyallup Jaycees were an active group in the early 1970s. Among other projects, they set up one of the first recycling facilities in the area, out at the Hi Ho Shopping Center. Private citizens, too, caught the environmental awareness spirit. Residents of Fruitland Avenue near the Johnson Rendering Plant took the owners to court to have the plant closed due to the nauseating aroma that assailed their noses. Eventually the firm moved to the Tacoma tide flats.

A 1958 city council ordinance had prohibited selling cars on Sunday. In 1972, dealers appealed to the council to repeal the prohibition, arguing that other car sale locations remained open all week and the law was discriminating against them. With the opening of the many malls in the area, local jurisdictions were losing the ability to control the marketplace.

Bill Korum established a new Lincoln-Mercury dealership in 1973. Cars continued to be a hot item until the nationwide gas shortage hit the area that year. Local stations began curtailing hours or closing as their pumps went dry. Christmas didn't sparkle that year as homeowners and businesses scaled back on electrical use.

Various governmental agencies continued to arrive in the seventies. The state's employment office and federal government's Social Security outlet provided ready evidence of taxpayer benefits.

Eddie Bauer Incorporated founded a plant in the McConkey Building next to the Meeker Mansion on Spring Street in the summer of 1974. The company produced down-filled jackets, vests, and camping equipment with a workforce of 200 at the site.

A new senior citizens apartment complex called Argus Manor served renters at Ninth Avenue Southeast next to the Puyallup Manor Nursing Home. Nupacific Company of Portland established Manorwood subdivision, one of the largest housing developments to date. The plot grew to a 425-unit site located north of Thirty-ninth Avenue Southeast between Wildwood Park Drive and Shaw Road.

Two local "boys" achieved high state office in 1973. State Representative Len Sawyer became the speaker of the house, and Frank "Buster" Brouillet was elected as state superintendent of public instruction. Both men had graduated from Puyallup High School.

Mr. and Mrs. Chuck Bond, owners of the Bond Blueberry Farm, were named Pierce County Conservation Farmers of the Year in 1973. Bond, a former mayor, had installed the first solid set irrigation system in the Valley and pioneered new and better varieties of blueberries. The award came at about the same time he situated the Valley Tennis Club on his property, one of the few indoor tennis courts in Western Washington.

Odny Wise, a Puyallup School District nurse since 1956, was named State School Nurse of the Year in 1974. This determined woman's list of community accomplishments is among the most impressive in the area.

During the sixties, folks continued to look out for each other and the strangers in their midst, exemplified by the Migrant Ministries program. Again young lads went off to war, and several died in the jungles of Vietnam. Fires, another earthquake, train derailments, unemployment, and other scourges, such as illicit drugs, all had an impact on the town. The construction of State Route 512 proved a mixed blessing, improving commutes while removing the need for travelers to visit the downtown area. As shopping malls loomed and open land disappeared, the character of the small agricultural town inevitably changed.

17. Paving Paradise

In September 1974, a citizens' group calling itself Prime Land Action Needed (PLAN) assembled to try to save agricultural land in the county. Local farmer Wally Staatz responded to the group in a presentation to the Kiwanis Club in January 1975. "Let's face it," he said. "This is no longer an agricultural area."

Staatz credited the demise of farming to the disappearance of the labor market in the area, the rise in the minimum wage, imposition of new industrial insurance and Social Security taxes, and the sudden upsurge of foreign competition. Valley farmers especially protested the requirement to pay unemployment tax on seasonal workers, but to no avail. Federally funded summer youth programs exacerbated the labor shortage. Valley farmer Lyle Radar complained, "Now we're competing with the Federal Government."

By 1975, virtually all of the daffodil planting and bulb harvesting was being done mechanically, which made production much cheaper than for berries, for example. But pressures on the land were growing. Increasingly the farmers were selling out to developers and the bulb industry was moving north to the Skagit Valley. By the end of the 1980s, only a couple of farms produced the golden blossoms.

U.S. District Court Judge Jack Tanner issued an order in 1978 allowing children aged 10 and 11 to work in the berry fields. His ruling helped; some 250 kids joined the pickers. But in 1980, the U.S. Department of Labor outlawed the use of 10 and 11 year-olds for berry picking. The Environmental Protection Agency had ruled that the fungicides farmers used were too dangerous. Growers argued in vain that they had been employing young pickers for 20 years without problems.

Local farmers, frustrated with the shortage of pickers, particularly blamed U.S. immigration law. Under the new law, farmers and other employers were required to certify each worker hired was legally able to work in this country. Farmer George Richen said, "Cambodian refugees are such good workers but they get scared and run the other way from all that asking for information. We're supposed to be Gestapo for the government?" Richen added that he feared local farmers wouldn't be able to resist the profits of selling out to developers, especially with the new picker shortage. He was proved right. Third-generation farmer Allan Scholz, recalling his 20 plus years of fighting various governmental dictates, said, "We're either swinging or ducking."

By 1976, housing was very tight in the area, especially at the lower price ranges. Builders complained they couldn't obtain land and permits took too long. The chainsaw's

OREGON TRAIL WAGON. The Washington State Bicentennial Wagon Train passed through Puyallup on June 18, 1975. The train started at Blaine on June 8 and made 20 miles a day on the Oregon Trail. They wintered at Fort Laramie, Wyoming, and reached Valley Forge by July 4, 1976. (Courtesy Ezra Meeker Historical Society.)

caterwaul, as increasing belts of trees were felled, belied their protests. In 1966, a new single family home cost about $25,000. In 1976, a comparable house went for $45,000. The five-year Manorwood project built homes in the $55,000–$65,000 range.

Garbage had been a Puyallup City responsibility for 18 years when the city sanitation's eight-man department was scrapped in the summer of 1979. Dave Murray's Garbage Service obtained the contract.

Water received considerable attention over the next few years as the City was forced by federal Environmental Protection Agency rules to chlorinate and by the State to install water meters on each business and home. By 1979, water meters were being installed at a cost of $200 each. Business owners and homeowners who could afford them had to pay. It took six years to complete the work.

While supporting their library was nothing new to Puyallup residents, a formal "Friends of the Library" association was established in 1978. In August 2002, the Friends helped dedicate a new library facing Pioneer Park.

The Western Auto Store on Meridian and Stewart Avenue closed after dying a slow death following the advent of convenience hardware stores. The Kirk Company that had operated the Christmas tree business for over 60 years snipped its floral operations and cut the staff.

A survey of businesses in the late seventies revealed that service-oriented businesses were on the increase, outnumbering retail outlets that moved to the malls or closed down. The downtown core area included 108 commercial entities, with over half providing services.

Dave Haley opened the first McDonald's fast food restaurant in town in August 1974. Mrs. Turner's Plantation restaurant on Main Street began serving in late 1975, about the same time as the first Baskin-Robbins ice-cream shop came to East Main Street. Weir Appliances had enough business in those days to open its third store in the county.

Racquetball came into its own in the mid-1970s. The Shakey's Pizza Parlor on South Hill and the War Memorial Building both contained overbooked courts.

Celebrations in commemoration of the nation's 200th birthday commenced in Puyallup when the Washington State Bicentennial Wagon Train camped at the Fairgrounds in June 1975. Ezra Meeker's original show wagon was part of the parade. The Puyallup Indian Tribe, however, did not take kindly to being asked to participate by "attacking" the wagon train while it was in the town.

Feminism and affirmative action arrived in October 1975. Puyallup no longer had firemen and policemen; instead, the City employed firefighters and police officers. A female consultant was hired to put the correct language into effect. It wasn't a whimsical effort—the City needed the documentation to meet federal and State anti-discrimination laws.

Mayor Mary Meyer was elected Puyallup's first female mayor in 1977. In 1978, she told the council she wanted to rid the city of saunas that served as "fronts for prostitution." She got her wish. In April 1979, police and county sheriff deputies raided three Valley saunas in a crackdown on prostitution.

Downtown, redevelopment plans continued. In 1979, a chamber of commerce committee unveiled Puyallup on the Move (POM). The plans called for rerouting traffic and creating a central mall-like area in the business sector. Again a Seattle engineering firm was hired with specialists from San Francisco and local firms.

POM resulted in more tangible improvements to the city than the other efforts had. One of the blocks was revitalized, some buildings painted and awnings affixed. The first downtown Farmers' Market greeted happy residents on July 17, 1982. Purveyors of fruit, vegetables, plants, and crafts still attract large crowds on summer Saturdays. "Operation Main Street" also grew out of the POM effort. Monies allocated cleaned up the streets, added litter cans, built a rest shelter for the Senior Center, and constructed wheelchair ramps.

Pierce County voters approved home rule in 1980, which established a county council with seven districts. Puyallup, at the center of District 2, was now assured of representation at the county level.

Meanwhile, "politics as usual" prevailed in the city. The second and third Puyallup city managers experienced shortened tenure when they ran afoul of city council members. Firefighter pension funds were at the center of the second manager's difficulties, when in the midst of all the brouhaha, a 14-year-old boy torched Kalles Junior High School, destroying the 25-year-old building. It was March 1981 and the students had to attend Aylen Junior High on double sessions for another year.

The Fred Meyer Corporation purchased the Hi Ho Shopping Center, including the retail space in two buildings, in January 1980. The company initially occupied the existing facilities, but eventually tore down the complex and built a new store, which continues to serve customers in northern Puyallup.

Bus service under Pierce Transit started up again in 1980 after many years of limited public transportation. Riders could commute from Puyallup and Sumner to Tacoma.

In 1982, the Puyallup Community Federal Credit Union was established on Stewart Avenue. Manager Darlene Miller noted that any resident was eligible, but that the credit union planned to remain small. Having access to more credit at the time was a boost for many residents. It would take four more years for debit cards to arrive at area banks.

The city council annexed 350 acres of north Puyallup, including a site for a proposed shopping mall. On paper, the mall was set to go, but the economic downturn of 1983 prevented construction. Before the owners could turn another spade, announcements came that Auburn was to acquire a 400-acre mall. The competition was deemed too nearby. The "Puyallup Park," like the Park Hotel, became the facility that never was.

The old YMCA building on Pioneer East was sold to Masonic Lodge 38 when the YMCA Board of Directors located a 10-acre site on Valley Avenue, west of North Meridian and across from Cedarhurst Road, and built an expansive facility. Unfortunately, the new YMCA location proved problematic. Out of town, without good transportation access, the organization failed to acquire the membership it needed. When the Puyallup Park Mall went off the books, there was no longer an anticipated draw to garner members. In 1990, the City agreed to buy the property for nearly $1 million and turned it into the Puyallup Recreation Center.

By the mid-eighties, the city's fortunes improved. In March 1984, ground was broken for a new court and council chambers adjacent to the Senior Center. The Washington Chapter of the American Institute of Architects awarded local architect Lorin Ginther honors for the building design.

Pierce County finally adopted a Growth Management Ordinance in January 1983. Citizen advisory groups were named to draw boundaries and help establish zoning regulations within their respective areas. From some perspectives, the effort came too late to thwart the development of the Valley, Puyallup, and South Hill.

In the Valley, landowners declared if the public wanted to pay to keep farmland undeveloped, that's what it would take. The farmers noted they were paying industrial taxes on land not being used for anything, but if the land were in the public domain, that tax base would be lost. Moreover, they echoed Wally Staatz's earlier position that the land was their retirement policy.

A *Pierce County Herald* headline in 1984 cogently framed the question "Is future suburban or rural?" There were no easy answers. While some argued for retaining large lots in the rural areas, nobody could decide where the rural area began and the larger density areas ended.

Meanwhile, absent detailed plans, outside the city, the County continued to authorize developments. Citizens on Fruitland Avenue, for example, unsuccessfully fought a multi-acre development. In 1985, one of Chuck Bond's blueberry fields became the site of a 120-unit housing project for people requiring nursing care.

But there were gains. Citizens on Shaw Road won a long battle to keep commercial businesses away. Some 350 acres around Shaw were rezoned in order to prevent commercial development.

Not only was preservation of earth an issue, air pollution was also becoming a topic of concern. Increasing numbers of automobiles, coupled with industrial pollution, produced a yellowish haze that hung over Puget Sound. Recognizing they could do little to curtail automobile usage, the Pierce County Commissioners amended the county zoning code to require all new apartment buildings to average at least 1.5 off-street parking stalls per unit instead of 1.

In the November election of 1985, an off-election year, voters in Pierce County were given the chance to decide if taxpayers should pay to keep farmland from being developed. Not enough voters went to the polls. The people had spoken—the majority either did not care what happened to the land or did not wish to pay the price for keeping it out of developers' hands.

Beginning January 1, 1985, the City acquired a third postal zip code. The next year, city building permits for multi-family housing units doubled. Single-family permits skyrocketed as well. To move all these people to their jobs out of town, Sound Transit authorities began discussing a rail that would link Seattle and Tacoma. It would take another 15 years before commuters would step on a train in Puyallup, as they had in the early 1900s, and head for the big city.

In 1987, city council members voted to decrease lot size on undeveloped land. More houses per acre meant more taxes—taxes used in part for roads. Road repair all over town

YMCA, c. 1987. At least six different buildings housed the YMCA over the years. This photo depicts members on the lawn of the building on Valley Avenue. Today the YMCA resides in a new complex on South Hill. (Courtesy Korum YMCA.)

prompted this sign on Realty World at 305 East Stewart: "All streets in town under construction. Expect delays—carry food and water."

The first cellular phones arrived in Puyallup in September 1984. McCaw Cellular One offered a basic rate of $39.95 monthly with 49¢ per minute during peak airtime. A standard car phone at the time cost $3,500 while a good cellular phone could be purchased for $1,000 or less.

Valley auto dealers began expanding as the economy improved. Puyallup Lincoln Mercury built a new facility, Korum Mitsubishi started up, and Ken Parks Chevrolet and Arnie Dahl Ford remodeled or added on.

The Rainier Vista Care Center opened its doors on Twelfth Avenue Southeast in the summer of 1986. The facility serves patients suffering from Alzheimer's disease.

By the spring of 1986, Pierce County had 17 known cases of AIDS, a deadly disease transmitted primarily by sexual contact or contaminated blood. Good Samaritan Hospital sponsored meetings to educate the public on the disease.

In November 1987, one of the town's oldest businesses closed when Gerstmann's Menswear shut its doors after nearly 80 years. The year 1989 saw the end of several old businesses: The IGA store; Coats Galore, an outlet selling outerwear; and Macy's Apparel and Bootery.

A yearlong state centennial celebration began in November 1988 with a band concert and program in Pioneer Park. Rominous Nix's 147-year-old farm, run by his grandson, was designated a Washington State Centennial Farm for being the oldest in the county, and third oldest in the state still owned by the original family.

The Tacoma–Pierce County Economic Development Board endorsed a plan to create a "Cascade Corridor" of business and industrial development along the Puyallup River. The

CENTENNIAL TREE PLANTING. *Hazel Hood, center, longtime member of the Ezra Meeker Historical Society, helps Peter Ziemke, a young man, and Campfire Girls plant trees in honor of Puyallup's 100th birthday. Many varieties of trees, some very old, line Puyallup's streets and byways. (Courtesy Bob Minnich.)*

plan envisioned a swatch of land from Commencement Bay, up the north side of the Puyallup, into the Stuck River Valley, to the King County line, planned and zoned for business parks interspersed with farms and wetlands parcels. The corridor is fast filling up with commercial enterprises, the fields becoming fewer and farther between.

The Puyallup City Council again engaged in "futuring" under the tutelage of a Federal Way consultant. Among the visions were the following: the Fairgrounds would include a convention center, and a full-service community college would be located nearby. The Puyallup Pierce Community College campus remains a tangible result of these visions.

"Main Street USA" focused on downtown revitalization in 1988. With extra money available, 10 acres were added to Woodbine Cemetery. In 1990, some city services were extended to South Hill.

In May 1989, the City unveiled a future framework. Moderate forecasts showed the city population would exceed 30,000 by 2010. (The 2000 census counted 33,011.) Plans called for a new two-story city hall, and a new library near Pioneer Park.

At about this time, county and local emergency planning groups began addressing the potential for Mount Rainier, an active volcano, to erupt, or for an earthquake to start a lahar (mudflow) off the mountain. The Orting and Puyallup Fire Departments agreed to blow their sirens to warn residents. While emergency planners have since employed modern technology to provide the earliest possible warning, given the geology and geography of the area, neither town will have much time to evacuate should a lahar occur. The mountain is both Puyallup's blessing and curse.

Well before the state celebrated its centennial, the city appointed a centennial committee that began planning for Puyallup's 100th birthday held August 17–19, 1990. Festivities over that weekend included volksmarches, a pioneer reception at the Meeker Mansion, a Company M Militia encampment, pony rides, skydivers at the Fairgrounds, and a grand barbecue. On Saturday various musical groups performed. At noon on Sunday bells rang citywide in commemoration of the milestone reached in the life of this pioneer community.

The centennial committee also wanted to leave a lasting memento of the city's 100 years by creating a new park centered on the Meeker Mansion. Ambitious plans called for phased development with a forecourt and formal gardens, a bandstand, perimeter plantings of various trees, and a market place with a bed and breakfast inn, turn-of-the century houses, and a tot lot. The trees were planted and a wrought-iron gate was installed on the Meeker Mansion outlet to Pioneer Avenue, but the other plans have yet to materialize.

Bumpy economic times dominated the seventies and eighties, but as the city approached its centennial, the town prospered, displaying the results of improvement schemes. If progress is measured in modernization, annexation, and productive lives, residents had much to celebrate in their town's 100th year. No longer a pioneer village, Puyallup was on the prowl, especially evident in the spread up South Hill.

18. Taking the Hill

This chapter is not meant to convey a comprehensive history of South Hill, much of which remains outside of the Puyallup city boundaries. Rather it provides an overview of the actions that brought development to a wooded rural area of considerable beauty.

Arthur Martinson, professor emeritus of Pacific Lutheran University, grew up on a farm on South Hill. His father ran a grocery store downtown and farmed on the side, as did many residents. Martinson recalls, "All around us, up and down every street, there were 5- and 10-acre places. We all did pretty much the same things—a couple of cows, some chickens, pigs, rabbits, etc. I can't think of any family that actually farmed their places without working at another job. We were 'Puyallup rural' in the local cultural context."

In 1878, German immigrants Alois and Mary Ann Kupfer settled on South Hill. They added an additional 80 acres to their 160-acre homestead and raised hops among other crops. Their homestead at the top of South Hill provided the land for the Willows, a shopping center.

By 1957, a food center, café, trailer court, lumberyard, and Thackeray Brothers' South Meridian Meats were all going concerns in the area. Piggly Wiggly, Pay N Save drugstore, Mr. Es (a division of Elvin's Department Store), Hallmark Cards, a music store, an ice-cream parlor, and real estate office opened at the Willows Shopping Center in 1973. The City of Puyallup annexed the center ten years later.

As the area grew, residential developers salivated at the opportunities afforded by all of those open spaces on South Hill. In the post-war years, development came slowly—the spurt years occurred in the late sixties. Developers bought property, logged it, put in streets, and poured concrete pads before anyone could protest. Citizens wishing to slow the growth were powerless to stop the process, although they did try.

In July 1973, the South Hill Community Council formed, intending to give the approximately 8,000 residents an unofficial voice in the area's destiny. Paul Hackett chaired the group, whose purposes were worthwhile, but the body held no legal authority over zoning or permit granting.

During the summer of 1978, crews cleared 30 acres of second-growth timber to build the commercial complex at 116th and Meridian East.

A Seattle developer built the Safeway, Ernst Home Center and Malmo Nursery, and apartment complexes.

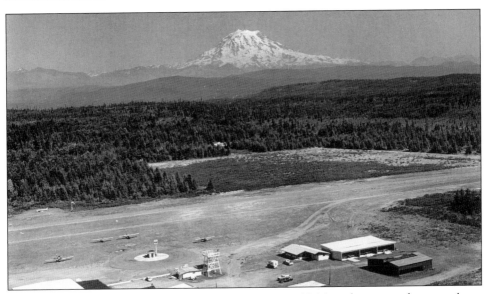

THUN FIELD, 1960s. Built by private investors in 1944 and once used as an Army auxiliary facility, the airfield was paved in the 1950s and bought by Pierce County in 1980 for corporate and private use. (Courtesy Beta Club Collection.)

As the woodlands and pastures yielded to the bulldozers, catchy names sprang up at the entries of tracts of homes: Forest Green, Rustling Firs, Manorwood, Firgrove, Gem Heights, Sunset.

Puyallup's first "Street of Dreams" debuted in 1986 along Twenty-first Avenue Southeast off Wildwood Park Drive at the new Manorwood Estates entrance. For a $5 parking fee, dreamers toured the fully landscaped lots holding homes replete with the latest amenities. Built by various construction firms, the top asking price was $180,000.

THUN FIELD

Private developers built an airport on East Meridian in 1944, intending it to serve as a training auxiliary field for the U.S. Army. The runway was an unpaved strip with a few buildings when John Thun bought it and the surrounding 350 acres of land in 1950. He lengthened the runway to 5,400 feet, paved it, and opened it as a private airport. By 1957, the Thuns, who lived in the building where they maintained a coffee shop, had several buildings and 45 aircraft tied down at any one time, 15 with hangar space.

The "back 40" acres of the field were used by Skookum Archers as an archery course, and two Boy Scout troops built camps in the wooded areas. Highly popular drag races were held on the runway until a separate raceway was constructed, attracting thousands of fans for car and motorcycle racing. Various air shows were also held to entertain visitors.

The Puyallup Valley Development Company purchased the airfield in 1966 and formulated plans to develop the site into an industrial park. For a time the company sold Cessnas from the field.

MERIDIAN AND AIRPORT WAY, 1940. This intersection is today the site of the Willows Shopping Center and South Hill Mall. (Courtesy Ezra Meeker Historical Society.)

In April 1979, Thun Field was offered at auction by Dwight Garrett of Enumclaw for $1.1 million. With the majority of funding from the federal government and help from the State, in 1980 Pierce County became the owner of the airfield. Now under the auspices of the Public Works and Utilities Department, the field continues to be used by corporate and private aircraft.

Local activists grew concerned over upgrades to Thun Field in 1985 that threatened to bring jet noise to their neighborhoods. Others were seeking to close the Hidden Valley Landfill south of 176th Street on Meridian. Together, they formed South Hill Action to Protect our Environment (SHAPE). In March, a SHAPE rally attracted 400 residents to discuss the airport and dump. They did not succeed in closing the dump, but Thun Field was not upgraded for large jet aircraft.

ELSEWHERE ON THE HILL

The state bought 40 acres of land for $204,450 on 144th Street East and Eighty-sixth Avenue East and transferred it to Pierce County for 40 years, with the understanding that a park would be developed and maintained there by the Pierce County Parks and Recreation Department. Governor Booth Gardener was on hand to help dedicate the park in January 1983. The tortured history that ensued over this land to the year 2000 still had not produced a useable park on this location. But it isn't the fault of the South Hill Citizens for Outdoor Recreation (SHORE), which mobilized to create a park and tried to entice funding out of the county.

The Puyallup City Council actively pursued industrial development on South Hill for several years. In January 1981, Fairchild Industries announced interest in a 100-acre site off Thirty-ninth Avenue Southeast to manufacture wafers for integrated circuits.

Fairchild began hiring people in 1983, but never the numbers envisioned at the outset. In 1987, Fairchild sold out to National Semiconductor, which subsequently closed its doors as well.

As commercial enterprises sprouted on Meridian East, vandalism and thefts increased. In January 1986, a Pierce County Sheriff's Department Precinct opened in a modular building on 160th Street. A permanent facility was established at Meridian East and 160th Street East in the 1990s.

SOUTH HILL MALL

The growth on South Hill did not escape a major national shopping mall developer. The Cafaro Company of Youngstown, Ohio, purchased 43 acres at the crest of South Hill, east of State Route 512 and west of the Willows Shopping Center, in December 1986, for $8.5 million. Two national retailers, Mervyn's and Target, were recruited to anchor the ends of the large complex.

Meridian Street widening projects over the course of the summers of 1986 and 1987 made it feasible to establish the mall and the first stores beckoned shoppers in the summer of 1988.

In the fall of 1988, a branch of the Pierce County Library system opened a pleasant brick facility on Meridian Street East. With over 31,000 residents, a library, shopping centers, an airfield, a community college, several public schools, and a variety of churches, South Hill has few vestiges left of its rural past.

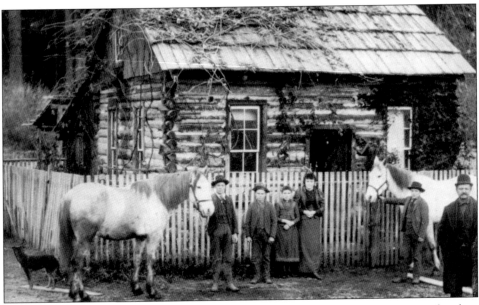

KUPFER RANCH, C. 1890. German immigrant Alois Kupfer, right; his sons, young daughter and a boarding teacher stand in front of the cabin Alois built on the homestead he claimed in 1878. The property is now the site of the Willows Shopping Center. (Courtesy Don Kupfer.)

19. Puyallup's Pearls

When viewed from a historical perspective, Puyallup's schools, Pierce College, the Western Washington Research and Extension Center, Good Samaritan Hospital, Fair, Daffodil Festival, and Meeker Mansion fulfill the pioneer vision of a vibrant, people-oriented community. Mills, hops, bulbs, and berries may be largely memories, but the institutions they helped to found—Puyallup's pearls—are thriving.

Public Education

Driving around Puyallup and its environs, a visitor would conclude that here is a town that cares about the education of its youth. From city settings to wooded suburbs, new and refurbished schools affirm the area's investment in its future. What the visitor doesn't see are the fires that destroyed several of the schools' earlier buildings, the lean years when teachers eked out a living on meager salaries, the student and teacher deaths during the flu epidemic, the bonds that passed or failed by a whisker, and the desks vacated during the world wars. The following represents but a thumbnail sketch of the progress of the Puyallup School District during the last century.

Elementary Schools

The District entered the twentieth century with four schools: Central; Meeker, or "Pink" School; Maplewood; and Spinning. Riverside followed in 1906, and the next year the district purchased its first typewriter. The Woodrow School on Waller Road was built in 1913 by an independent school district and did not consolidate with the Puyallup School District until 1950.

On June 17, 1922, the old Central School building, originally erected in 1886 and added on to in 1903, succumbed to a devastating fire. When school started in the fall, pupils occupied classrooms and halls in various churches. Another six-room unit, again called Meeker, was built on Fourth Avenue and Fifth Streets, and a two-room unit was added to the Spinning School.

At the end of the 1925 school year, rebuilt Central School was renamed J.P. Stewart School in honor of the early Valley pioneer. In 1928, when Stuart Van Slyke was in the sixth grade, Principal Cowan would send two boys up town, about eight blocks on foot,

KARSHNER ELEMENTARY SCHOOL. *This now 400-student school was built in 1953 and named in honor of Dr. Warner M. Karshner. In 1904, fresh out of medical school, he established a practice with Puyallup's other doctor, Thomas McCracken. In 1917, Dr. Karshner became a Washington State Senator. Later Dr. and Mrs. Karshner traveled extensively and provided the artifacts for the Karshner Museum, named in honor of their son Paul, who died from polio at age 16. (Courtesy Beta Club Collection.)*

to get a case of milk at the local creamery for school lunches. Van Slyke made a two-wheel cart to ferry the milk, which made it more fun than carrying the heavy case.

At the height of the Depression, teachers took 5 percent pay cuts, and music and gymnasium classes were curtailed or stopped altogether. Yet, through the lean years, the town continued to support the schools.

The 1891 Maplewood School was razed to make room for the new school, which was dedicated on March 8, 1935.

Superintendent of Schools Paul Hanawalt served from 1930 to 1959, the longest-reigning administrator to date. He stressed character education as a prime objective for the schools and each year admonished the teachers to teach students how to think.

By 1944, the local schools felt the pressure of a full-fledged influx of new students. City schools were eight rooms short by the end of World War II, with students convening in halls and on playcourts.

The first school demonstration of fluoride applications, believed to double resistance to dental decay, began in November 1948. When the Salk anti-polio vaccine came available, in 1955, it too was administered through the schools with parental permission.

The Warner Karshner Elementary School on Eighth Avenue Northwest was dedicated in November 1953. When Mrs. Karshner followed Dr. Karshner in death in 1962, her entire estate went to the Puyallup School District. After all the Karshners had done for the town, to include the donation of so many artifacts, naming a school after Dr. Karshner seemed quite appropriate. In November 1965, the Karshner artifacts were moved to the old Stewart School on Fourth Street Northwest. As it has since, the Karshner Museum

continues to be owned and operated by the Puyallup School District for the children of the town.

One of Puyallup's first private schools was founded in September 1954 in All Saints Parish. In January 1955, the 27-year-old Riverside School was razed by fire, leaving 140 students without their classrooms. Other schools had to make room. The next year the Woodland School District consolidated with the Puyallup School District.

In 1949, the district purchased a blackberry field on Third Street Southeast, which became the site of Puyallup Junior High School. Dedicated in April 1957, the school served 700 students in grades seven and eight from the entire district. The district again grew when voters in both Firwood and Puyallup elected to consolidate the two districts. Henceforth, Firwood seventh and eighth graders attended Puyallup Junior High.

School construction projects abounded in 1960—Firgrove, Waller Road, and Spinning were all refurbished or enlarged. Unfortunately, at the end of December, a fire of unknown origin destroyed 9 of the 12 new classrooms under construction at Firgrove. As a result, the school wasn't finished until July 1961.

Groundbreaking began for West Puyallup Junior High School in March 1962, but labor strikes intervened and the classrooms weren't available until November. Puyallup Junior High went to double shifts until the new building was complete.

When West Puyallup Junior High opened, the ninth graders left the senior high school building and both junior high schools became three-grade schools. At this time Puyallup Junior High School became East Junior High, serving students from Firgrove, Firwood, Meeker, North Puyallup, Spinning, and Stewart Elementary Schools.

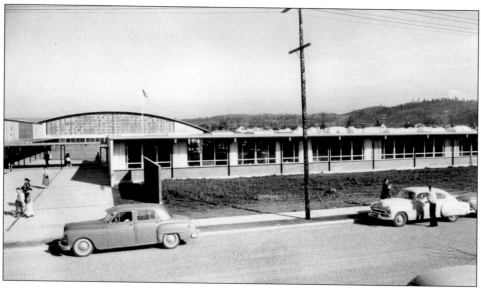

EILEEN B. KALLES JUNIOR HIGH SCHOOL. *Puyallup's first junior high school was dedicated in April 1957. Originally called Puyallup Junior High School and later East Junior High, in 1970 it was named for Kalles who served on the Puyallup School Board for many years. (Courtesy Beta Club Collection.)*

The Riverside School District consolidated with Puyallup that year as well, bringing more students to the junior and senior high schools.

The school district purchased two new elementary school sites in the summer of 1964—one on South Hill off Shaw Road and another near the newly constructed water tank near Twenty-third Street. The Fruitland Elementary School was ready in September 1965 and a year later, Wildwood Park School. In 1967, the Edgemont District consolidated with Puyallup, making 9,500 students attending Puyallup schools.

Yet another fire nearly claimed Meeker School in October 1976. Students went to Maplewood with new hours until their repaired school reopened in December.

Over the course of the next 14 years, taxpayers provided funding for six additional schools: Sunrise, 1973; Northwood, 1974; Puyallup Alternative, 1975; Ridgecrest and Pope, 1981; and Hunt, 1990.

PUYALLUP HIGH SCHOOL

Thirty-five students graduated from Puyallup High School (PHS) in 1912. More classrooms were added, but even they proved insufficient and portable rooms had to be added to the grounds by 1926.

Budding journalists at PHS started a newspaper in 1920. Named the *High Life*, by 1923, the name had been changed to the *Viking* in commemoration of the athletic field built in 1923. To this date the school newspaper carries the name *Viking Vanguard*.

From the report card of one Townley Pierson, we learn what subjects PHS taught in the mid-1920s. In the ninth grade Townley took English, algebra, Latin, general science, and gym. By his senior year, he was studying geography, bookkeeping, and common law.

On May 9, 1927, fire gutted the high school and the 101 seniors graduated that year in a packed Liberty Theater. A referendum provided the funding needed to rebuild, and 23 rooms were ready for junior and senior high in the fall. Classes were rotated and hours changed to enable all students to attend. It took three years to complete PHS, this time finished in stucco with a tiled roof.

Governor Clarence Martin spoke at the dedication of the new school auditorium in 1935, hailing the $26,000 facility as the most complete and beautiful school auditorium in the state. The room served as a dance floor as soldiers poured into Fort Lewis. Local girls were urged to attend, and more than one landed a future husband. School sports, movies, and the new Puyallup Bowling Center, which started up in the fall of 1941, provided other opportunities to date. Unfortunately, the 1949 earthquake severely damaged the roof and ceiling over the auditorium, but both were restored.

Flexibility became the game for the local area schools as World War II intervened. In 1941, for example, Al Dahlberg, Puyallup High School head football and basketball coach, was called for military duty. His replacement, Carl Sparks, had been in town for a short time, but he soon proved himself. When the Puyallup School District created a director of athletics position in April 1950, Sparks accepted the position.

An arsonist caused $75,000 in damages to the gymnasium and auditorium at Puyallup High School during a basketball game in February 1950. Fortunately, nobody was hurt in this chemical-induced blaze.

By 1958, the school board determined that high school students would be required to have 42 credits to graduate, an increase of 8. That same year, school improvement levies and a bond to fund a new town library both went down in defeat. But a new gymnasium for the school was approved and dedicated in December 1959.

The American Field Service International organization brought foreign students to PHS in 1959. Teens also organized Safe Teens that year after a series of tragic traffic accidents led the students to improve driving skills.

In 1960, the first foreign language laboratory was installed at the school, and for the second year in a row, PHS students won most of the top awards at the University of Puget Sound Science Fair. Much of the credit went to physics teacher Ray Provost, who said, "Gone are the days when a physics course meant a study of gears, levers, heat, and sound. The new physics is designed to teach optics, wave natures . . . heat and light mechanics, electricity and atomic energy."

After literally decades of attempts to fund a swimming pool, voters finally approved a bond for a public pool at Puyallup High School in 1960. On June 30, 1963, over 700 swimmers took their first splash in a facility that proved to be very popular.

Puyallup High School badly needed remodeling by 1971, as it did not meet life safety requirements and other codes of the day. The fire chief declared the third floor a potential death trap, and by a narrow margin voters approved funding to remodel the classroom wings and build two new elementary schools. While the school was undergoing its extensive renovation, students used classrooms at Aylen Junior High and in the Presbyterian church across the street.

By the mid-1970s, vocational education had become a vital part of the high school curricula. Over 400 students were learning agricultural practices, business and office occupations, retailing, transportation, auto mechanics, carpentry, and building. Ezra Meeker, who constantly urged that students in his day be educated on practical subjects, would have approved.

The alumni association of the Puyallup High School has a long tradition of annual meetings and banquets. The association also sponsors scholarships and contributes in other ways to the ongoing activities of the student body.

JOHN R. ROGERS HIGH SCHOOL

John R. Rogers High School matriculated over a thousand seventh through tenth graders the fall of 1968 on South Hill. Dubbed the "Little Red Schoolhouse," the $3.5-million facility contained 36 classrooms on two floors while a two-story instructional materials center held the library and audio-visual equipment. Students had an up-to-date gymnasium and music wing in their tranquil, wooded setting.

Rogers, a Populist Party candidate from Puyallup, served as governor of the state from 1897 to 1901 and was author of the Barefoot Schoolboy Law, which placed responsibility on the State for providing yearly allotments for each child of school age. Local districts still had the major responsibility, but Rogers also acknowledged the State's role.

Puyallup and Rogers High School students gained entry into high-tech jobs with an agreement with Fort Steilacoom Community College and Central Washington University.

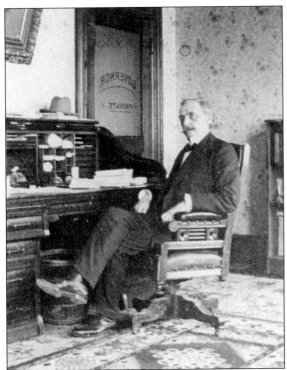 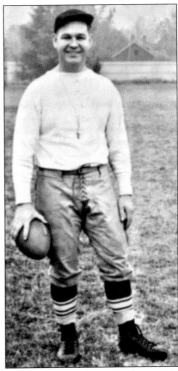

LEFT: GOVERNOR JOHN R. ROGERS. Rogers was a Puyallup resident and businessman for only six years when he was elected as the third governor of Washington State, in 1896. RIGHT: CARL SPARKS. The Puyallup High School coach arrived during World War II. In 1950 he was appointed the first director of athletics for the Puyallup School District. The district's sports complex still bears his name. (Both images courtesy Lori Price Collection.)

Students graduating from the technical program at the high school level were prepared for entry-level technician work with local industry or could continue on at Fort Steilacoom to obtain an associate degree in electronic engineering technology. The program was reportedly the second in the nation.

Various sports played a major role in both high schools. Space does not permit discussing all of the sports and the many stars who competed, some of whom went on to regional and even national fame. Football, baseball, basketball, wrestling, swimming, and many other athletic adventures kept the students fit and fostered teamwork for generations. Girls' sports began to flourish in 1978 as a result of the federal Title IX program, which dictated that schools provide sports programs for them.

Much-beloved athletics director Carl Sparks died at 61 in 1969 from heart failure. The district's stadium was named for him as was its successor built in 1987. Along with all the schools in the district, youth organizations and Pacific Lutheran University make good use of this facility for games and other functions. The Puyallup pool at the high school had to be demolished in 1987 for safety and health reasons. The rebuilt pool was ready in 1989. A new high-tech pool at Rogers High School opened in September 1987.

THE NAME GAME

In February 1970, Puyallup School facilities acquired new names. The Carl Sparks Stadium honored the recently deceased athletic director. The Puyallup High School Swimming Pool was named the Harry. P. Hansen Pool in honor of the retired former principal. The building known familiarly as the "new gym" was formally designated the Paul B. Hanawalt Pavilion.

East Junior High was designated Eileen B. Kalles Junior High School. Kalles had been director of the Puyallup School Board from 1952 to 1967 and had risen to president of the Washington State School Directors Association. Before her retirement, she served on the National School Board Association Policies Committee.

West Junior High School carries the name Charles H. Aylen Junior High School in honor of the retired physician who served on the school board from 1931 to 1942. When it was first ready for students in the fall of 1970, the new junior high was named the Frank H. Ballou Junior High School to honor the Firgrove community leader, who was instrumental in bringing about the consolidation of the Firgrove and Puyallup School Districts.

The newly named schools seemed more in touch with community roots with the honored names and less a location on a map. Still there were some who asserted that the older names meant little to current students. Such will always be the case.

The school district established a "gifted" program in 1979. The State provided funding for up to five hours a week of special instruction in grades one through six for 60 children. At the time the district had identified over twice that many who deserved the special attention. Local funds made up the difference as more and more students qualified for the extra attention.

PIERCE COLLEGE, PUYALLUP CAMPUS. *Higher education first came to South Hill in 1974 as an Individual Progress Center. That effort grew into the Fort Steilacoom Community College Eastern Campus. In 1986 the college name was changed to Pierce College, and in 1990 the Puyallup campus, pictured here, opened. (Courtesy Pierce College.)*

When a 14-year old boy torched Kalles Junior High School in March 1981, the State made it possible for the district to spend the $3.4 million to build the new school to code. It reopened in November 1982.

Ferucci Junior High School, named after Dr. Vitt P. Ferucci Jr., veterinarian and longtime school board member, opened near Wildwood Park in the fall of 1982.

For many years the State had supported local school districts from the taxes from lumber sales. As fewer board feet of timber were sold due to both its declining availability and environmental restrictions, school districts had to come up with more local funding. Most Puyallup School District levies and bonds passed over the years as the town did its level best to support the student population.

The school district continued to procure portable classrooms at various schools. Superintendent Dr. Herbert Berg reported in 1989 that they had gained over 1,200 students in the past three years. In 1990, over 830 students graduated from the two high schools, a substantial increase from the 35 that graduated in 1912.

PIERCE COLLEGE

Puyallup city fathers and school administrators angled persistently for a higher education institution long before Pierce College opened its doors on South Hill in 1990. As early as 1961, Puyallup applied for a State-sponsored community college. Although initial promises would have brought a college by 1972, it wasn't until September 1974 that an Individual Progress Center started up in rental space on 112th Street on South Hill. The center developed packaged learning programs, which allowed students to begin at any educational level. Subjects included English, reading, history, mathematics, science, and social studies.

The center became the Fort Steilacoom Community College Eastern Campus, a part of the permanent college located in Fort Steilacoom near Lakewood. Ten years later the thriving school was still operating in increasingly crowded rental space on both sides of 94th Avenue East and 112th Street East.

Administrators and the Puyallup City Council continued to petition the Washington State Legislature for permanent space. Proponents argued that the college should be close to high-tech industries, such as the Fairchild plant on South Hill, so the campus could serve as a work training center.

As both the permanent campus and Puyallup rental campuses grew, the name changed to reflect more accurately the broader scope of services. Pierce College, with extensions in Fort Steilacoom and Puyallup, was instituted on March 15, 1986.

The next year, the Washington State Legislature approved funding for a permanent campus in Puyallup. A 122-acre site was purchased just south of the Fairchild campus on Thirty-ninth Avenue Southeast. The fall quarter of 1990 students and faculty celebrated the grand opening of the first building. It had taken nearly 30 years for a permanent campus to arrive in Puyallup, and the celebrants made the most of the happy occasion.

Puyallup can be proud of its dedication to education. From the earliest days the youngsters of the community have had access to schooling, taught by good teachers and managed by caring administrators. Whether graduates went on to higher education

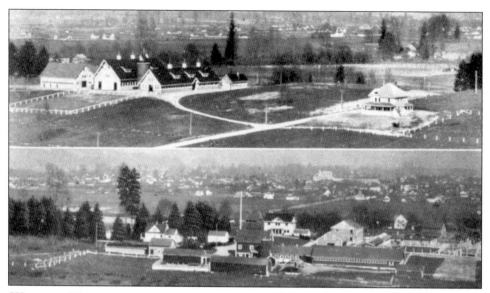

WESTERN WASHINGTON RESEARCH AND EXTENSION CENTER. This prestigious station opened in 1895 on property donated by the Ross family. In 1971, Extension faculty members developed the Master Gardening Program, which spread throughout the United States. (Courtesy Perkinson Collection.)

institutions or into a vocation, if they applied themselves in the Puyallup schools, they were well prepared for their future.

WESTERN WASHINGTON RESEARCH AND EXTENSION CENTER

If it hadn't been for a couple of generous farmers, the Western Washington Experiment Station might never have been located here. Darius M. Ross laid claim to high-quality farmland west of Puyallup in 1865. His son Charles H. Ross, who had been born on the Oregon Trail, eventually owned adjoining acreage, and together, they became the benefactors of Puyallup's most celebrated institute.

According to the memoirs of Charles Ross, the movement to establish the station in Western Washington originated with the State Board of Horticulture, of which Charles was a member. After traveling over the state, the group realized that experiments taking place at Washington State College in Pullman wouldn't necessarily aid farmers on the western side of the Cascades. Hence, the members appealed to E.A. Bryan, president of the college, to establish an experiment station in Western Washington.

Bryan agreed, provided at least 40 acres could be located. Charles conferred with his father and each agreed to donate 20 acres to the project. Bryan visited the properties and asked for an additional 20 acres, which Darius offered for $3,500, considerably under market even for those days.

Subsequently, the Washington State Legislature appropriated $2,500 for the additional land purchase and the Tacoma Board of Trade donated the remainder. Clearing for "Ross

Station," as it was initially called, began in 1895. The first superintendent, F.A. Huntley, a scientist, took on the onerous task of blasting apart the mammoth stumps that had once grounded mighty trees. At the time less than 5 percent of accessible land in the western part of the state had been cleared. Huntley's crews experimented with various explosives, finding the optimum charges to blow out the stumps and roots. The acreage was tilled, and by 1907, staff members planted many varieties of crops.

By 1913, the station had grown to a staff of five professionals, who not only conducted research, but who reached out to the remotest communities with agricultural and home economics information. For many years the station conducted Winter Schools, which offered practical instruction in berry growing, orchard production, dairying, poultry husbandry, and nutrition. Eager farmers and housewives took advantage of the opportunities to learn the latest tricks. In 1919, an $800,000 grant provided funding for a dairy herd, a dairy barn, and an additional 60 acres of land.

Among all of its many claims to fame, Puyallup has the honor to be mentioned in the *Guinness Book of World Records*. The entry concerns the findings of Puyallup-based scientist Theophilus Scheffer, who cooperated with the station in performing a biological survey of agricultural pests in 1913–1914. In the course of study, this eminent researcher extracted fleas from a mountain beaver's nest. Apparently, because they were exceptionally large, he measured them. A female version of the flea, which came to be known as *Hystricopsylla scheffer schefferi*, measured up to 0.31 inches, about the diameter of a pencil. The record stands today—Puyallup, home of the largest known flea in the world.

When Dr. J.W. Kalkus, a veterinarian, became superintendent in 1926, he shifted from demonstrations to a strong research program. Dr. Kalkus became well known for his research on iodine deficiency and supplementing livestock food with iodine. His work contributed to the value of placing iodine in table salt to ward off human goiters.

In the 1920s, plant pathologist D.J. Crowley discovered that frost injury to fruit buds could be prevented by turning on sprinklers when the temperature dropped to 34 degrees Fahrenheit. This simple application saved countless crops.

The Great Depression years brought hardships, and World War II brought emphasis on increasing seed production for the United States and our Allies. After the war, the center hit its stride in research. In 1949, Dr. C.D. Schwartze and others introduced the "Northwest" strawberry, the first of many virus-tolerant strawberries for the Pacific Northwest. This rich, juicy berry rapidly became the most widely planted strawberry in the country. Later, Dr. Schwartze developed the "Meeker" raspberry, which became very popular as well.

A host of other accomplishments ensued, including improved calf health, increased milk production, fungicide treatments for bulb diseases, food and nutrition programs for low-income families, and fast-growing poplar trees used for pulp and fuel production. In August 1965, the center was named the Western Washington Research and Extension Center, a name that more accurately reflected the work underway.

Many long-lasting agricultural developments arose from the Center's efforts in Western Washington. The Master Gardener program stands out as a particular accomplishment. Extension faculty members Arlen Davison, David Gibby, Bill Scheer, and Bernard

Wesenberg, experiencing the increasing demands of a growing urban population, developed the program for Pierce and King Counties in 1971. Under the concept, the Center's faculty and specialists train volunteers to be master gardeners in various metropolitan areas. The master gardeners then provide homeowners with the knowledge and skills to be successful in their gardening. The program is so effective that it has since spread throughout the United States.

"Ross Station" has proven to be a tremendous asset to generations of Northwest farmers, gardeners, and consumers. From tree and stump removal to new methods of tree production, researchers continue to fulfill the goals envisioned when the land was donated.

GOOD SAMARITAN HOSPITAL

The first Puyallup "hospital" occupied a most elegant building—the Meeker Mansion. Winnifred Merwin and Myrtle Nagle leased the home in 1910, painted it gray, and operated it as the Meeker Rest Sanitarium. The first patient, Bob Dudley, was hauled up the stairs in some agony, to the billiard room where Dr. S.D. Barry performed an apparently successful appendectomy.

In 1915, the Ladies of the Grand Army of the Republic purchased the mansion as living quarters, and town patients needing hospital care again had to be driven to Tacoma.

At last, in 1922, five area doctors—Raymond C. Morse, Charles H. Aylen, S.D. Barry, F.J. Cullen, and Warner M. Karshner—pooled their resources and built a $32,000 brick facility east of the Clark Hotel on Fourth Avenue Northwest. When the 25-bed clinic was readied that summer, it offered the latest in standard equipment. Among its other boasts, the hospital housed the city's first elevator.

GOOD SAMARITAN HOSPITAL, 1956. The hospital grew out of the amalgamation of Lutheran Home minor hospital on South Hill and Puyallup General Hospital downtown. Brick was later added to this facade. (Courtesy Good Samaritan Archives.)

LUTHERAN HOME, C. 1940S. This spacious brick facility was built on the northern slope of South Hill in 1913 by the Masons as a lodge for older and infirm members. In 1938, they sold the home to the area Lutherans, who opened it for seniors. (Courtesy Beta Club Collection.)

The first baby born in the new Puyallup Valley Hospital arrived on August 19, 1922. His parents named him Rufus Kiwanis Biggs in honor of the Kiwanis Club, which had helped to furnish the facility.

A month later the newspaper printed a picture of C.S. Corbitt with the Studebaker Big Six he had modified as an ambulance. Dubbed Corbitt's Taxi, the stylish, low-slung vehicle was finished in cream enamel and came equipped with both gong and siren.

Martha Lee and Edith Sterling leased the hospital facility in 1935 and called it Puyallup General Hospital.

In 1942, when war threatened the town, they installed the latest surgical equipment, converted private rooms to wards, added cots, arranged a blackout capability, installed a portable gas-driven generator, and declared their hospital ready as a home defense base.

After the war, in 1947, Genevieve Houston, an experienced nurse, leased the facility and again remodeled it.

LUTHERAN HOME

In 1913, the Masonic and Eastern Star organizations constructed their first lodge in Washington State for older or infirm members on the northern slope of South Hill. The stately home with its broad windows and wide verandas perched on 26 acres, comprising both the view property at the top of the slope and rich bottomland. A scant decade later, the Masons consolidated their holdings and abandoned the Puyallup facility, which sat unoccupied until 1938.

At that time, Vincent Thoren was managing an overcrowded Lutheran home for the aged in Tacoma. The Masonic Lodge Grand Secretary approached Thoren and offered the Puyallup property. According to Thoren, at this time Reverend John Hager of Minot, North Dakota, was visiting with Reverend Ervin Jahr of Peace Lutheran Church in Puyallup. Hager headed a chain of Lutheran facilities in the Midwest known as Good

Samaritan Homes. On his first morning in Puyallup, Hager stood on the back porch of the Peace Lutheran parsonage and found himself looking up the hill at the beautiful set of buildings. Before long the Lutherans had agreed to buy the home and 7.5 acres, worth over a $100,000, for a mere $15,000 with a 30-year mortgage at 4 percent interest. Later the Lutherans purchased an additional 14 acres below the hill to use as pastureland.

John Engfer, carpenter, farmer, and member of Peace Lutheran, loaned the $500 needed for down payment and the deal was consummated. President of Pacific Lutheran College, Reverend Jesse P. Pflueger, and Reverend Ervin H. Jahr serving on the first board of directors, dedicated the Lutheran Home on September 3, 1938. By December 1939, 72 seniors resided in the pleasant, if modestly furnished rooms.

The complex produced its own vegetables and dairy products, keeping costs down and nutrition high during the years of rationing. By 1945, the Lutherans had burned the mortgage and two years later began raising funds to build a hospital for the aged and disabled on their property. The United States Public Health Service gave their approval for the "minor hospital" and provided over $135,000, which was matched locally.

GOOD SAMARITAN HOSPITAL DEBUT

The doctors who owned Puyallup General Hospital approached the Lutheran Home board, which agreed to assume responsibility for their facility in January 1952. That July, Governor Arthur Langlie dedicated the minor hospital at the Lutheran Home. From the amalgamation of the two facilities, a new non-profit hospital organization was incorporated. Its name—Good Samaritan, a title that befit the town's legacy.

Dr. Sherburne W. Heath Jr. established a health rehabilitation center in 1954, offering services to disabled as well as elderly. Four years later a new 72-bed hospital was added to the complex. In 1959, "Good Sam" as it is affectionately known, won full accreditation by the Joint Commission on Accreditation of Hospitals. With the advent of the new construction, the old facility on Fourth Avenue converted to the Stillwell Sanitarium in 1959.

Good Sam opened a Children's Therapy Unit in 1966. Six years later the hospital added an adult mental health service, the first hospital-based community outpatient mental health center in the state. Home health services also started up in 1972.

In 1973, residents of the Lutheran Home were moved to a new complex in Tacoma. Their departure paved the way for expansion.

Concern over the need for better emergency services led the board of Good Samaritan Hospital to build a rooftop heliport in 1973. The hospital also joined forces with Powers Ambulance Service to outfit a new mobile intensive care unit. Good Samaritan continued to be on the leading edge of total health care. Adult day health services, founded in 1976, was one of the first such programs in the nation.

By the late 1980s, the rehabilitation center had become the premier rehab center in the Northwest. Upon Dr. Heath's retirement, after four decades of directing the service, the center was named the Heath Rehabilitation Center. The facility continues to offer physical, occupational, and recreation rehabilitation services that rank among the best in the country.

Good Samaritan has come a long way from its modest beginnings as a minor hospital. Over the years the not-for-profit board and administrators have acquired the latest technology and high-quality health professionals to build the reputation the hospital enjoys. This growing facility, with branch clinics spreading throughout the town, factors as a major economic and social force in the region.

THE FAIR

In the spring of 1900, a small group of visionaries forever changed both the landscape of an emerging rural town in Western Washington and its standing in the Puget Sound. Lewis Alden Chamberlain ("Dad" Chamberlain), whose long white beard rivaled Ezra Meeker's, gathered like-minded farmers around him, collected $81, a board of directors, and the fair was born.

The association determined the first fair would be open three days—Thursday, Friday, and Saturday, October 4–6, 1900. The site incorporated an open area across the street from the west end of current Pioneer Park. A large canvas tent held the exhibits while livestock grazed on hay, tethered to a nearby fence. Nearly 3,000 people attended, arriving in every known conveyance of the day, including railroad coaches from Seattle and Tacoma.

In 1901, Chamberlain and his fellow directors located a 10-acre plot on the current site and established a purchase price of $2,000. They had no trouble raising the funds from public-minded citizens. Before the fair that fall, the first wooden buildings had been

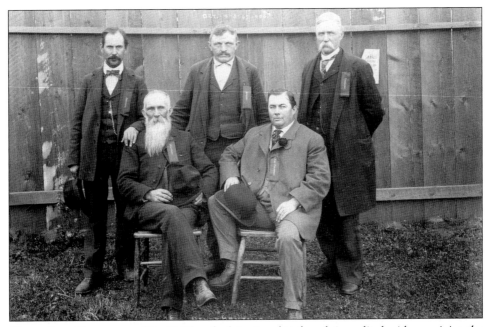

FIRST FAIR OFFICIALS. "Dad" Chamberlain, in white beard, is credited with conceiving the idea for the first Valley Fair in 1900. William Paulhamus is seated next to him. (Courtesy Beta Club Collection.)

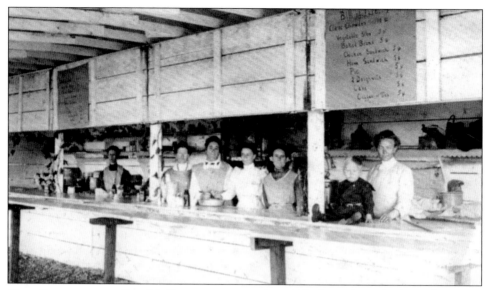

FAIR LUNCHROOM. Local ladies serve up a variety of foods in the early days of the Fair. (Courtesy Lori Price Collection.)

constructed. The directors may have been all male, but they knew how to keep peace with their womenfolk.

When a committee from the Washington Equal Suffrage Association met with the directors and asked for the designation of a "Women's Day," the request was graciously granted. Among their many other contributions, the women organized a "Best Baby" contest that ran for many years.

William Paulhamus succeeded Chamberlain as president in 1906 and held the position until his death in 1925. Under his skillful management, the fair grew in the number of days held, exhibits multiplied, and races were held for not inconsequential purses. Paulhamus's son Dwight wrote that from the earliest days of the fair, entertainment and culture played an important role.

The Valley Fair changed its name from the Puyallup Fair to Western Washington Fair Association in 1913. Acreage was doubled and $25,000 in improvements, including a new $5,000 grandstand, were authorized.

May 1921 brought the preparation of a tourist campground on the 100-foot strip on the north side of the parking grounds of the fair. The next year the Kiwanians installed a larger tourist camp at the corner of Meridian and Fifth Avenue Northeast in what came to be called Grayland Park. In May 1923, the city council purchased the Tourist Camp and agreed to maintain it.

The Fair Association became a non-profit organization three years later with earnings used only for necessary upkeep and betterment. The next year it cost $100,000 to stage the fair, with proceeds of $130,000. Interestingly the budget for the City at the same time amounted to little more than half that of the fair. By the next year the association was free of debt.

One of the most famous visitors to date spoke before a crowd of 30,000 during the 1932 Fair. New York Governor Franklin Delano Roosevelt, Democrat Party nominee for president, won future votes with his pledge that the value of the farm dollar be raised.

World War II brought a halt to the fair with first the military encampment, followed by the Japanese internment. The first fair after the war welcomed thousands of visitors in September 1946 for a nine-day run. The return of the fair signaled an end to the upheaval of the previous four years.

Nettie's Café took over the Farm House at the Fairgrounds and prepared to feed 800 at a time in the large restaurant. By 1957, Nettie was serving 100,000 meals over the course of the fair.

As the various granges in the area were organized, they commandeered their own section of the agricultural building, each year creating attractive displays of fresh and canned produce. The 4-H displays have long been a part of the fair as have the Future Farmers and Future Homemakers of America organizations. From the very young who proudly display their pet bunnies to the senior citizens who annually enter their baked goods or crafts, the fair has offered a time and place to showcase hours of good old-fashioned labor.

Among the more memorable features were the Indian encampments and bareback horse races, which provided attendees with a greater appreciation for the culture of the native peoples.

Outside entertainment has ranged across a broad spectrum of America's popular artists. In 1950, a water follies ballet company performed. Carla Wallenda of the famous flying family thrilled onlookers in 1959. Frank Sinatra Jr. starred in 1967, a year that brought over a half million in attendance for the first time.

Throughout the years the Puyallup City Council, recognizing the value of the fair, enacted favorable ordinances to support the fair association. For example, in 1965, the council voted to grant "unclassified" zoning to the fair for its new property lying south of the Fairgrounds. At this point the fair encompassed over 60 acres.

Regrettably the fair has not escaped the arsonist's match. Early on Sunday, June 14, 1970, a malcontent set fire to the northwest section of the Fairgrounds near Fourth Street Southwest and Ninth Avenue Southwest. Before the 100 firemen from Puyallup and surrounding communities could contain the blaze, nearly 40 percent of the buildings had been destroyed, as had a section of the grandstand and part of the roller coaster. The fair board immediately ordered cleanup and reconstruction, and the fair opened as planned in September. The next fall a new grandstand and a new restaurant building awaited fairgoers.

Robert Carlson of Union City, California, arrived to take the position of manager in 1972 and has overseen impressive growth in both display areas and use of the grounds. To memorialize the Japanese internment, world-renowned sculptor George Tsutakawa from Seattle designed an 8-foot-tall bronze statue that was dedicated inside the Fairgrounds on August 21, 1983.

By 1984, the fair was pumping $5 million into the region's economy each year. The annual Western Washington Fair was only one of many events occurring at the grounds. In 1990, a four-day "Spring Fair" was inaugurated. Other interim events, including

DRIVING CLYDESDALES AT THE FAIR. Keeping the robust horses on rein is one of many skills tested at the fair over the years. The non-profit fairs bring millions of dollars into the city each year. (Courtesy Beta Club Collection.)

displays and shows ranging from guns to teddy bears, keep the buildings occupied much of the year.

It remains the annual fall fair, sixth largest in the nation, which gives Puyallup its noteworthy role in the Northwest.

Farmers and dairymen have dwindled and agriculture no longer supports many people in the Valley, but the fair continues to thrive, offering an opportunity to showcase high-tech products as well as the fruits of manual labor. Dad Chamberlain's vision lives, and he would probably enjoy the theme song penned as an advertising slogan: "All the people and the animals down at the fair, they do the Puyallup like they didn't have a care. And it looks like so much fun to do, I think I'm gonna learn how to do it too. You can do it at a trot, you can do it at a gallop, you can do it real slow so your heart won't palpitate; just don't be late, do the Puyallup."

OF DAFFODILS AND PRETTY MAIDS

Mrs. Charles Orton, wife of a major bulb producer, organized the first garden party in honor of the bright yellow blooms that surrounded their lovely farm home. In April 1926, she invited area dignitaries to attend the event, including officers from Camp Lewis.

With increasing acreage sporting the blossoms, or pink and white hyacinths as spring gathered momentum, Sunday drivers began touring the roads that ran along the fields. The growers encouraged this, establishing Bulb Sunday in 1932 and advertising it in Seattle and Tacoma. Despite the hard times, 25,000 visitors in 7,000 to 8,000 cars clogged the narrow country roads as the occupants admired the splendid displays.

Two years later the Daffodil Festival debuted. Well-known area newsman Lee Merrill returned from observing flower festivals in Europe and recommended bulb growers fasten blooms to vehicles to create a parade.

Every parade had to have a queen. Herman Zander, first parade organizer, bumped into Elizabeth Lee Wotton, a student nurse and married woman from Puyallup, and asked her to preside. The few floats subsequently assembled paraded from Pacific Avenue in Tacoma to Puyallup to Sumner in March 1936.

The next year, city and civic organizations came on board and the Daffodil Festival became an annual event, stopping only for the war years of 1943–1945.

The heyday of a national advertising campaign for the Valley's daffodil trade came in April 1957 when the Marshall Field Department Store in Chicago filled its nine floors with the flowers. Lowell Thomas, national journalist and commentator, gave the Daffodil Festival nationwide attention in his March 21, 1966 CBS newscast, calling Puyallup "The birthplace of spring."

Financial difficulties, lack of volunteers to decorate the floats, and other organizational problems have plagued festival organizers over the years. Yet we cannot but admire the foresight of those who picked up on Mr. Merrill's dream and the diligent workers who labor every year to bring this loveliest of all Northwest festivals to the people of Puget Sound.

MEEKER MANSION

Eliza Meeker, diminutive pioneer wife and mother, endured much hardship in her journey west and in putting down roots in an untamed land. With Ezra's many efforts to clear and cultivate the land, establish his hop crops, plat a town, start businesses, and encourage newcomers, there wasn't time left for improving the two cabins that served as home. Eliza's patience with the primitive living conditions lasted until Ezra took her on a hop-selling trip to England. There she was introduced to Queen Victoria and experienced a much more refined way of living. Upon their return she gathered her inheritance and funds from selling lands that had been in her name, commissioned Tacoma architects Ferrell and Darmer to design a real home, and waited patiently through the three years it took to build the house.

In 1890, the Meekers, in their early 60s, moved into their 17-room, Italianate Victorian mansion, the two of them rattling about in the tastefully decorated and furnished rooms. Sadly, Eliza became ill not long after and spent many of her remaining years alone in the house while Ezra worked in the Yukon and traveled. After she died in 1909, Ezra literally walked away from the house, which he had never appreciated.

Initially the house served as a hospital. In 1915, the Ladies of the Grand Army of the Republic (Civil War widows) bought it for a retirement home. The GAR foundation sold the house in 1948, and the first of a series of doctors used it for a nursing home and minor hospital.

In 1970, Dr. E.O. King sold the property and would have destroyed the building but for a group of historically minded local citizens who formed the Ezra Meeker Historical Society. They persuaded King to donate the house to them and planned to move it, but

155

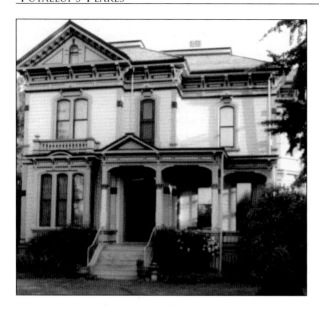

MEEKER MANSION. When Eliza Meeker died, Ezra walked away from his home. The 17-room Victorian mansion is now a favorite attraction for tourists and area schoolchildren. (Courtesy Ezra Meeker Historical Society.)

the new owner agreed to accept a nearby piece of property, which society members scrambled to buy. With the property issue settled, the mansion remained on its original site. Three years later the society had the home listed on the National Register of Historic Places. For over 30 years, with the generosity of citizens, foundations, and the City, and through untold hours of backbreaking volunteer labor, the Meeker Mansion has slowly regained its original imposing presence.

Opened to the public nine months of the year, the mansion serves as a prime tourist attraction and source of pride for the community. As with the fair, Eliza's home provides lasting evidence of the taming of this fertile land. Nearly all other noble vestiges of Puyallup's Golden Age have succumbed to earthquakes or development.

THESE BEAUTIFUL TREES

Along about 1861, pioneer John Carson planted a European-species chestnut tree on his homestead north of the Puyallup River. The sapling apparently liked the soil for it grew to a magnificent height, its sturdy branches stretching in all directions. The massive tree managed to escape the blight of 1904, but it nearly succumbed to the chainsaw in 1972 when freeway construction threatened. Puyallup residents intervened, the route was revised, and the tree still stands as a monument to one of the first families in the Valley.

Over the years many trees were planted in Puyallup to commemorate events. Charles J.A. Pihl, pioneer berry farmer, planted a black walnut tree in 1889 as his living memorial to Washington Statehood. By 1976, the venerable tree had spread its thick branches over Seventh Street Northwest, near Eighth Avenue, an area that had once been farmland. When city engineers planned the widening of Seventh Street, they decided the tree would have to go lest its roots crack the roadbed. Local residents wouldn't hear of it, and after a massive blitz campaign, the rare tree was declared safe.

Twin Norway Spruce trees were planted in Grayland Park following World War I in order to commemorate the city's lost soldiers. In the intervening years, one tree has succumbed, but the other remains. In the 1960s, trees were planted all over town in a beautification campaign.

The 1990 Puyallup Centennial Committee introduced a campaign to reestablish Puyallup as a setting for a wide variety of our nation's arboreal delights. Autumn drives past the spectacular sunset maples on Meridian Street testify to the campaign's success.

LAND ON LOAN

In the beginning it was the land, formed by natural turbulence and endowed with water, majestic trees, and fertile soil. With the mountain as backdrop, native people fished, harvested the wild berries and plants, and offered generous trades for their bounty.

White men arrived by water, oxen, and rail, finding potential in the timber, in cultivation, and the harnessing of the rivers. Men and women labored, beckoned others, and the land soon yielded to their efforts.

A town was born that became a vibrant member of the Puget Sound community—a place for fall fun at the annual fair, a site for innovation at a distinguished experimental station, an arena for successful entrepreneurship, and perhaps best of all, a great locale to raise a family.

It's still a paradise of sorts, this small city between the ocean and the mountain. But 150 years after settlement, man-made structures obscure much of what nature created. Ever more acreage lies covered in concrete, unavailable for the tiller's plow. The once huge trees are largely a memory.

Yet the unpredictable mountain, flood-prone rivers, and underground fault lines remain to remind us that the future belongs to them.

LOOK TO THE MOUNTAIN. This view of downtown Puyallup looks to the southeast and shows Mount Rainier's constant presence over the town. (Courtesy Beta Club Collection.)

157

BIBLIOGRAPHY

Alt, David D., and Donald W. Hyndman. *Roadside Geology of Washington*. Missoula, MT: Mountain Press Publishing Co., 1984.

Bonney, W.P. *History of Pierce County, Washington*. 3 vol. Chicago: Pioneer Historical Publishing Co., 1927.

Denny, Arthur A. *Pioneer Days on Puget Sound*. 2nd ed. Seattle: Alice Harriman Co., 1908.

Drummond, Val. *Doin' the Puyallup: An Illustrated History of the Western Washington Fair Since 1900*. Puyallup, WA: Western Washington Fair Association, 1991.

Dryden, Cecil. *History of Washington*. Portland, OR: Binford & Mort, 1968.

Eckrom, J.A.. *Remembered Drums: A History of the Puget Sound Indian War*. Walla Walla, WA: Pioneer Press Books, 1989.

Ekman, Leonard C. *Scenic Geology of the Pacific Northwest*. Portland, OR: Binford & Mort, 1970.

Federal Writer's Project. *The Oregon Trail*. 1933.

Kolano, Larry. *Puyallup Perspectives*. Tacoma, WA: Graphic Press, 1977.

Matson, Emerson M. *Legends of the Great Chiefs*. New York: Thomas Nelson Inc., 1972.

———. *Longhouse Legends*. New York: Thomas Nelson Inc., 1968.

Matthews, William P. "Puyallup School District No. 3: A Brief History." Unpublished, 1947.

Meany, Edmond S. *History of the State of Washington*. New York: Macmillan, 1946.

Meeker, Ezra. *Hop Culture in the United States*. Self-published, 1883.

———. *Seventy Years of Progress in Washington*. Tacoma, WA: Allstrum Printing Co., 1921.

———. *The Busy Life of 85 Years*. Self-published, 1916.

———. *Old Oregon Trail*. Self-published, 1920.

———. *Pioneer Reminiscences of Puget Sound: The Tragedy of Leschi*. 1905. Reprint, Seattle: Historical Society of Seattle and King County, 1980.

———. *The Ox Team, or The Old Oregon Trail*. 1906. Reprint, Puyallup, WA: Ezra Meeker Historical Society, 2001.

———. *Uncle Ezra's Short Stories for Children*. 1910. Reprint, Puyallup, WA: Ezra Meeker Historical Society, 1999.

———. *Personal Experiences on the Oregon Trail*. Self-published, 1912.

Morgan, Murray. *Puget's Sound: A Narrative of Early Tacoma and the Southern Sound*. Seattle: University of Washington Press, 1980.

Morgan, Murray, and Rosa Morgan. *South on the Sound: An Illustrated History of Tacoma and Pierce County*. Woodland Hills, CA: Windsor Publications, 1984.

Rau, Weldon W. *Pioneering the Washington Territory*. Steilacoom, WA: Historic Fort Steilacoom Association, 1993.

Reid, Robert A. *Puget Sound and Western Washington*. Seattle: Self-published, 1912.

Rushton, Alice. *The History of the Town of Orting, 1854–1981*. Orting, WA: Heritage Quest, 1989.

Stevens, James. *Green Power*. Seattle: Superior Publishing Co., 1958.

Van Slyke, Stuart O. "The Life of Stuart O. Van Slyke." Unpublished, 2001.

Washington State University Pamphlet. *100 Years in Western Washington*. 1989.

Newspapers
Pierce County Herald
Puyallup Herald
Puyallup Valley Tribune
Seattle Post Intelligencer
Sumner News Index
Tacoma Daily Ledger
Tacoma News Tribune

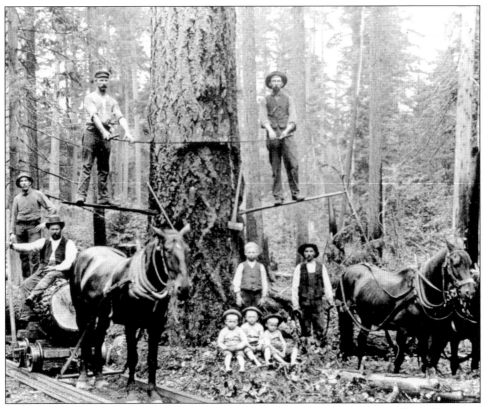

LOGGING DAYS. Logging lasted for nearly 50 years in the Puyallup Valley. The track on which the horse pulled the log places this photo in the latter days. (Courtesy Beta Club Collection.)

INDEX